MICHIGAN'S HISTORIC RAILROAD STATIONS

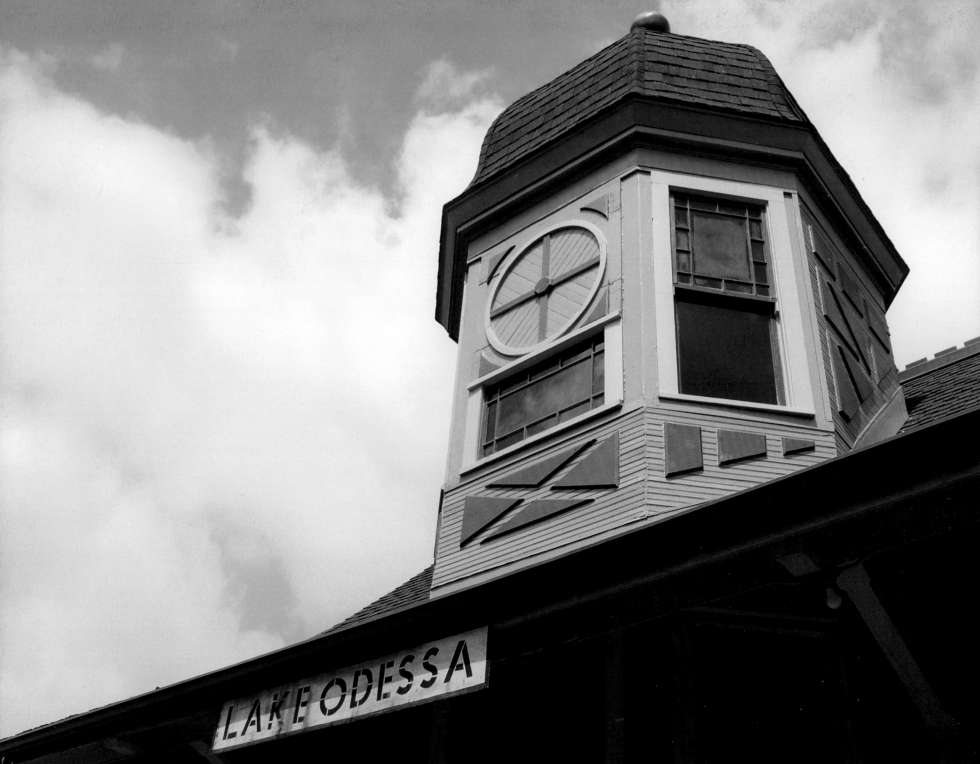

MICHIGAN'S HISTORIC RAILROAD STATIONS

Photographs and Text by

Michael H. Hodges

A Painted Turtle book
Detroit, Michigan

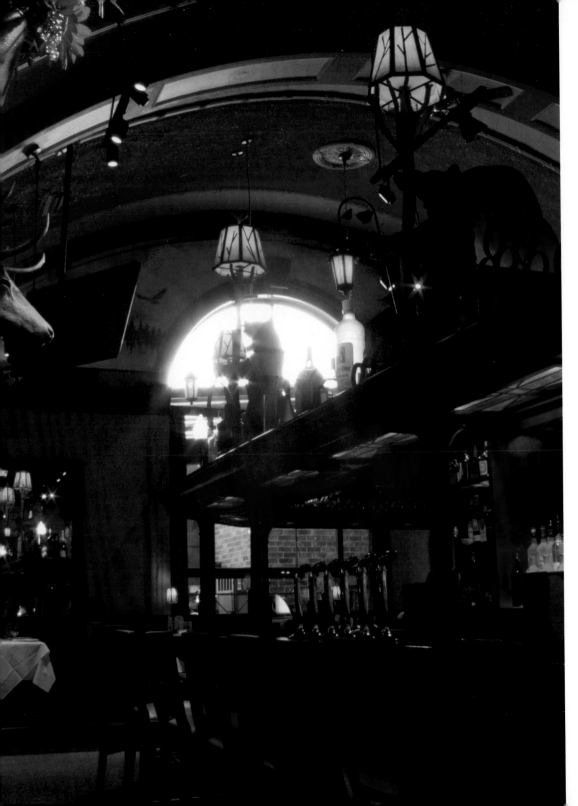

Library of Congress Cataloging-in-Publication Data

Hodges, Michael H., 1954–

Michigan's historic railroad stations / Michael H. Hodges.

pages cm — (A painted turtle book)

Includes bibliographical references and index.

ISBN 978-0-8143-3483-6 (cloth : alk. paper) — ISBN 978-0-8143-3812-4 (ebook)

1. Railroad stations—Michigan. 2. Historic buildings—Michigan. I. Title.

TF302.M63H63 2012

385.3'1409774—dc23

2012004235

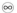

At left: Birmingham's old Grand Trunk commuter station now houses the Big Rock Chop House restaurant.

Frontispiece: The "Russian" tower atop the Lake Odessa depot.

Designed and typeset by Maya Rhodes

Composed in Apollo Mt and Frutiger

Contents

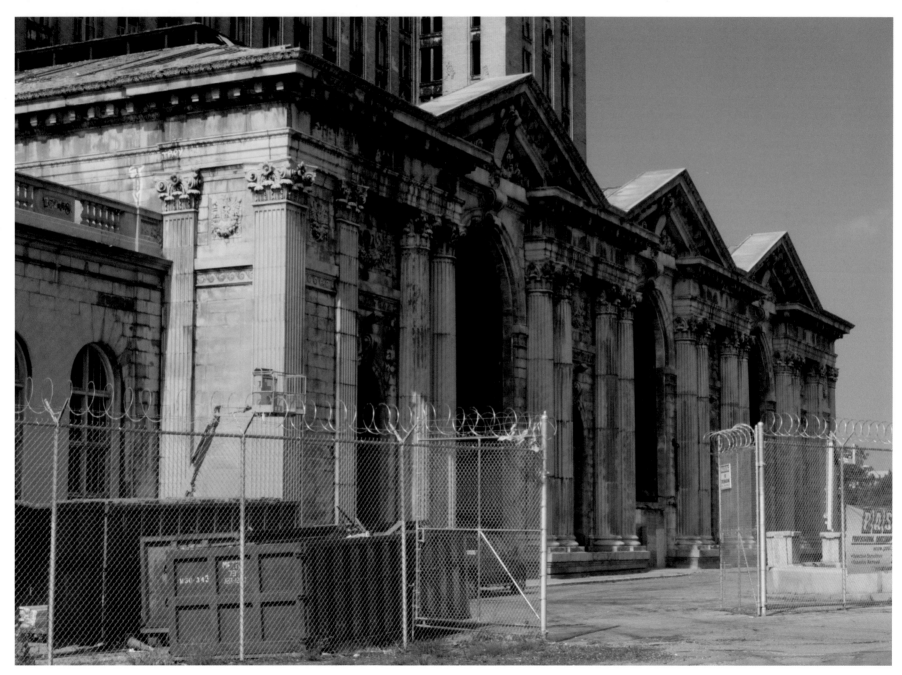

The queen of them all—the Michigan Central Station in Detroit.

Preface

Photographing a specific type of building across many styles was a project I had long wanted to tackle. Little did I know how many depots Michigan actually boasts. The Uhelski brothers, who inventoried the state's stations in the late 1970s, counted over four hundred at the time, though that number is bound to have declined significantly since then. All the same, there are far more Michigan depots than you might expect. Given this, it goes without saying that I have overlooked many fine examples—Standish and Evart come to mind—and to the citizens of those and any other neglected towns, I extend my sincere regrets.

To discover which stations were worth shooting, I relied heavily on several websites. The sites Michigan Passenger Stations, Michigan Railroad Passenger Depots, and Michigan Railroads were particularly useful because they post thumbnail images; these gave me a sense of whether a station was interesting for my purposes or not. I also relied on illustrated texts like Kathryn Bishop Eckert's *Buildings of Michigan* and Janet Greenstein Potter's *Great American Railroad Stations*. And inevitably, I leaned heavily on word of mouth. Don Westcott at the Michigan Railroad History Museum in Durand was a source of many good ideas, as was architect Randy Case in Battle Creek. And I'll always be grateful to my friend Barbara Murray for steering me to the winning little depot in Suttons Bay.

One of the pleasures of this undertaking was discovering three marvelous academic works on the subject, broadly, of train stations—enjoyable, literate essays that vastly deepened my understanding. Carroll L.V. Meeks's 1956 *The Railroad Station: An Architectural History* is the standard work on the topic—a slender, remarkably readable trek through the structure's evolution since 1830, when the first American depot, Baltimore's Mount Clare Station, came into use. Equally absorbing was Jeffrey Richards and John M. MacKenzie's *The Railway Station: A Social History*, a fascinating look at the integral role the depot used to play in daily life both here and abroad. And finally, *Metropolitan Corridor: Railroads and the American Scene* by John R. Stilgoe offers a wealth of insight into the impact railroads had on both the American built environment and popular culture.

This project ended up consuming two whole summers—giddy seasons spent crisscrossing the state, windows down, iPod on, poking into unknown little towns, searching, sometimes high and low, for railroad tracks that may or may not have been removed. More often than not, I'd stumble on a handsomer-than-expected station bathed in (check one) dawn or sunset light. For those lucky souls who don't fret about light quality, the hours close to sunrise and sunset—heavy with reddish light—lend a depth and luster to colors that shots at midday, with its flat, bluish cast, simply can't match. (I'd like to note, incidentally, how envious I am of photographers who make beautiful pictures of buildings under heavy overcast. For the life of me, I don't know how they do it. Yet anyone who remembers the 2011 Super Bowl commercial that's come

to be known as the "Chrysler-Eminem" spot will recall it was gaspingly beautiful, and yet shot under leaden, wintry skies. Go figure.)

I should also note that the history of railroad companies over time, and the mergers that generated a parade of ever-changing names, is as complex as the succession charts of some European monarchies. Suffice it to say that I take my hat off to those who know the subject well. I make no pretense to anything like that myself. So if I accidentally refer to the "Ann Arbor Railroad" at a date when it was still technically the "Toledo, Ann Arbor & North Michigan Railway," my apologies to all the sharp-eyed historians out there.

The hope with this sort of photo book, of course, is that the pictures are interesting enough to seduce readers who don't ordinarily give architecture much thought, causing them, even momentarily, to dwell on buildings and the virtues of historic preservation. As a rule, architecture is shockingly little discussed in American culture, so the opportunity to remind readers of the simple pleasures of older structures appealed to the evangelist in me. If this little volume sparks fresh appreciation for the ways in which architecture, that most public of all art forms, frames, organizes, and enlivens our daily lives, it will have succeeded beyond measure.

All writers thank their editors profusely, but sometimes the latter really deserve it. Both Jane Hoehner and Kathy Wildfong at Wayne State University Press were enthusiastic about this project from the get-go, supportive of an untried photographer and author, and helpful when things momentarily looked rough. Thanks go out as well to two architectural wise men kind enough to lend their expertise, both of whom spent hours poring over images to help this writer identify architectural styles. Professor Robert Fishman, distinguished architectural historian at the University of Michigan, and Reed Kroloff, director of the Cranbrook Academy of Art and Art Museum, were both generous with their time and patience, steering a layman through the vagaries of Eastlake and Richardsonian Romanesque. Without them, I would never have had the confidence to expound the way I have, though it goes without saying that any errors are mine alone, and not Kroloff's or Fishman's.

Thanks also to fellow authors Ronald Campbell and Jacqueline Hoist, both architects with deep experience renovating old depots, whose handsome book *Michigan's Destination Depots: Lighthouses Along the Rivers of Steel* was published in 2010. What could have been a competitive relationship between authors covering the same subject instead quickly morphed into friendship. Their excitement over my book provided oft-needed encouragement. And, critical to illustrating this book, Ron and Jackie graciously lent their extensive collection of old depot postcards for my use, many of which appear in these pages.

I'd also like to salute J. Patrick Jouppi, master's candidate in public history at Western Michigan University, who conducted historical research for me in several west Michigan towns that, toward the end of this undertaking, involved more driving than I could afford. His work was of the highest caliber, and he was gratifyingly enthusiastic about the project to boot.

To my family and close friends, who probably feel like they'd heard me griping about this project for twenty years (it was actually two, okay?), I offer my heartiest thanks—particularly to my sister-in-law Kathryn, whose enthusiasm and support for my photography from the start helped convince me I was onto something.

And I'd like to salute Tom Stamp, Reynolds Farley, and David Lynn—talented editors all—who were kind enough to read parts of the manuscript in preparation and offer highly useful suggestions and insights.

Others, from Charlevoix Historical Society head David L. Miles to *Michigan History Magazine* editor Patricia A. Majher, were remarkably helpful and generous, as was Robert Christensen at the State of Michigan History Library. I am also indebted to Lois Bahle, Fabian Beltran, Dale Berry, Richard Borsos, Cary Church, Kathleen Clark, Rose Cohoon, Robert Cosgrove, Bill Cummings, Ray Detter, Candace Fitzsimmons, Frank Franzel, Elaine Garlock, Edward Gross, Randall Hazelbaker, Rose Hollander, Lynn Houghton, Craig Jolly, Joyce Kerr, Floyd Klauka, Larry Lewis, George Livingston, Alan D. Loftis, Greta Mackler, James Mann, Valerie Marvin, Bruce Marx, Don Meints, Tom Mull, Bob Myers, Carolyn Nash, Danny Neudell, Diane Nowak, Larry Noyes, Karen Persa, Leslie Pielack, Brendan Pollard, Linda Roth, Neal Rubin, Al Rudisill, Ed Rutkowski, Merritt B. Scharnweber, Diane Schmidt, Trent Smiley, Norm Somers, Curtis Stewart, Mary Stone, Wystan Stevens, Richard L. Stoving, Joyce Thatcher, Beth Timmerman, Tom Trombley, Nancy Van Blaricum, David Votta, John Waite, Charlie Whitt, Phil Willis, and Don and Mary Wilson.

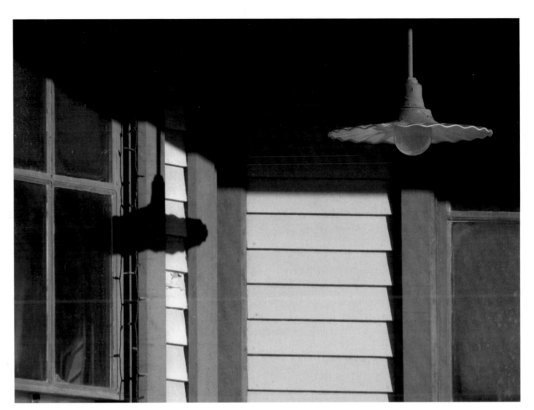

Chelsea depot.

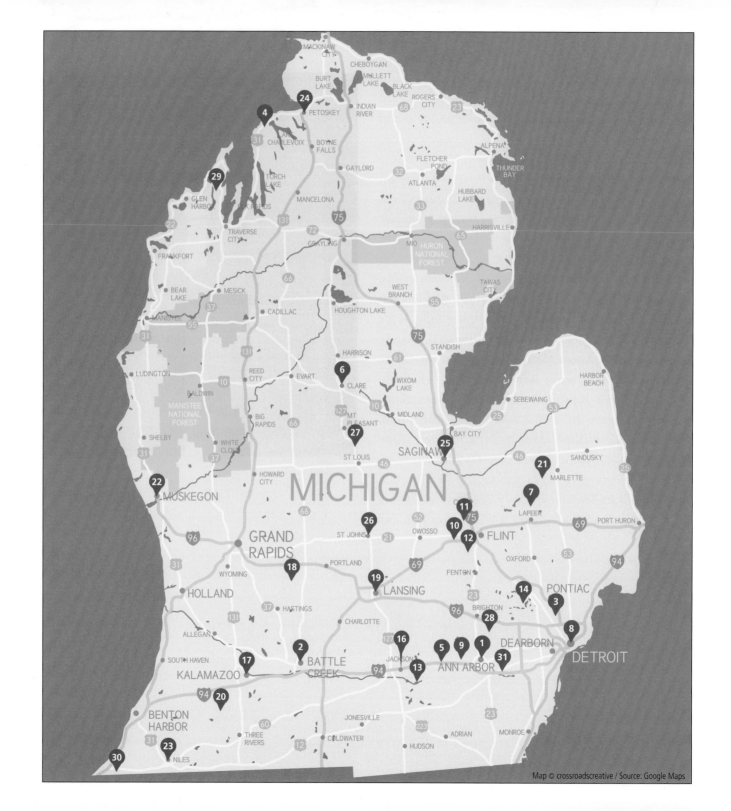

X

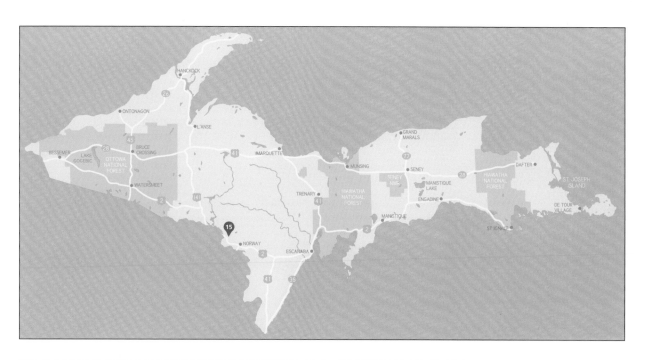

Michigan's Historic Railroad Stations

1 Ann Arbor	12 Gaines	23 Niles
2 Battle Creek	13 Grass Lake	24 Petoskey
3 Birmingham	14 Holly	25 Saginaw
4 Charlevoix	15 Iron Mountain	26 St. Johns
5 Chelsea	16 Jackson	27 Shepherd
6 Clare	17 Kalamazoo	28 South Lyon
7 Columbiaville	18 Lake Odessa	29 Suttons Bay
8 Detroit	19 Lansing	30 Three Oaks
9 Dexter	20 Lawton	31 Ypsilanti
10 Durand	21 Mayville	
11 Flushing	22 Muskegon	

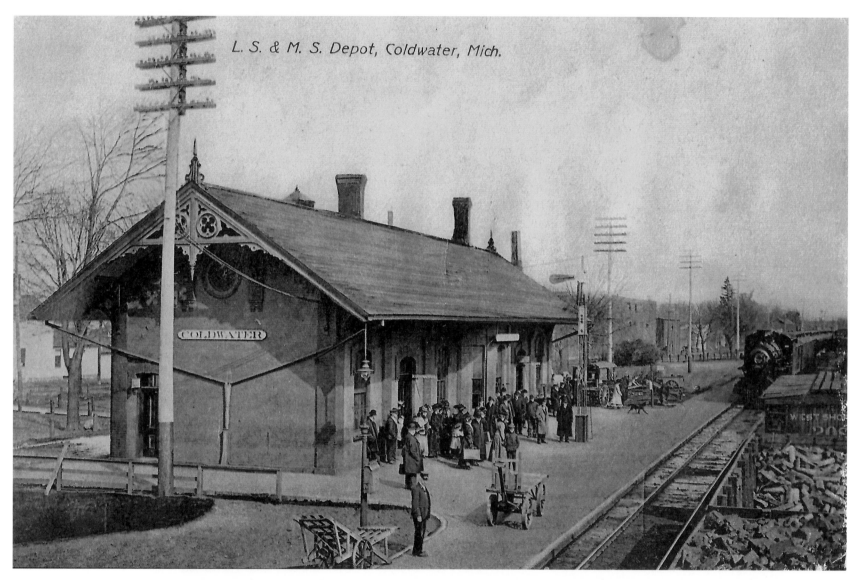

L. S. & M. S. Depot, Coldwater, Mich.

It's hard to overstate how central the train station was a hundred years ago, particularly to small-town life. Not only did it grant access to the most thrilling technology of the age, but—before the telephone, at least—the depot was the center of all means of long-distance communication known to man. The telegraph office was invariably housed there, while bags of U.S. Mail—sorted by postal employees on speeding trains—landed on platforms with a loud thud, often heaved from speeding expresses. And, as the Coldwater crowd waiting for the Lake Shore & Michigan Southern train in the picture above could tell you, the depot was a great crossroads—sooner or later, you bumped into everyone there. Coldwater's stolid, brick station was built in 1883 and still stands. The town's original depot, a board-and-batten shed erected in 1850 widely thought to be Michigan's oldest surviving depot, sits just a few yards to the left. It's now a hair salon.

Introduction

It was the snow-heavy winter of 1997 when I first got to know Catfish, a homeless man living in Detroit's abandoned Michigan Central Station. Photographer Donna Terek and I had been interested in profiling the daily life of a homeless person for the *Detroit News,* and in Catfish we found a prickly, forty-five-year-old white guy who defied most common assumptions about life on the street. Catfish was no study in addled dissipation. All things considered, he was surprisingly adept at his catch-as-catch-can existence, which he approached very much like camping.

He and the towering, empty station had an unlikely relationship you could almost call symbiotic. The building with the gouged-out widows sheltered the man, who—part squatter, part Phantom of the Opera—did his level best to protect what was left of the lavish detailing within the station that once was the tallest in the world. While Catfish had a powerful love-hate relationship with the eighteen-story building he called "the big tomb," this grizzled hobo was also as conscious of the depot's visual power as any graduate student in design.

The building's decline echoed the man's. Both were abandoned in 1988 and began their slow-motion disintegration. The last Amtrak train pulled out of the depot in January, months short of the station's seventy-fifth anniversary. Then they padlocked the building. Six months later and a few miles north, Catfish's wife grabbed their baby boy and walked out. She disappeared, he said, "like she got beamed up or something." Then the rot set in. Catfish lost his grip on regular life,

all his possessions, and most of his teeth. When Donna and I met him, he'd been officially homeless for about a year and a half. "After my old lady left," Catfish said, "I didn't care if I lived or died. I sold my microwave. I sold my weights. Then I just lost myself."

Over those same years, intruders and the elements savaged the Beaux-Arts train station just west of the old Tiger Stadium with an aggressiveness that makes one gasp. Vandals—in the main, suburban boys out on a lark—smashed every inch of sandstone and marble detailing they could crowbar loose, piles of which littered the rose-colored floors. The waiting room's great Tuscan columns—a luminous saffron in afternoon sunlight—were riddled with water damage and tarred with angry graffiti, giving the cavernous space, fifty-five feet above the floor at its apex, the feel of a desecrated Egyptian tomb. Catfish took it upon himself to try to restrain the teenagers' joyous impulse to bust and bash. This preservation campaign won him a few friends but far more enemies, judging by the violent, spray-painted epithets still visible on the walls fifteen years later.

Still, as some kids discovered to their delight, if you got on his good side, Catfish could give a fascinating tour that ranged from the depot's basement—no darker, creepier place on planet earth—up eighteen flights of collapsing stairs to the tower's roof. Back on the main floor, he'd point to the arcade stretching from the ticket windows to the east entrance, where streetcars once dropped off passengers hustling to trains like

the Detroiter, the Twilight Limited, and the Mercury. "Look at this arch," Catfish would say. "Why'd they need to make that so high? Well," he'd answer himself, smile breaking across his face, "just so you'd walk in and go"—jaw dropped in mock amazement—"*Wow!*"

Is there any better summary of monumental architecture's role in modern society? Indeed, railway companies increasingly turned to spectacle and grandeur in the last years of the 1800s, once American station building hit its affluent phase. (Up until then, we'd lagged far behind Europe in station magnificence, despite the fact that railroading was born simultaneously—in 1830—in both England and America.) The earliest stations, of course, were mostly sheds or houses—sometimes taking their cue from inns that had acted as stagecoach stops. (Michigan's oldest surviving station dates from 1850 and is now a hair salon in Coldwater. The oldest in the country is the 1830 Ellicott City station outside of Baltimore.) But neither stagecoach nor sailing vessel ever generated its own unique building type. The depot was, as Jeffrey Richards and John M. MacKenzie argue in *The Railway Station: A Social History,* the nineteenth century's "distinctive contribution to architectural forms." And it all had to be invented from scratch.

The depot also constitutes one of the first original building types created by corporate America. The depot's "unique functional characteristics were repeated so often," write architects Ronald Campbell and Jacqueline Hoist in *Michigan's Destination Depots: Lighthouses Along the Rivers of Steel,* that any such structure is "easily recognized as a train depot." This is as true of modest structures as it is of grand ones. In Michigan, the smart little cottage stations in Chelsea, Gaines, Shepherd, and Three Oaks could hardly be mistaken for anything else.

While nineteenth-century architecture has sometimes been dismissed as a grab bag of revival styles with no overall coherence, Carroll L. V. Meeks argues in *The Railroad Station: An Architectural History* that all the design enthusiasms from 1815 to 1914 can be loosely grouped under the rubric "picturesque eclecticism." Meeks sketches an architectural history of action and reaction, starting in the early 1800s with a powerful swing away from the formal simplicity of both the Classical Revival and Academic styles. If symmetry and repetition were suddenly "boring," the picturesque new century would pioneer a design philosophy that can be summarized as "form follows fancy," a celebration of historical motifs both real and imagined that added up to a riot of individualism. Gone were the smooth planes of Classical surfaces. The new century's architectural hallmarks would be variety, movement, irregularity, intricacy, and roughness. Silhouette trumped all—and make it asymmetrical while you're at it. It made for a lot of visual activity. Victorian-era depots, Meeks notes, "bristled with turrets, gables, pinnacles, cresting, or whatever devices would ensure the greatest amount of intricacy and irregularity" (a stylistic explosion the more austere Richardsonian Romanesque struggled mightily to tamp down). In Michigan, stations with particularly strong profiles include Ann Arbor's Michigan Central station, Niles, Muskegon, Lake Odessa, and the Michigan Central's Kalamazoo and Detroit depots.

The inevitable reaction to nineteenth-century architectural fussiness blew in with the 1893 World's Columbian Exposition in Chicago, whose majestic white buildings acquainted the country with the pleasures of classicism in the Beaux-Arts style. That in turn launched a parade of early twentieth-century Classical Revival depots—Pennsylvania Station and Grand Central Terminal in New York, Toronto's Union Station,

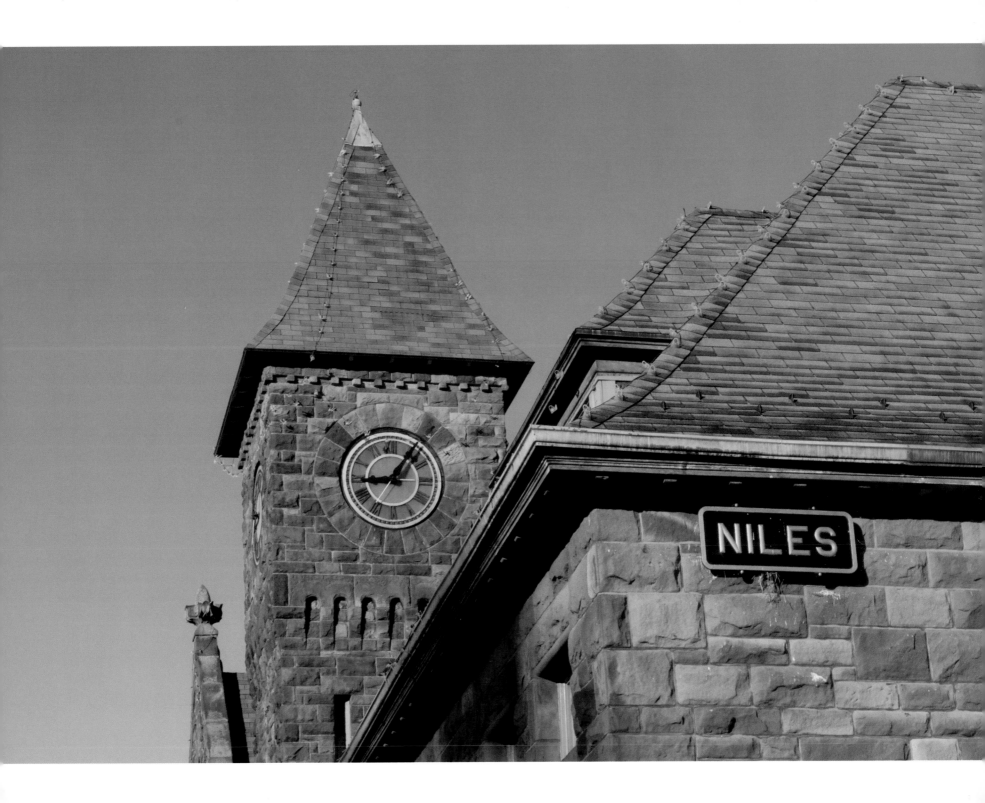

As far as architectural riches go, some stations enjoy an embarrassment of riches—very much the case with the Muskegon Romanesque masterpiece.

and Detroit's Michigan Central Station to name four—that could hardly be any different from, say, Muskegon's richly textured Romanesque masterwork. (Station building slowed dramatically after the First World War, with just a couple triumphs like Cincinnati's magnificent Art Deco showpiece. But the application of the International style to the depot was in general not a happy bonding. Doubt it? Take a look at Toledo.)

Looking back, it's got to be hard for modern travelers to imagine how stunned our ancestors must have been by the novelty of it all. When land transportation was limited to animal speed, getting from Detroit to Chicago on lousy roads could take up to a week. The railroad's arrival revolutionized the individual's place in the world. Cities across the country that had been as remote as other planets—unless you could get there by boat—were suddenly and dizzyingly within reach,

marvelous to contemplate even if one never actually boarded a train. The isolation of the preindustrial era, both crushing and beautiful, was erased once and for all, and humankind would never be quite the same. Together, the train, the telegraph, and radio upended the old world, plunging residents of big city and small alike into the maelstrom of the wider world. Indeed, there were many who initially regarded the iron horse with alarm. As Richards and MacKenzie note, the belief was relatively widespread at the dawn of rail transport that going faster than thirty-five miles per hour, say, could cause your body to "burst and be scattered across the railway lines"—a dismaying image, to be sure. That fear was dismissed fairly quickly, of course, but other anxieties lingered. So as it evolved, the depot necessarily acted as more than just a shelter and a way of organizing traffic. It was intended to string a hazy, reassuring scrim between the public and the belching monster on the far side of the street façade—a stage set meant to muffle the shock of the new and, inspire confidence and trust.

It called for some improvisation. "Architects didn't know quite how to handle the train," said Reed Kroloff, architect and director of the Cranbrook Academy of Art and Art Museum in Bloomfield Hills outside Detroit. "It moved quickly, poured smoke into the air, and scared people—the machine come to take over the world. So what did architects do? They slammed history all around it as a way of domesticating the uncontrollable machine and our inevitable slide into the machine age." Architects' role, as Richards and MacKenzie note, was to "comfort and reassure those concerned about the newness of it all."

Some, of course, found that slide into the machine age nothing short of thrilling. Kids in particular were in thrall to the

stirring powers and promises inherent in the new age of steam locomotion. The depot exerted a special pull on teenagers "because it was the threshold opening on metropolitan glamour and technological excitement," as Richards and MacKenzie put it. "It opened away from the restrictions of childhood and the smothering effect of conformist shabbiness." The train station was where young boys and girls would go to get a whiff of power and the future—well documented in Edmund G. Love's *The Situation in Flushing,* a deadpan account of a train-mad Michigan boyhood.

There was more going on than mere transportation, apparently. In the absorbing *Metropolitan Corridor: Railroads and the American Scene,* John R. Stilgoe reminds us how often the depot appears in literature "as a liminal zone through which young people pass into adulthood, into adventure, and into real or seeming wisdom." Think of stations and trains in pre-1945 literature and cinema, when the train passage is so often the hinge between a past the protagonist is fleeing and the glittering promise of a new life. Such is the case for the doomed young hero of Willa Cather's short story "Paul's Case." Paul's overnight ride, uncomfortably sprawled on a day coach from Pittsburgh to New York City, marks his final break with a past that threatens to choke him—and his train journey is clearly a hyphen setting that off from his upcoming slide into quicksilver luxury and disaster at the Waldorf Hotel. Similarly, when Sherwood Anderson's young narrator in *Winesburg, Ohio* finally makes his longed-for escape to New York City, his face as the train pulls out of his hometown station registers neither glee nor vindication. Rather, Anderson says, the lad sinks back in his seat, his features struck quite dumb by the magnitude of all that lies ahead and all he is leaving behind.

It's hard for modern viewers to push beyond the nostalgic gloss that coats everything connected to the railroads. "Quaint" keeps popping up to coat the works like honey. But railroading's early years weren't quaint at all. These trains were blazingly modern machines in their day, and dangerous as the deuce. Crushing horsepower and rocketing speed both carried the implicit chance of violent death. Indeed, until the widespread adoption of air brakes in the early twentieth century, brakemen had to crawl along the tops of moving, jerking freight cars—unspeakably treacherous in winter—to screw brake wheels shut one by one, as close to a suicidal job description as you could find.

"Picture it," said Farmington Hills resident Richard Borsos, eighty-seven, who worked for forty-two years on the New

The train doesn't stop here anymore—it just roars on by. In Chelsea, at least, you can't say you weren't warned.

York Central in Michigan. "You're a brakeman on a freight train. And the engineer blasts one short blast. Your job was to walk along the tops of the cars to wind the brakes on each one, turning a wheel on a vertical shaft to pull the brake shoes against the wheels. In the winter, it's icy up there, and those cars are rocking back and forth. Men were falling between the cars, losing both legs or getting killed. It was just part of the job."

Track and wheels consumed an untold number of limbs and lives, and newspapers in the late nineteenth and early twentieth century reveled in disturbingly precise accounts of these dismemberings. Headline writers seemed to compete to "mangle," "butcher," "crush," and "cut" their unfortunate victims "repeatedly in two," in bloodthirsty language shocking to one raised on the primmer journalism of the modern era. On August 2, 1921, the *Detroit Free Press* reported that thirteen-year-old Arza Durst died trying to hitch a ride on a Michigan Central freight; he lost his grip and was "literally ground to pieces." In 1874, a Dr. E. H. Drake of Detroit was hit on November 15—his fifty-third birthday—by an express bypassing the Ypsilanti depot. As the poor man fell, his right hand was cut off. "When he was dressed that night at the undertaker's," the *Free Press* reporter made a point of noting, "his watch was still running." One other unlucky fellow was left in so many pieces along the track near Durand, the *Free Press* reported in 1909, that he had to be gathered up in a washtub. Little wonder the train emerges as the favorite agent in literary suicides from "Paul's Case" to *Anna Karenina*— wherein mortals are devoured by the avaricious new machine age.

But the dominant impression of the depot, particularly in the glory days from about 1890 to 1925, was one of optimism and can-do confidence, a tangible symbol that embodied the era's vaulting self-regard. No surprise, then, that it was often the gathering point for celebration and civic ritual. Newspapers enthusiastically wrote up celebrations at stations when soldiers set off for the Spanish-American War in 1898, accounts that echo across the century with equal parts bombast and naïveté. Similar scenes were enacted in 1917 as the United States entered what was then called the Great War. A crowd four hundred strong, the *Detroit Free Press* noted, turned out to see off the Highland Park boys on November 16. "From a balcony [at the Michigan Central Station], three little girls, golden-haired and in white dresses, were waving miniature Old Glories," the reporter wrote. "Boys and girls clung to the ledge and iron bars of the depot palisade surrounded by a dense throng of women and girls with reddened eyes and heaving breasts." By the start of the Second World War, however, you find little of this celebratory hoopla. Perhaps the horrors of the previous war loomed too large.

For those members of the armed forces killed abroad in both World War I and World War II, the local train station probably constituted their last physical contact with "home." This almost surely had to have been the case with both Sergeant Louis Frank Antozak and "Private Nikansky" (as the newspaper had it), Detroiters whose deaths in 1918 the *Detroit Free Press* reported on October 3 and October 7 respectively— just weeks short of Armistice Day and the end of the war.

Conflict overseas, of course, wasn't the only issue that drew crowds to the depot. When athletic teams still traveled by train, not bus or plane, thousands of University of Michigan undergraduates would mob Ann Arbor's Michigan Central station to see a favorite team set off for glory or return with it in firmly in hand—a tradition that mostly did not survive

the switchover to rubber-wheeled transport. Ann Arbor's Michigan Central station was also the usual setting when the great and grand visited. In the case of former president Grover Cleveland, campaigning in 1892, this meant meeting the guest at the depot with a carriage pulled by four white horses, the city bands from both Ann Arbor and Ypsilanti, both towns' military contingents and—delicious to contemplate—university "law students with banners," according to the *New York Times.* All processed solemnly up the State Street hill to the old towered courthouse, another long-gone focal point for civic celebration. (It must have been a chilly walk. The visit fell on February 23.)

The depot's decline, in fact, parallels a sharp drop in the use of public space generally in American life over the twentieth century. Bus terminals never rose to the dignity required for such activity, and while there was a time when expectant crowds gathered at airports—think of the teenaged girls pressed against fences the world round when the Beatles toured—airports have rarely been as satisfying, stuck as they are out in the hinterlands, and now completely cocooned from regular life by security concerns. This is not to say, however, that airports don't produce great architecture. Eero Saarinen's sculptural masterpiece, the 1962 TWA Terminal at New York's Kennedy Airport, comes to mind, as does Helmut Jahn's 1987 United Terminal at Chicago's O'Hare Airport. For that matter, so too does the SmithGroup's McNamara Terminal at Detroit Metropolitan Airport, built in 2002 and as gracious an experience as you're likely to find with any big-city airport. But visiting an airport is never something you just "happen" to do because the spirit moved you. Airports and train stations may offer much the same great people watching, but one was knit

into the fabric of a city's daily life in a way the other never has been. Many old depots were integral parts of a thriving downtown. Airports never were.

And yet the airplane—and the automobile—won, soundly trouncing rail transportation as early as the 1930s. The cultural shift was more profound than just a decline in depot use. "Suddenly," Stilgoe writes, "in the years of the Great Depression, in the ascendancy of the automobile, [the train station] vanished from the national attention." That certainly was the experience of this author while conducting newspaper research. In railroading's glory days, reporters clearly hung around in the hopes of chancing on stories, and depot stories popped up in print all the time. But even with the sudden boost in ridership that gas and rubber rationing gave the railroads during World War II—to say nothing of troop movements—the depot as a symbol of American life, where the most important and vital things occurred, utterly vanished. By the mid-1950s, the only stories are those commenting on how eerily deserted the old station is. By 1962, train travel had dwindled to just 2.5 percent of intercity passenger miles traveled. Happily, many abandoned stations nationwide have been rescued for new uses ("embalmed" is Stilgoe's tart term), whether offices, restaurants, or historical museums. The Gaines, Michigan, depot is now a Saturday-only branch of the Genesee County Library System—a magnificent reuse that preserves the building's public purpose. Many times, however, stations have been moved from their original sites, as with the Michigan depots in Mayville and South Lyon. Often as not, they end up in historical parks, sometimes arranged with other "antique" buildings in uneasy juxtaposition. If a depot is threatened with destruction, of course, then moving

Among imperiled Michigan depots, Detroit's Michigan Central Station ranks near the very top—though first place surely goes to Saginaw's spectacular, ravaged Potter Street Station. In Detroit (and like as not, Saginaw), depressed real-estate values and the cost of demolition cooperate to preserve the looming sentinel a mile or two west of Detroit's downtown.

it is the best possible solution. Still, divorced from the train tracks and their historic role in the urban fabric, such stations often feel oddly out of place and forlorn.

Out of place and forlorn as well, Catfish was forced to move on from Detroit's Michigan Central Station a few years after Donna and I did our piece on him. In 2000, the train platforms behind the station were ripped out. In the process, a broken water pipe that had supplied a constant stream of fresh, clean water was sealed off and fixed. Without a water source, the depot became a far more inconvenient place to live. The last I knew, Catfish—who sent me Christmas cards several years running—had moved into an unheated house in Detroit's Mexicantown.

I don't know if he's still in Detroit. I doubt it. But if he is, I can't help but think that Catfish, the homeless preservationist, would smile at the attention that Detroit's Michigan Central Station has enjoyed in recent years, both locally and on the national stage. While aficionados have revered the building for decades, its rise as one of the most visually recognizable symbols of Detroit is new and unexpected. Whether public adoration can save a building with no clear use, of course, is the big unanswered question, one we can only hope will be answered in the affirmative. The Michigan Central Station, like so many depots scattered across the state, is a cultural marker deeply embedded in the local consciousness, a visual link to our past, and—let us be frank—far more striking than anything that will ever take its place.

MICHAEL H. HODGES
Ann Arbor, October 12, 2011

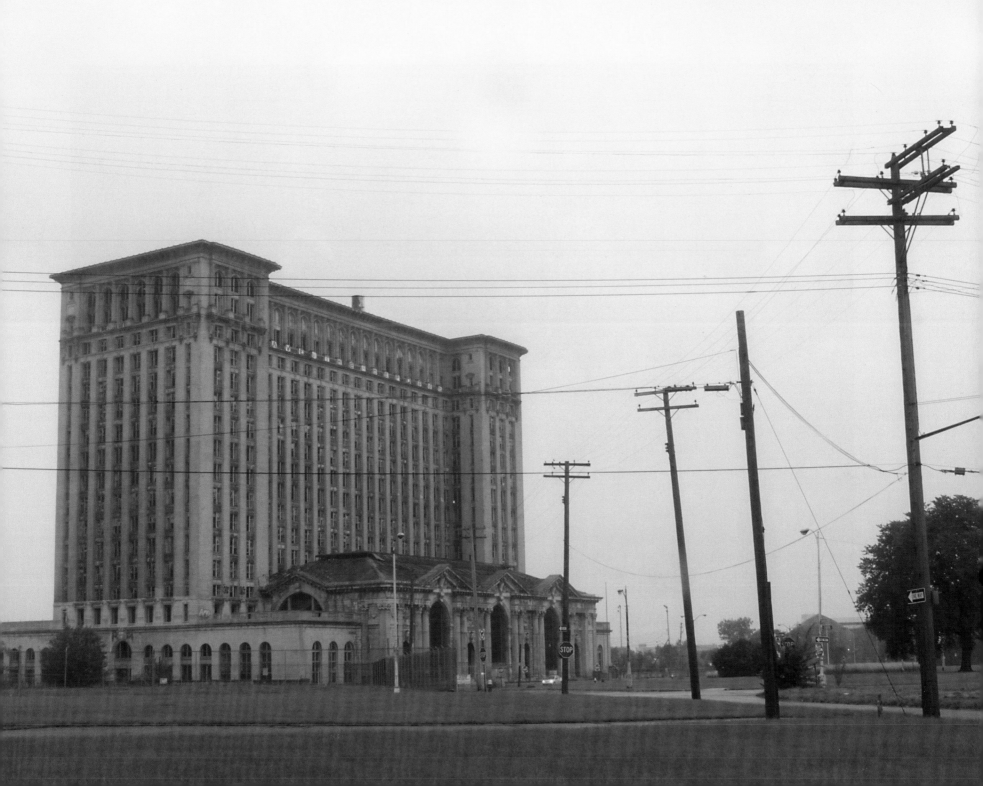

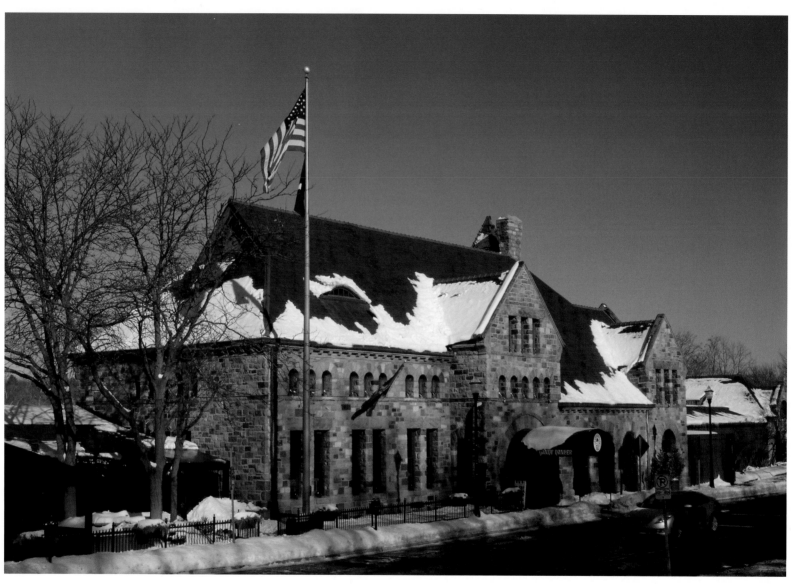

Ann Arbor's 1887 Michigan Central depot reflects Detroit architects Spier and Rohns' deft touch for Richardsonian Romanesque design, with outstanding stations here as well as in Niles and Grass Lake. This cut-stone building is the most colorful of the three, however, with geometric patterning on the two towers that bears close study.

Ann Arbor

1887—Michigan Central Railroad
401 Depot Street

ARCHITECTS: Spier and Rohns

LAST PASSENGER SERVICE: 1970

CONDITION: Outstanding

USE: Gandy Dancer restaurant

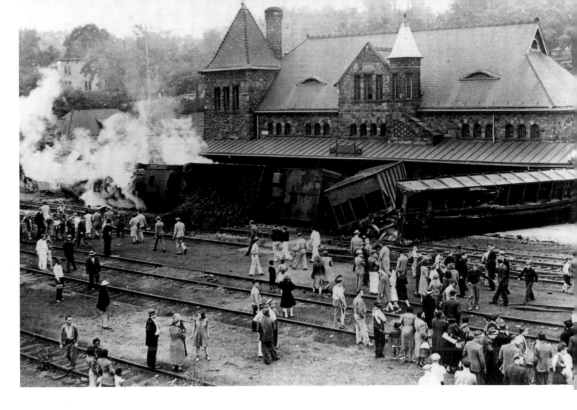

The 1941 train wreck occurred when a freight derailed right at the station. Remarkably, nobody was killed. (Claude Stoner Collection, Bentley Historical Library, University of Michigan)

*A*nn Arbor's striking Michigan Central Railroad Depot opened in 1887, designed by the Detroit firm Spier and Rohns, which over the next two decades would in effect become the state's master builders of train stations. It was an early commission for the two German-born and German-trained architects, who'd joined forces only in 1884. Other notable Spier and Rohns depots include those at Dexter and Grass Lake near Ann Arbor as well as larger and more imposing stations in Niles, Lansing, and Battle Creek.

For the Ann Arbor station (now the Gandy Dancer restaurant), Frederick H. Spier worked in the rough-textured Romanesque style popularized by the most famous architect of the era, H. H. Richardson of Boston. Yet for all its Richardsonian Romanesque elements—the heaviness of the stone, the massive entry arch, and stubby towers that don't dwarf the rest of the building—the station is a more colorful affair than most of Richardson's buildings, which tended toward the monochromatic. You see this especially with the towers—one square and roofed in red tile, the other circular and copper topped—each of which sports geometric patterns rendered in Ohio blue stone, Lake Superior red, and the pinkish hues of local Ionia stone. (Those familiar with the University of Michigan campus might note similar multicolored stone at the Kelsey Museum of Archeology, another Spier and Rohns Romanesque building that bears more than a passing resemblance to the depot.)

Ann Arbor's previous Michigan Central station had come to be seen as shabby and small, so it's no surprise local media exulted over their grand new gateway with its stained glass, red-oak trim and ceilings, and French tile floors. On its inauguration in March 1887, the *Ann Arbor Courier* grandly declared the station "probably the finest depot on the conti-

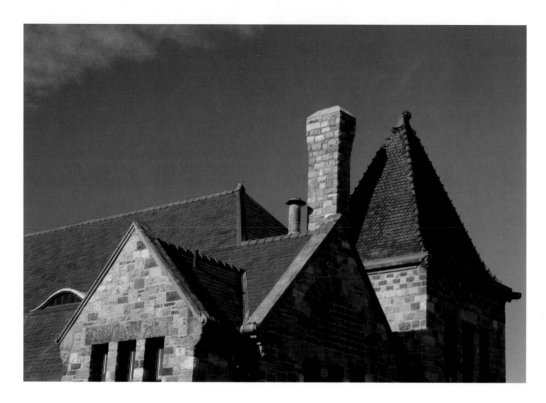

In its zeal for puncturing the sky with gables, chimneys, towers, and an eyebrow window at left, Ann Arbor's Michigan Central station is classically Victorian in aspiration and flourishes. Given its location in a college town, at certain points in the calendar the station would be overwashed with a great incoming or outgoing tide of students. By the way, the platform visible in the postcard at right has mostly been enclosed to add more seating for the Gandy Dancer restaurant that's been in business here since the 1970s. (Personal collection of Jacqueline Hoist and Ronald Campbell)

nent." Other critics were more measured. The April 1, 1887, *Railroad Gazette* complained that the floor plan was flawed: "[L]adies have to enter the gentlemen's waiting room or stop in the lobby or passageway to buy tickets," both considered affronts to what was then regarded as the "weaker" sex. Since the lobby also acted as the direct passage from front door to train platform, the magazine warned that in winter that configuration was likely to funnel cold air throughout the building, notwithstanding the best efforts of the lobby's large terracotta fireplace.

As a university town, Ann Arbor (and thus its depot) was witness to a fairly steady parade of the great and famous over the years—and those who came by rail from Chicago or the Northeast were likely to take the Michigan Central, not the

pokier Ann Arbor Railroad out of Toledo. In February 1892, former president Grover Cleveland arrived at the station while campaigning for his second term. (The New York Democrat was the only president to win reelection who didn't serve consecutive terms. He won in 1884, lost in 1888 to Benjamin Harrison, and then beat Harrison in 1892.) Ann Arbor was "agog" over the candidate's presence, according to the *New York Times,* and clearly, as noted in the introduction, the town fathers pulled out all the stops—a good example of the one-time use of the train station as a gathering point for public ceremony, something almost entirely lost in the bus and air-port era. At the depot to greet Cleveland in 1892, the *Times* reported, were two thousand students, "noisy with tin horns and their college yell," plus a flotilla of bands and local dignitaries.

Teddy Roosevelt would blow through the station three times, most notably on April 11, 1899, just after the end of the Spanish-American War, when he was received with wild acclaim as the "Hero of San Juan Hill." Roosevelt was tickled, saying, "I have had a corking good time!" according to a University of Michigan account of his visit. The young Winston

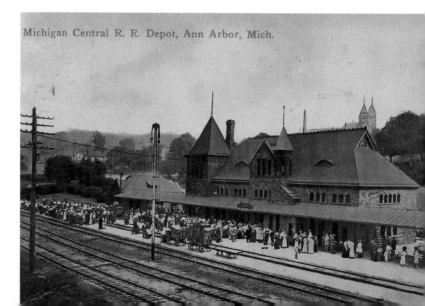

Michigan Central R. R. Depot, Ann Arbor, Mich.

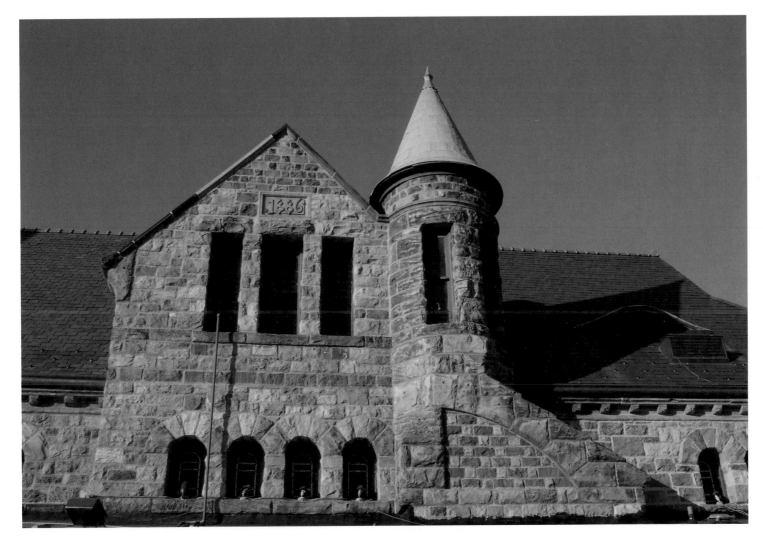

Churchill stopped briefly in 1901, and former president William Howard Taft came to give a speech in 1915. In a mix-up all too familiar to modern travelers, Taft discovered on arriving at the depot that his bag had been lost—he'd mistakenly been given one filled with women's garments. Finding appropriate clothes for "Big Bill," who weighed over three hundred pounds, set university officials scrambling. As a consequence the ex-president's address at Hill Auditorium was somewhat delayed.

On the cultural side of things, poet Robert Frost arrived from New Hampshire in 1921 to take up the teaching position he held at the university till 1927, and *My Ántonia* author

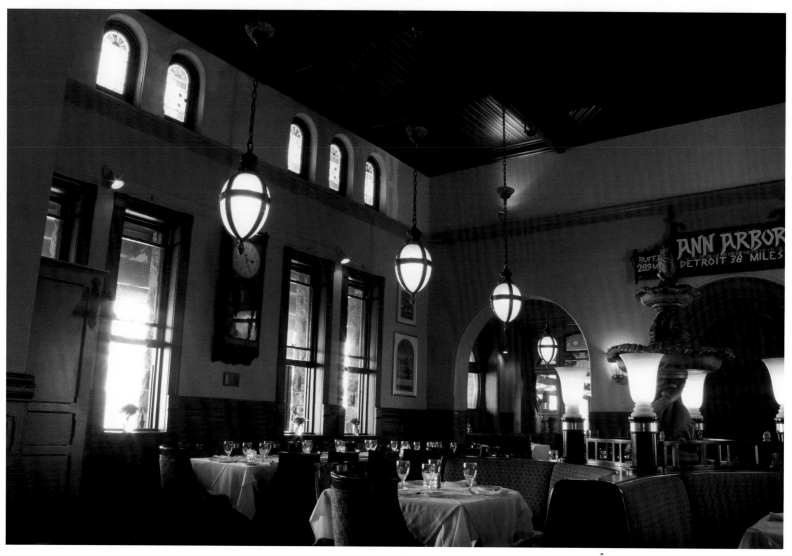

Train stations, with their large waiting rooms, tall ceilings, and ample windows, often make for handsome restaurant spaces. In the case of the Gandy Dancer in Ann Arbor's old Michigan Central depot, grace notes include stained windows just beneath the coved ceiling and classic, egg-shaped hanging lights. Note also the old sign advertising the distance to Detroit—38 miles. The railroad-station "standard" clock (*opposite*) is another authentic touch. Our modern system of standard time and its clearly delineated time zones was a creation of railroads and was imposed nationwide on November 18, 1883. Before that, as Willis F. Dunbar notes in *All Aboard! A History of Railroads in Michigan,* there were no fewer than 27 local time zones in Michigan.

Willa Cather came from New York to accept an honorary degree in the spring of 1924. Great Depression or no, in 1933 pianist and composer Ignace Paderewski chugged into the station in his very own sleeping car. Other famous musicians to pass through the depot's horseshoe-arched main entrance included bandleader Benny Goodman and cellist Pablo Casals.

In 1942, Vice President Harry Truman and the wartime Truman Committee took the New York Central (the successor to the Michigan Central) to town to inspect the Ford Bomber Plant at Willow Run. In October 1960, both the Democratic and Republican presidential candidates, John F. Kennedy and Richard Nixon, campaigned at the depot, just two weeks apart, re-creating for one last time the whistle-stop political tours already vanishing from American politics. Kennedy spoke to crowds from the back of an observation car, but his "arrival" involved more than a little sleight of hand. The Massachusetts senator had given his famous Peace Corps speech the night before at 2 a.m. on the steps of the Michigan Union, and then spent the night in town. The next day Kennedy was driven a short distance beyond the city limits to where the Michigan Central tracks crossed Dixboro Road. There he boarded a special train for the short trip back into town and the photo op.

But great crowds didn't gather at the depot just to greet the great and famous. Undergraduates by the thousands used to mass at the depot to cheer University of Michigan athletic teams and give them a rousing send off, back when they all traveled by train—a practice that disappeared after World War II.

Thirteen Detroit to Chicago trains stopped daily at the Michigan Central depot in 1915. By the time the building was sold in 1970 to restaurateur Chuck Muer, traffic had dropped

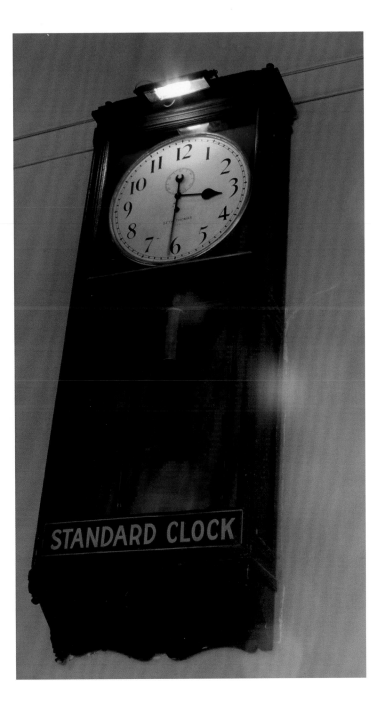

The Ann Arbor Railroad quite naturally had a station in town (*top right*)—for years the only other depot in Ann Arbor. Without train service since 1950, the well-maintained building now houses a Montessori school. Ann Arbor's Amtrak station (*bottom*) was built in 1983 just a few hundred yards down the track from the Gandy Dancer. In fact, as low-key modernist design goes, it's not a bad building but suffers profoundly by comparison to its magnificent predecessor.

Opposite: Additional seating the Gandy Dancer won by enclosing the trackside platform.

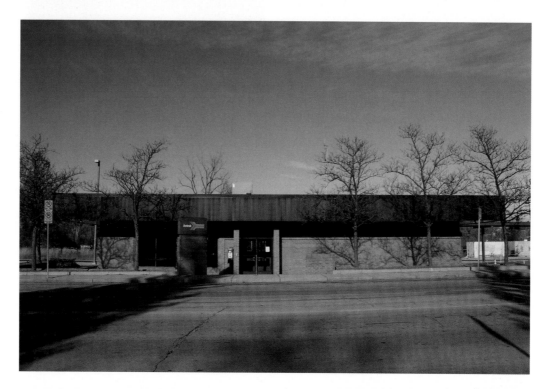

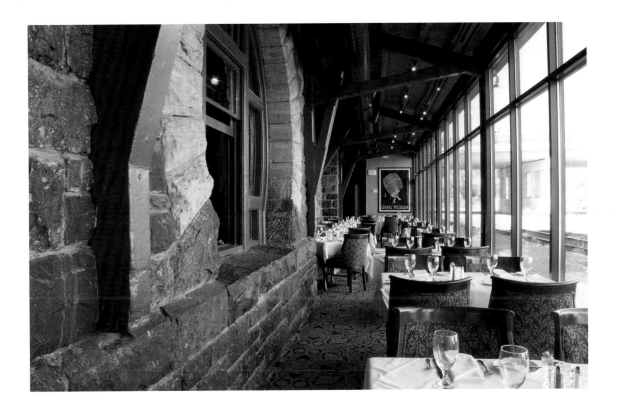

to a fraction of that. But in its transfer to Muer, the station—and Ann Arbor—were very lucky. Muer had a strong interest in historic preservation, and under the guidance of Southfield architect Jack Green, the new Gandy Dancer restaurant was sensitively renovated, retaining many of the original interior elements while making some railroad-appropriate additions—such as the installation of lamps that had once hung in Detroit's Michigan Central Station. In the biggest exterior change, Muer enclosed the long trackside platform with windows. From the street, if not the tracks, the station looks very much as it ever has. Perhaps the only detail worth quibbling about is the addition of a large, green entry canopy that ob-

scures the remarkable horseshoe arch at the front door. Still, the awning is undeniably good looking and, given Michigan's changeable weather, it's probably unreasonable to expect a restaurant to let its guests get soaked on the way in.

And finally, the peculiar name "Gandy Dancer" comes from the Gandy Tool Company in Chicago, which made the pole-driven wedges used to raise and lower the heavy steel rails into place before spiking them to the ties. The procedure required several men working in synch, and they had to achieve a sort of rhythm to properly manipulate the heavy steel. Once coined, the name stuck.

Battle Creek

1906—Grand Trunk Western Railway
175 Main Street

ARCHITECTS: Spier and Rohns

LAST PASSENGER SERVICE: 1971

CONDITION: Good

USE: Offices

The Grand Trunk Depot, designed for Battle Creek by Detroit architects Spier and Rohns, is one of Michigan's most exuberant, with its twin towers and a cheerful synthesis of styles ranging from Mediterranean to South Asian. The station's first floor is faced in white granite, while everything above is done in an unusual shade of light orange brick. Shortly after the station opened in 1906, *Railway Age* declared the $100,000 depot a "handsome brick-and-stone structure in the Mission style of architecture." And indeed, its curvilinear gables have a distinctly Mission cast to them, as do the towers—even if they're all built of brick, not Mission's traditional stucco. Ornamental balconies at the tower tops also fit the Mission spirit, though details elsewhere are as likely to be Italian as Spanish—notably the traditional columns that divide the various sets of tripartite windows.

Distinctly non-Mediterranean—but pleasingly exotic—were the "Hindu domes" originally capping the towers, re-placed in the modern era with more Mission-appropriate, if somewhat less visually entertaining, red tile that matches the rest of the roof. Then there's the intriguing forward thrust of the first-story bay, with its crenellated roofline that looks like it was lifted from a seventeenth-century English fortress. On the inside, designers reached for elegance with a grand, vaulted waiting room lit by multiglobed chandeliers and clerestory windows. In a nice touch, a fanlight motif was repeated in the ground-floor entry arches.

The Grand Trunk Depot was one of two stations in town. The other was the Michigan Central's Norman Romanesque depot, also by Spier and Rohns. But although the two railway lines split the list of distinguished visitors between them, the Grand Trunk still saw its fair share of the spectacle and drama once associated with these great public spaces, before the automobile and the airplane elbowed them into irrelevance. In 1908—a year after the high-water mark of American immigration, when 1.3 million migrants crowded through Ellis Island—"a queer little Christmas gift" arrived at the depot, the *Detroit Free Press* reported on Christmas morning. The

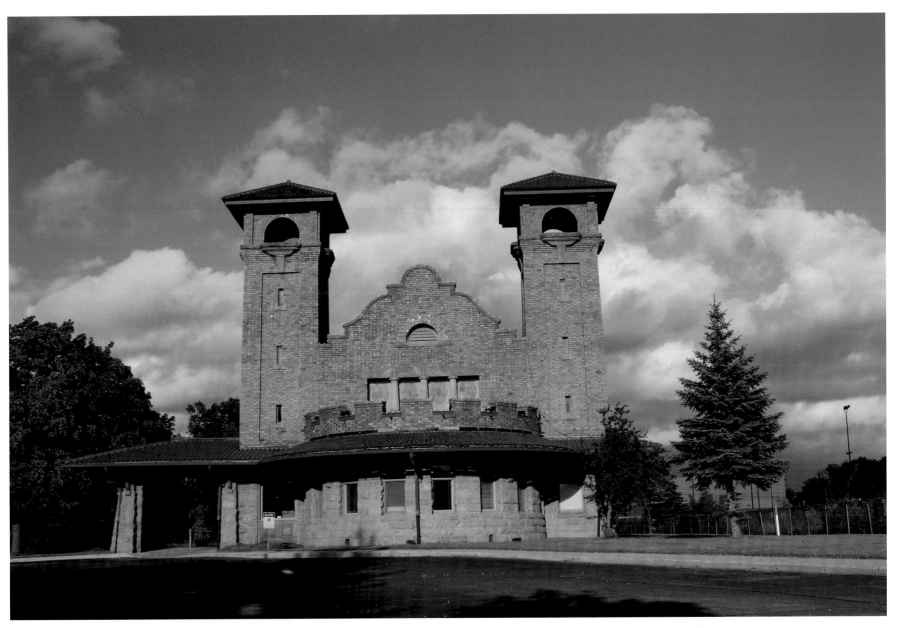

The 1906 Grand Trunk station in Battle Creek was designed by the Detroit firm Spier and Rohns in an eclectic mix of elements. The overall effect is Mission (it's the sculpted gable that clinches it), but Italian and South Asian spices have been thrown in as well. Sadly, the original, concentric "Hindu domes" atop each tower were replaced in the 1940s with ordinary red tile.

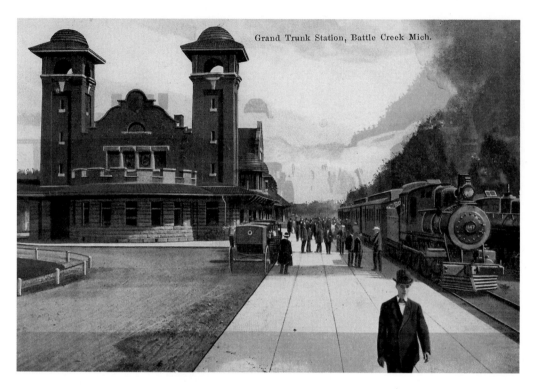

Grand Trunk Station, Battle Creek Mich.

his left wrist. Rushed to Nichols Hospital, he survived—no sure thing in those days. Still, the fireman seems to have had a gift for bad luck: just two years before he'd been struck by lightning, which he also survived. No word on whether his second near-death experience prompted a search for new employment.

Perhaps the greatest to-do associated with the station, however, was the cameo role it played in one of the twentieth century's most notorious legal cases, the prosecution in 1913 of heavyweight world boxing champion Jack Johnson for allegedly transporting women across state lines for immoral purposes—a violation of the Mann Act.

Before Johnson, African Americans had been prevented from competing for the heavyweight world championship, long regarded as the exclusive province of whites. Other titles were fine, but not the heavyweight champ. That ended on July 4, 1910, when Johnson beat "the great white hope"—reigning world champ James J. Jeffries, who came out of retirement for the fight—in the fifteenth round in Reno, Nevada.

Above: This postcard shows the original "Hindu domes" atop each of Battle Creek's towers, amusingly out-of-place details that disappeared in a later renovation, replaced with red tile that matches the rest of the roof. (Personal collection of Jacqueline Hoist and Ronald Campbell)

Bottom right: A brick sunburst is centered beneath the Mission cornice.

Opposite: Note as well the way granite stonework gives way to orange brick halfway up that quartet of arched windows beneath the sunburst.

gift was an eight-year-old Italian boy, all by himself, speaking no English whatsoever, with a sign tied around his neck—a practice with children that was shockingly common in this era of vast European migration across the Atlantic. The sign implored strangers to help the child reach Battle Creek and his father, who had preceded him. In the article "Xmas Package Real Live Boy" that ran Christmas Day, the paper confirmed that the two were happily reunited.

More disturbing, and a reminder of the potential violence always associated with steam locomotives, was Grand Trunk fireman Hugh Pettingill's sad tale the following year. The fellow was dutifully shoveling coal into the firebox when the locomotive lurched as it came to a halt at the station. Pettingill plunged headlong through the cab, severing an artery in

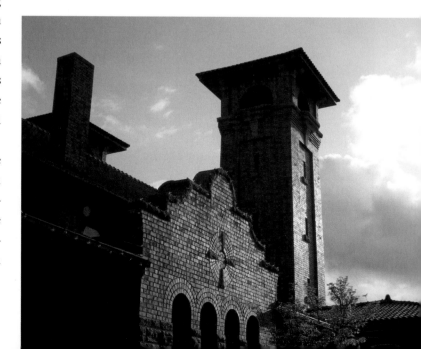

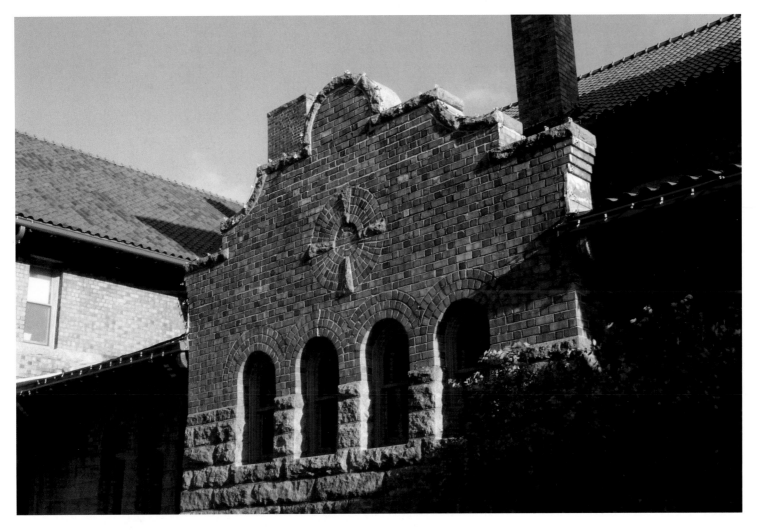

The black man's victory sparked Independence Day race riots across the country in which thirteen African Americans were killed. (It also inspired the 1968 Broadway production *The Great White Hope*, starring James Earl Jones and Jane Alexander.) Panicked whites in 1910 read apocalypse in Johnson's victory. "The press reacted to it as if Armageddon was here," said Johnson biographer Randy Roberts in Ken Burns's 2005 PBS documentary *Unforgivable Blackness: The Rise and Fall of Jack Johnson*.

It would be no exaggeration to say that police authorities at all levels had it in for the boxer, particularly once he had the temerity to marry a white woman, a onetime prostitute named Lucille Cameron. Shortly before their 1912 marriage, Johnson had been arrested on trumped-up charges under the

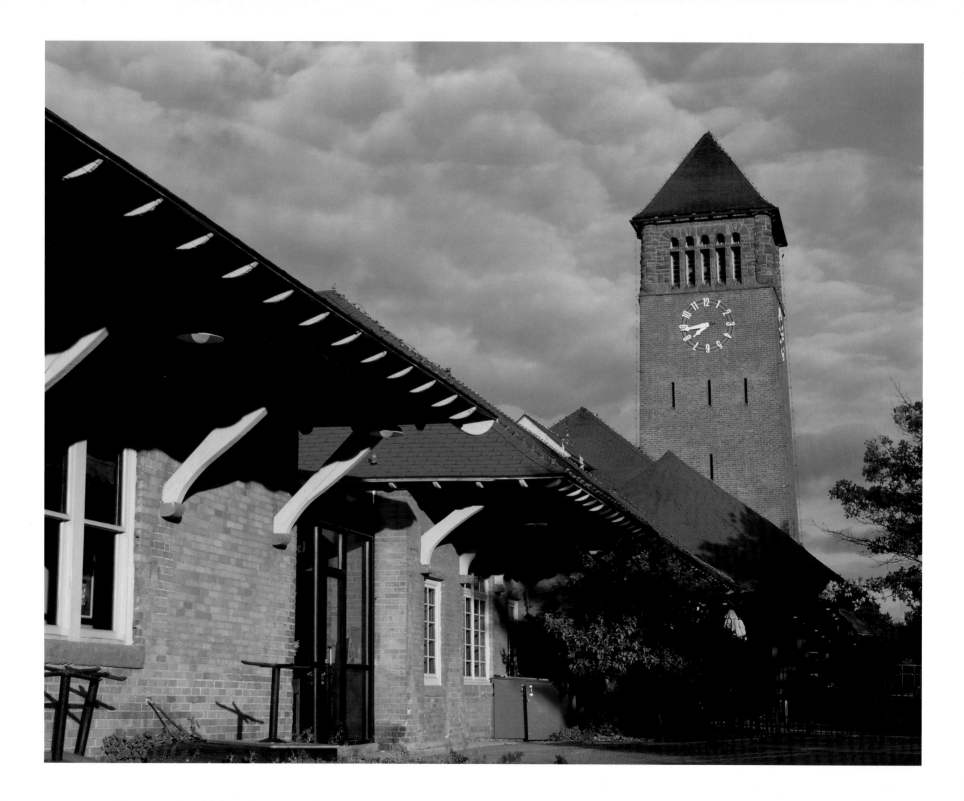

Mann Act—written to criminalize the transportation of prostitutes across state lines, but in the overheated racial climate of the day often employed to fight "white slavery" and the supposed victimization of white women by black men. Johnson, an extraordinarily colorful character who by that point was rich with winnings from the title bout, posted bail. A few months later, in January 1913, U.S. marshals seized the champ, his wife, and their valet on a Toronto-bound express when it stopped at Battle Creek, and shipped them back to Chicago. The next day the judge threw out the charge of trying to flee the country on the basis of scanty evidence (though he wondered out loud why Johnson had already shipped two of his cars to Toronto), but warned the "pugilist," as the papers always had it, not to leave Illinois till after his trial. Johnson was eventually convicted by an all-white jury but skipped bail and fled to Europe for seven years. On his return to the United States, he surrendered to authorities and served one year in prison.

Finally, an incident at the Battle Creek Grand Trunk Depot involving an heiress, a purse, and a whole ton of cash made headlines nationwide in 1935. Mrs. Isabel Mulhall McHie, sixty-eight, was taken from a train at the depot because she was acting strangely and appeared to be ill. While being helped from platform to ambulance, she dropped her large black purse, which "snapped open and a total of $173,505—most of it in bills of $5,000 and $10,000 denominations—was scattered about," according to the *Chicago Daily Tribune*. Taken to Lelia Montgomery Hospital, McHie steadfastly refused to say why she was carrying the fortune. McHie—regarded as one of the great beauties of her day—had a history of colorful personal incidents. In 1930 her mother had her committed to a mental hospital, but McHie managed to escape and regain

control of her fortune, estimated at $450,000. And in 1923, McHie had announced that all her assets would ultimately go toward building the world's largest animal hospital, to be sited outside New York City. The terms of the bequest were highly specific, requiring that a marble bust of McHie be erected in the hospital lobby inscribed with the following legend: "The more I saw of people, the more I thought of dogs."

The Grand Trunk ran steam locomotives long after most of its rivals had switched to diesel, and didn't retire its last one until 1960. That same year, the railroad presented steam engine No. 6325 to the City of Battle Creek—said to be the locomotive that pulled then president Harry S. Truman on his 1948 cross-country barnstorming campaign. The city invited Truman to the July ceremonies, but the former president sent his regrets, according to "Whirlwind Whistle Stops" in *Michigan History* magazine (November–December 1993). However, in his own hand at the bottom of the letter Truman added, "I still like steam engines."

The last passenger train pulled into the Battle Creek depot in 1971, after which Grand Trunk handed its passenger operations over to Amtrak. The national rail service would continue the Michigan Central line through Battle Creek, but not the Grand Trunk's. In 1988, the social service agency Community Action bought the depot for its offices. With a grant from the Kellogg Foundation, the agency undertook a significant renovation—replastering, taking out newer partition walls, rebuilding and restoring windows where they'd been bricked over, and repairing the oak wainscoting throughout. However, some significant alterations were also made, including the addition of a mezzanine in the great waiting room to take advantage of space beneath the station's high vaulted ceiling.

Architects Spier and Rohns enjoyed a Battle Creek monopoly, building not only the Grand Trunk station, but also the town's Michigan Central depot—a red-brick Romanesque structure with an imposing Norman clocktower that's been handsomely recast as a restaurant, Clara's on the River.

Birmingham

It's hard to imagine any building that says "Penny Lane" more persuasively than this little commuter station built in 1931. Certainly no other Michigan depot summons blue suburban skies quite as well as Birmingham's tidy Grand Trunk depot, designed and built by Detroit contractors Walbridge Aldinger. Stylistically, the station is reassuringly domestic, built in the Tudor Revival style that was all the rage in Detroit in the 1920s and 1930s. And in this, it is a most successful little structure. From its half-timbering and herringbone brickwork to the round-head entrance with its grand canopy to the handsome slate roof, this depot promises order, comfort, and solidity.

A persistent historical rumor has it that the station was built as a stripped-down version of the one at Birmingham, England. It's a pleasing story, and it would be great were it true. But when e-mailed an image of the depot in suburban Detroit, several English architectural historians and librar-ians in Birmingham—the one in the old country—said they'd never had anything like it in their town. (They did, however, admit it was pretty.) What is perhaps more accurate is that the station was built in Tudor style so it would bear a resemblance to Birmingham City Hall and Baldwin Public Library a mile or so west, both built of a similar orange-brown brick.

The little station offers something you don't get that often in American cities—it's sited to act as a beckoning destination, one that's fun to approach when heading east on Yosemite Avenue. Yosemite terminates at Eton Street, and there right in front of you—almost framed—is the depot, centered and forming an unusually satisfying visual terminus. For all its domesticity, the little building looks rather grand.

The station was built to coincide with the launch of Detroit to Pontiac commuter service on brand-new tracks the Grand Trunk Western Railroad had laid down. Track and depot location were determined by a little logrolling and a timely payoff from state to railroad in the mid-1920s. The legislature passed the Wider Woodward Act in 1923, establishing a two-hundred-foot right of way along the avenue all the way to Pontiac. Grand Trunk's old track bed was just a few yards off Woodward Avenue and in the way. Clearly, were the avenue to add lanes, something had to give. The railroad played hard to get, holding out for its asking price. Company executives were doubtless tickled when they got it, but Michigan had the last laugh. Over the next decade, the state more than made up for that expenditure by jacking up taxes ninefold. The relocated track bed is now a mile or so east of Woodward.

The station opened on August 1, 1931. It was a big day—one that years later some would describe as the last hurrah before the Great Depression really started to bite. People from all over gathered at the depot, and the daylong festival was en-

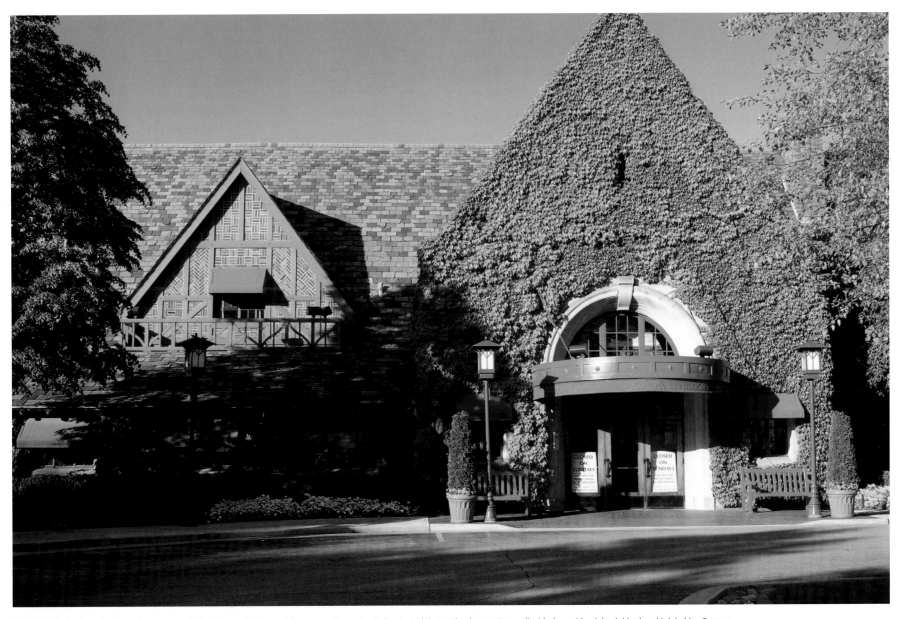

The 1931 Birmingham Grand Trunk commuter station is one of Michigan's handsomest—a trim, Tudor-Revival design that harmonizes well with the residential neighborhood it inhabits. Contrary to longstanding rumor, however, the depot was not built in imitation of one in Birmingham, England. The striking little structure now houses the Big Rock Chop House.

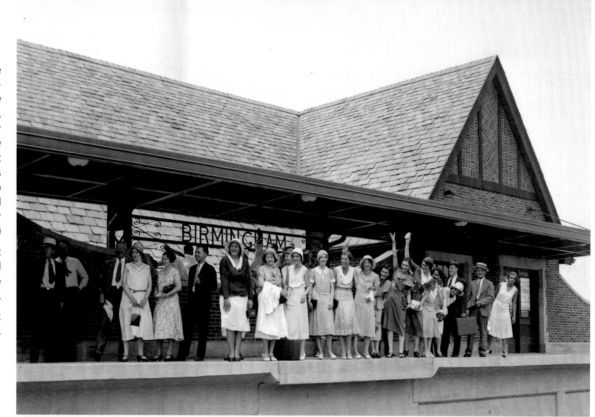

Top right: Expectant crowds wave from the platform in a 1931 photograph probably staged shortly before the station's grand opening. The arrival of Grand Trunk commuter service knit Birmingham more tightly into the Detroit suburban orbit than ever before and for decades provided easy, quick access to downtown for those who preferred not to drive. (Walter P. Reuther Library, Wayne State University)

Bottom right: The current owners have made a good choice in allowing ivy to take over the principal gable.

Opposite: One of the Big Rock Chop House dining rooms.

26

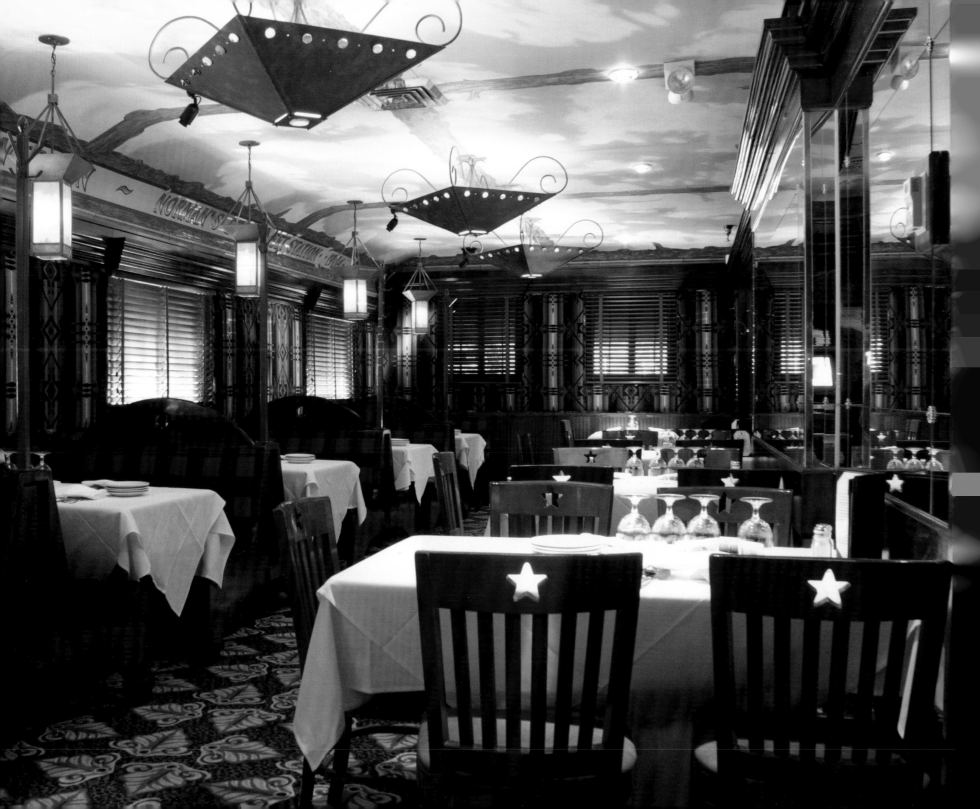

Birmingham's main waiting room (*below*) with its barrel-vault ceiling has been imaginatively retrofitted as a bar at the center of the Big Rock Chop House.

At top right: A race between a locomotive and an airplane back in more halcyon days when it was still uncertain which mode of transportation would triumph over the other.

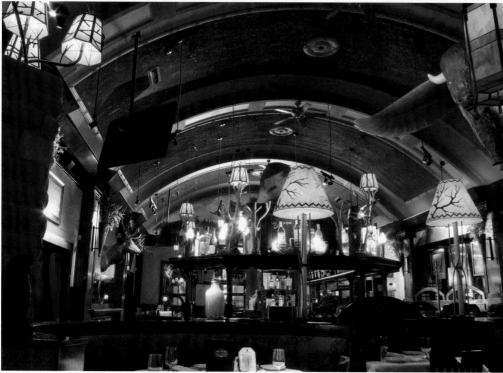

hanced by the presence of both Governor Wilber M. Brucker and former governor Alexander J. Groesbeck. The celebration started promptly at 9 a.m. with a "Kiddies' Parade." But the big excitement was a sixty-float afternoon parade, "The Pageant of Progress." Grand Trunk even struck commemorative medallions for the occasion—bronze coins with an image of the station on one side and a charging locomotive on the other.

Train and station knit Birmingham much more tightly into the Detroit suburban orbit, helping to boost its appeal as a bedroom community. But it acted as more than that. For years the service allowed local women the opportunity to pop down to J. L. Hudson's Department Store without the worry of driving and parking, while the 11:30 p.m. last train out of Detroit meant suburban revelers could get in a good Friday night's partying before they had to head home.

Birmingham enjoyed a working station until 1978. At that point, the Southeast Michigan Transportation Authority—which inherited the line when Grand Trunk sloughed off its passenger service—said it couldn't afford vital safety repairs, and shuttered the aging station. For years commuters were herded into an outdoor shelter just south of the station. In 1979 the depot was acquired for a restaurant, and the following year Norman's Eton Street Station opened. Today the admirably maintained building houses the Big Rock Chop House.

Charlevoix

1892—Chicago & West Michigan Railway
Chicago Avenue at Depot Beach

ARCHITECT: Charles Pelton

LAST PASSENGER SERVICE: 1962

CONDITION: Excellent

USE: Charlevoix Historical Society

The Chicago & West Michigan Railway built Charlevoix's handsome station in 1892, the same year as the larger Petoskey depot seventeen miles north. Those railway magnates were nobody's fools. Just look what they created—a Shingle style cottage of immense charm right on the lake (in 1892 still Pine Lake, not yet Lake Charlevoix). If urban train stations act as gateways to great cities, you could just as easily say that this domestic little building framed the gracious "Up North" vacation experience for generations of travelers in ways advantageous to railroad and town alike.

Modern eyes inevitably romanticize century-old buildings. But in 1892, this turreted shingle-and-clapboard cottage with the steep pitched roof was entirely up to the minute, brisk and efficient. The *Charlevoix Sentinel* assured readers before construction began that the building would be "an elegant and modern affair." The finished product apparently lived up to the newspaper's expectations—architecturally "it was one of the finest depots on this system," the *Sentinel* wrote on May 11, 1892. "The interior is metropolitan in every respect."

The celebration for both the new depot and the railroad's arrival was held on July 4, 1892. It was an exuberant affair. *Sentinel* editor Willard Smith was almost beside himself, as his prose suggests: "We celebrated! We celebrated big! We covered ourselves all over with glory . . . a colossal, gigantic blowout! And the folks! Great Scott! They were all here! Ten thousand of them! Not one less! They began coming by hourly trains from Petoskey early in the day, and 3,000 came from Petoskey alone. The excursion train from the south brought 800. The Maccabees excursion from Boyne City brought nearly 350. The steamers *Columbia, Crescent* and *Cummings* came from Grand Traverse loaded. They filled the town and hung on to the edges."

Judging by the horse-drawn drays, this was taken not many years after the railroad reached Charlevoix in 1892. The dapper gentleman at center doubtless appreciated the liberty the train brought in tow—transportation much faster and more reliable than either of its predecessors, the wind-blown lake schooner or stagecoach plying miserable roads. (Charlevoix Historical Society)

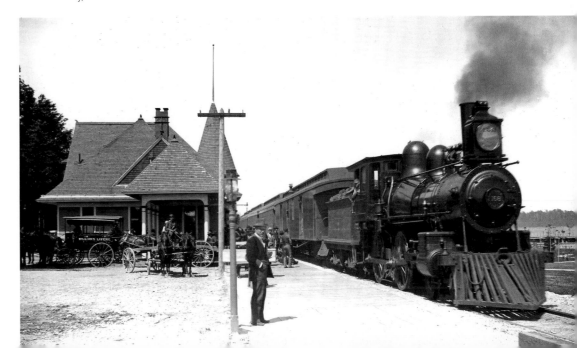

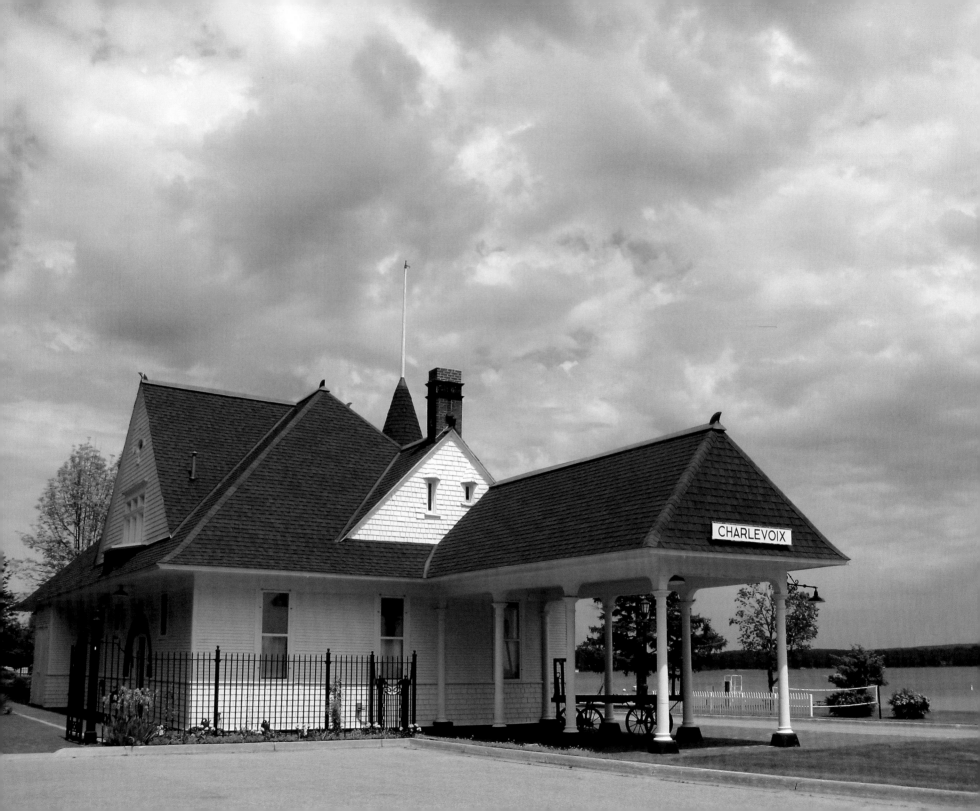

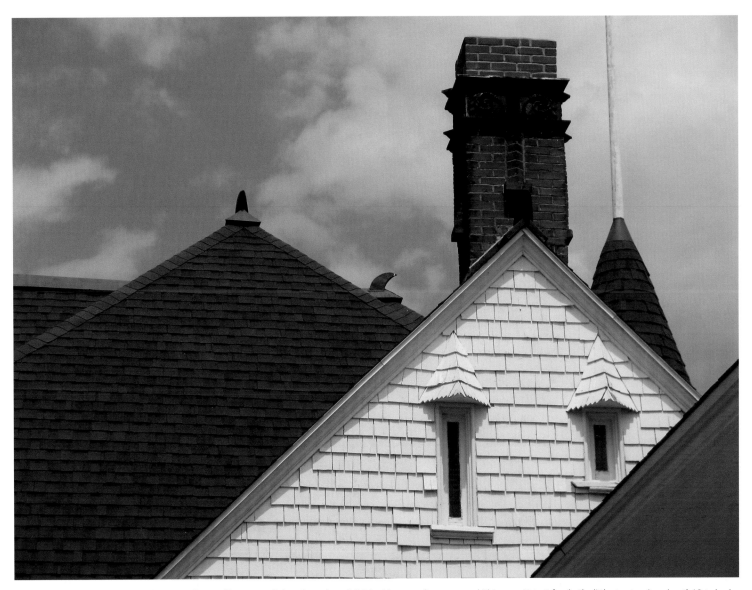

The Charlevoix depot is a shingle-style cottage that could just as easily have been the stylish lakeside retreat for some grand Chicago or Detroit family. The little structure is eminently Victorian in its exuberant detail and desire to puncture the sky with chimney, turret, flagpole, and gables. Note in particular the little shingled "eyelids" over the narrow slit windows (*above*), as well as the beak-like finials on the roof. The station's principal charm, however, is its location on a beach a stone's throw from the water. Depot Beach is now a municipal park, and the station within it is owned and used for special events by the Charlevoix Historical Society, which renovated it in the 1990s.

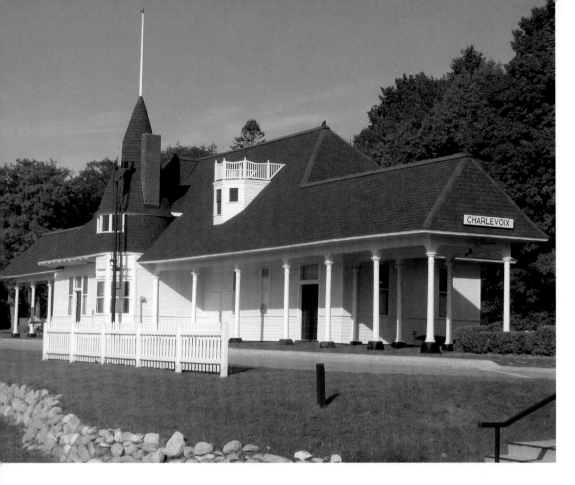

The railroad tracks are gone, but the Charlevoix station itself is in superb shape—a much-revered local monument overlooking a much-used public beach on Lake Charlevoix.

the train chugged into town, particularly in the winter. For a small town like Charlevoix in the late nineteenth century, entirely dependent on schooners or stagecoaches plying substandard roads, inconvenience morphed into spectacular isolation once snow fell and lakes iced over, when little could arrive or leave for months on end. What did the coming of the railroad mean for a northern town like this? As David L. Miles notes in his illustrated history, *Bob Miles' Charlevoix II,* it meant fresh food on the table all winter long. Mail six days a week. And the ability to escape in midwinter on a whim.

The railroad sped up Charlevoix's development as a desirable resort town. Recognizing this and the market its trains had helped create, in 1897 the Chicago & West Michigan started building the Inn, a rambling, four-story shingled hotel with porches stretching thirteen hundred feet, perched on a small rise overlooking both depot and lake. It was a project dogged by disaster. Under pressure to finish quickly, work crews plastered the upper floors before the lower ones had stabilized. A sharp gust of wind in early October smacked the top-heavy structure, and the building collapsed in on itself, killing two workmen and two horses. The railroad promptly rebuilt, however, and the Inn operated until it was pulled down in 1941—a victim of the automobile and its own limited parking space.

The decline in train travel kicked off by the Depression briefly went into reverse during the Second World War as troops surged through stations across the country. But that uptick didn't last. Decline accelerated throughout the 1950s as the automobile replaced the train in the nation's affections. Depots and trains became, almost overnight, relics of a quickly receding past. The last passenger train pulled out of Charlevoix on September 1, 1962, with its very last passenger, Mrs.

Still, progress inevitably comes at a cost. Two days after the great party, the *Sentinel* reported the first victim of the new railroad—Myron Geer's dog. "A north bound train cut him in two several times last week," the paper said, with alarming precision, "and Myron mourns."

In the nineteenth century and the early twentieth, small towns fought tooth and nail to get the railroad to cross their village, knowing it brought a sure uptick in prosperity, with farmers and businessmen suddenly able to move goods cheaper and faster than before. Forgotten, perhaps, is another aspect—how remote and inaccessible some places were before

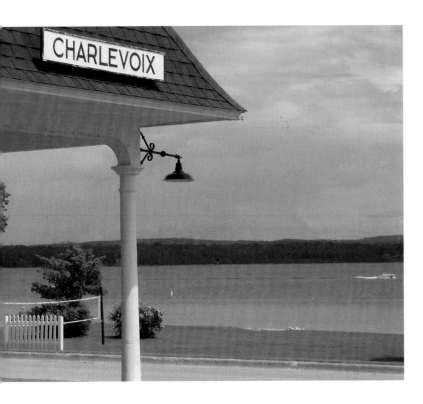

CHARLEVOIX

Crossing paths at the depot in those years would have been well-to-do summer people bound for the Chicago Club cottage community and locals waiting for the "Dummy," the one-car suburban service to Petoskey. (The Belvedere Club, another tony cottage cluster like the Chicago Club but on the other side of the Pine River, got its very own little station.)

Likely spotted at some point—perhaps stepping out of one of his REO motorcars (the factory was built right across the tracks from Lansing's handsome Grand Trunk station)—was Oldsmobile magnate R. E. Olds, who over time owned several homes in town. For David May, the founder of the May Department Store chain, the depot would have been a short trip from his Michigan Avenue mansion overlooking Lake Michigan.

Among the depot's grace notes are the circular wood columns that march in handsome repetition, and, when you look through them, frame views of the lake beyond in a most-satisfying fashion.

R. L. Lewis. She was leaving Charlevoix behind for good, the *Charlevoix Courier* reported, to start a new life in California.

Yet at train time on almost any day in the previous ten years, Lewis would have found a largely deserted station. Not so during the heyday of American passenger rail travel, the 1910s and 1920s, when thousands of Chicago and Detroit businessmen rode overnight "Resort Specials," which started service in 1904. Trains were sometimes so long they had to make two stops—one for the front half, the second for the rear. On summer Saturdays a century ago, the sharp-eyed observer could probably pick out who'd spent the night in a Pullman sleeper and who'd sat bolt upright the whole night in a seat as husbands and fathers spilled out from the morning train.

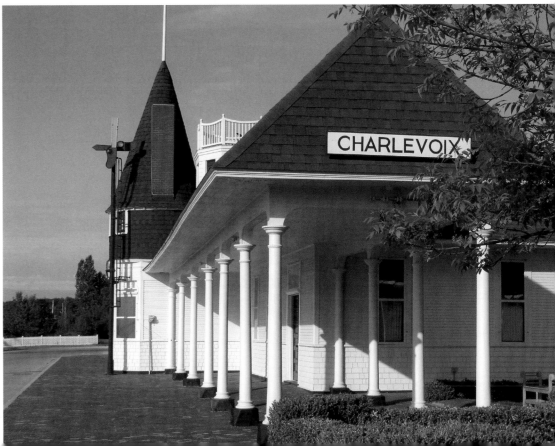

CHARLEVOIX

Depending on the railroad he took from Chicago, the young Ernest Hemingway would have passed through Charlevoix on occasion en route to Petoskey and his family's Walloon Lake cottage. (Charlevoix invariably gets reduced to the jaunty abbreviation the 'Voix, in Hemingway's Nick Adams stories, semiautobiographical tales from the author's Up North youth.) On a creepier note, the young Chicago aristocrats who would go on to become the most notorious murderers of the early twentieth century, Nathan Leopold and Richard Loeb, spent part of the summer of 1920 at the Loeb family's fanciful estate on Lake Charlevoix south of town, presumably plotting.

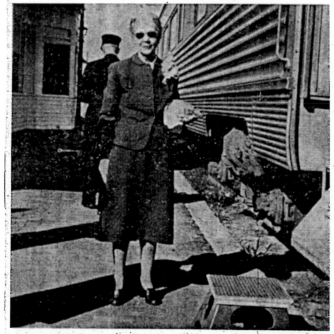

Farewell to Charlevoix

Courier Photo

Mrs. R. L. Lewis (above) was the last and only passenger to board the last passenger train out of Charlevoix on the C & O railroad. She departed Saturday afternoon on a journey to California where she plans to make her future home.

Few who embarked from the depot, however, had as peculiar an experience as Bruce Bacon, whose plight occasioned this opening line from an October 6, 1935, *New York Times* article: "Burnside police announced today that Mrs. Bruce Bacon can have her husband back by calling at the station and identifying him." Young Bacon, a Charlevoix resident, had been swept off his feet by a Chicago belle in the summer of 1935, and after a three-week romance, they married and set off for her home in Chicago. The bride's father met the couple at Chicago's Burnside station. The two men shook hands, and Bacon announced his immediate intention to set out and look for a job. They all agreed they'd meet later for dinner at the father-in-law's house. At day's end, however, the exhausted young man found he'd lost his father-in-law's address and

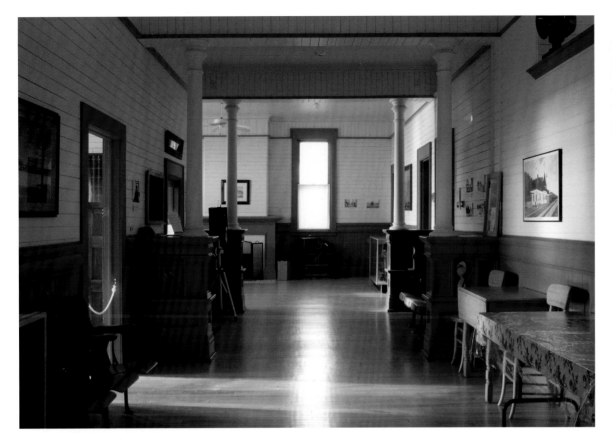

The Charlevoix depot has been well restored and boasts a warm and beckoning interior. Several years after putting up the station, the railway built a hotel, The Inn, right next door that ran until 1946 when it was pulled down.

couldn't for the life of him remember the family name. In a city of millions, he hadn't a clue where to look. So he spent the night in the Burnside station, hoping to be fetched. If worse came to worst, Bacon told the reporter, he could always go back to Charlevoix. He had his wife's maiden name written down there.

Freight service to Charlevoix ended in 1982, outliving passenger service by twenty years. Eventually, the depot was acquired by the family that lived next door. In 1992, one hundred years after the station opened, Mary and Robert Pew deeded the structure to the Charlevoix Historical Society.

The society kicked off a fund-raising campaign with a 1994 "Restoration Gala" at the station, and ultimately put in over $150,000 in repairs and upgrades as well as countless volunteer hours restoring the building, which has long been one of the town's architectural treasures. In a nod to onetime railroading tradition—when companies planted depot gardens for competitive advantage—the Charlevoix Area Garden Club maintains a spectacular garden on the building's west side, in early summer a pleasing riot of pink peonies and sharp-blue Cranesbill geraniums.

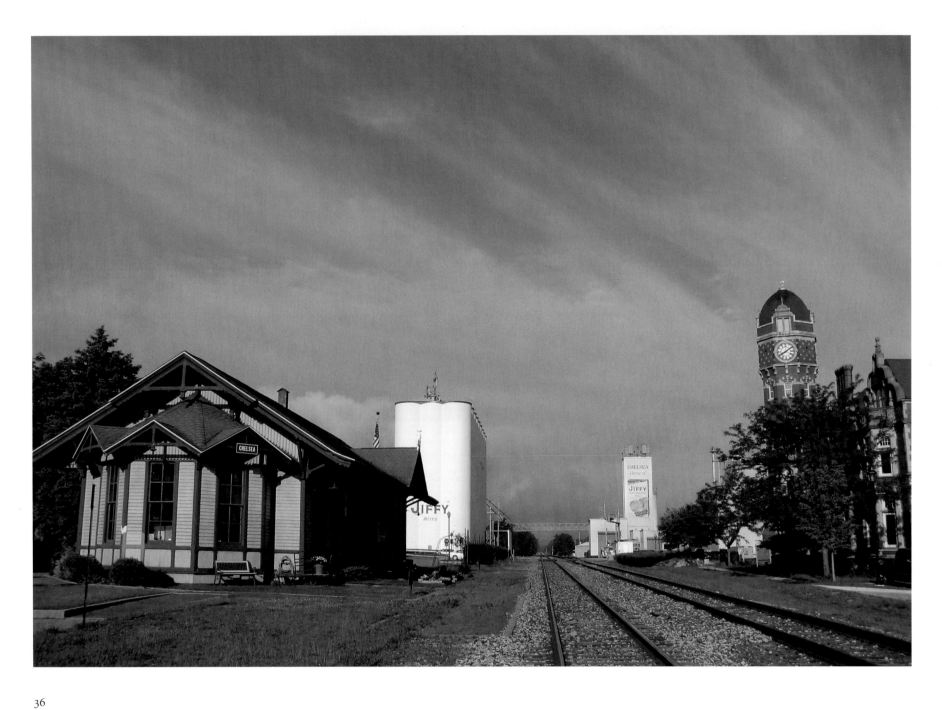

Chelsea

1880—Michigan Central Railroad
150 Jackson Street

ARCHITECTS: Mason and Rice
LAST PASSENGER SERVICE: 1982 (Amtrak)
CONDITION: Excellent
USE: Rental space for Chelsea Depot Association

In terms of small-town architecture, Chelsea—west of Ann Arbor, midway to Jackson—enjoys an embarrassment of riches. The impulse to build on the part of hometown stove magnate Frank P. Glazier left Chelsea with an unusual collection of fine structures designed by Ionia architect Claire Allen, including a fieldstone, neo-classical bank; a Victorian office building with a clock tower disguising a water tower beneath; and a Flemish Revival "Welfare Building," where Glazier's employees could go for recreation. Add the towering white Jiffy Mix silos right at the heart of Chelsea—majestic in their own right, and right across Main Street from the depot—and you've got a townscape of unusual punch and visual drama.

At the center of all this exuberance is Chelsea's Stick style Michigan Central station. Built in 1880 by the Detroit firm Mason and Rice—which also did the Grand Hotel on Mackinac Island—this Victorian, board-and-batten depot is a many-gabled affair with triple bays at each end and broadly overhanging eaves that flare on stick-work brackets. Gingerbread detailing, rich and satisfying without being cloying, is everywhere. With the exception of some alterations to chimneys and loss of the roof crest and finials, the station looks just as it did in the 1880s—once again painted the Michigan Central's trademark blue-green.

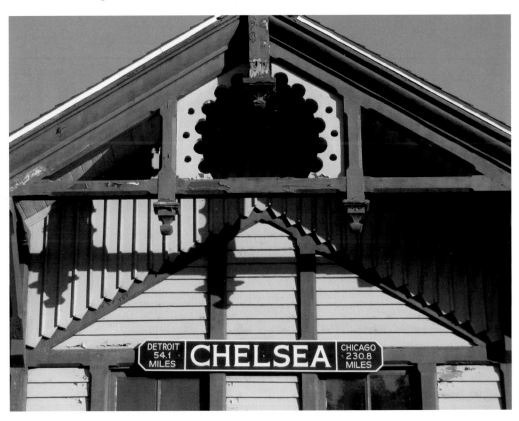

Looking west past Chelsea's Stick style depot (*opposite*) the Jiffy Mix silos loom geometric and majestic, while stove magnate Frank P. Glazier's Victorian clock tower and Flemish-style Welfare Building stand at far right. Together, these elements sculpt one of Michigan's most-appealing cityscapes. And that's not even counting the striking commercial blocks at the heart of Main Street, just to the left outside the picture frame.

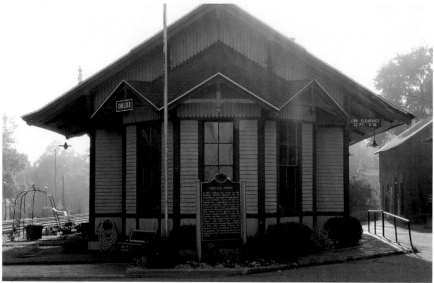

The Michigan Central Railroad rebuilt most of its stations on the Detroit to Chicago main road in the late 1800s, responding to passenger gripes about shabbiness and neglect. And Chelsea was in particular need. It hadn't had a depot for five years, owing to some unusual shenanigans. The popular story is that the old 1850 station—just a shed attached to a freight house—was hitched by pranksters to the caboose of a departing train in 1875 and destroyed. That story is repeated in the town's 1959 official history, in which the unnamed author suggests, "Perhaps you remember when the local boys hooked the old depot to the caboose of a departing train with a stout cable."

Or perhaps you don't. While the Chelsea Depot Association's 1986 application for federal historic designation repeats the tale, according to the most recent town history, there's no evidence a train was ever involved. The problem, according to *Chelsea: 175th Anniversary, 1834–2009* (Chelsea Historical Society) coauthor Cary Church, is that none of the actual witnesses to the late-night demolition—and there weren't many—ever confirmed the story. Twenty-eight years after the event, the *Chelsea Herald* interviewed the man who was station agent at the time and reportedly at the depot when it was destroyed. But Jim Speer mentioned neither cable nor train. Instead, he said that just before the structure collapsed

Mason and Rice, a Detroit architecture firm that also built the Grand Hotel on Mackinac Island, adorned this 1880 Victorian, Stick style confection with bays, gables, finials, and bracket work both delicate and complex. It was a long time coming. The wooden shed that preceded the present depot was hauled off its foundation and later burned under suspicious circumstances in 1875. Some reports suggest the good people of Chelsea, unhappy for years with their substandard depot, weren't helpful when Michigan Central Railroad detectives blew into town to ferret out the vandals. Such resistance, if that's what it was, may have cost the town dearly. Chelsea would have to wait five full years before the railroad got around to building them a new station, much less one commensurate with the town's aspirations.

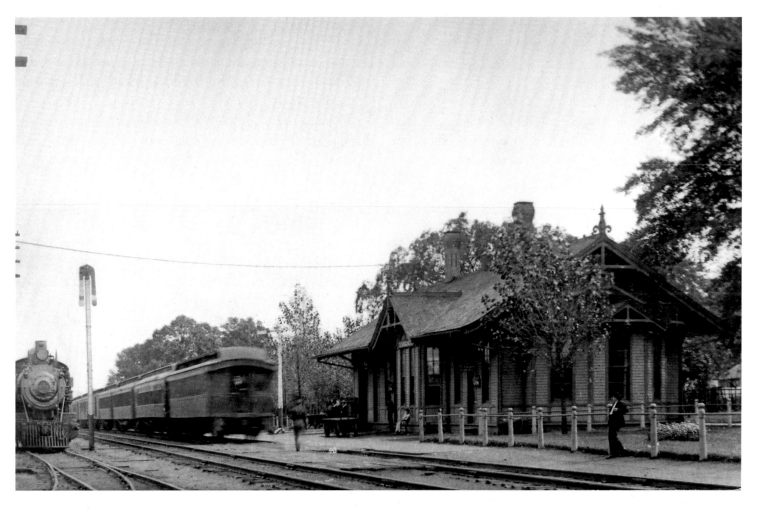

he heard the apparent pranksters calling the way they men do when trying to hoist something extremely heavy, or as one might to encourage a team of horses—"He ho! He ho!"

Arsonists torched the remains one week after the demolition. The Michigan Central sent detectives to investigate, but they never identified any culprits. Townspeople, long unhappy with the rickety depot, were none too cooperative.

In 1982, a little over a century after the station's construction, Amtrak notified the village of Chelsea that it planned to tear the building down. This sparked a great flurry of activity, and preservationists quickly formed the nonprofit Chelsea Depot Association. The group negotiated with Amtrak president W. Graham Clayton Jr. to purchase the building. The association organized congressional support in advance for the

purchase and preservation of the structure, and the final bill of sale—for $16,000, all private funds raised in a rush in just four days—was signed in 1982 in the Washington office of Chelsea's congressman.

Since then, the association has put about $100,000 into the building. The interior walls were restored, heating and electrical systems updated, and closets and partitions added later were stripped out. The original benches were brought out of storage and refurbished by a onetime fireman on the New York Central Railroad, which operated the line (through its subsidiary the Michigan Central) throughout the twentieth century. For awhile the Chelsea Area Historical Society had a museum at the depot's west end, while the local chamber of commerce occupied the stationmaster's office, but both have since moved to larger quarters. Today the Chelsea Depot Association rents the structure out for events and parties.

Clouds play above two of Chelsea's most-impressive buildings—the depot (*left*) and the old Welfare Building (*right*).

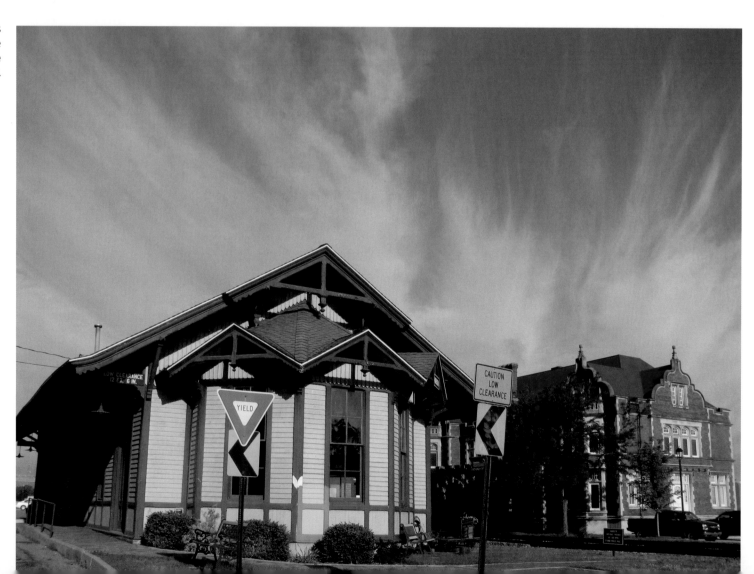

Clare

1887—Toledo, Ann Arbor & North Michigan Railway
West Fourth Street at Maple Street

ARCHITECT: Unknown

LAST PASSENGER SERVICE: 1957

CONDITION: Poor

USE: Empty, pending renovation by Clare Depot
Preservation Corporation

Worse for wear after years of neglect and abandonment, the Clare station still holds itself with simple dignity—its conical tower surveying the emptiness beyond the dramatic X where the Ann Arbor and Pere Marquette Railroad lines crossed. As the new kid on the block in the mid-1880s, the AA struck a deal with the PM: they would be allowed to cross the PM tracks and in return would build a new union station. The result was this symmetrical depot, where both railroads enjoyed precisely the same space and accommodation.

Clare's V-shaped 1887 depot—clapboard from the foundation to windowsills, with shingling above that—is a classic Queen Anne design, however simple, and is unique in appearance among Michigan stations. The round tower with conical roof and use of fish-scale shingles (as well as rectangular ones) announce it as Queen Anne, while its complete lack of pretensions makes this little building instantly likable. There is, however, more embedded design than you might at first glance suspect—including five different shingling patterns.

The depot sits at the X where the old Toledo, Ann Arbor & North Michigan Railway crossed the Flint & Pere Marquette tracks. As a consequence, since this was a "union" station inhabited by two companies, there are two stationmasters' boxy bay windows beneath the round tower, each equipped with the standard narrow side windows to afford a clear view up and down that particular track. The Pere Marquette was al-

ready well established when the Toledo, Ann Arbor & North Michigan wanted to push through Clare and cross its tracks, so a deal was struck that the latter would pay for and build a new station both companies could share. The building burned in 1894 but was rebuilt to the original specifications.

Some depots, like those of Niles and Ypsilanti on the old Michigan Central main road to Chicago, built flowerbeds and greenhouses to supply the entire system's need for table bouquets and the like. Not so in Clare. However, in the early

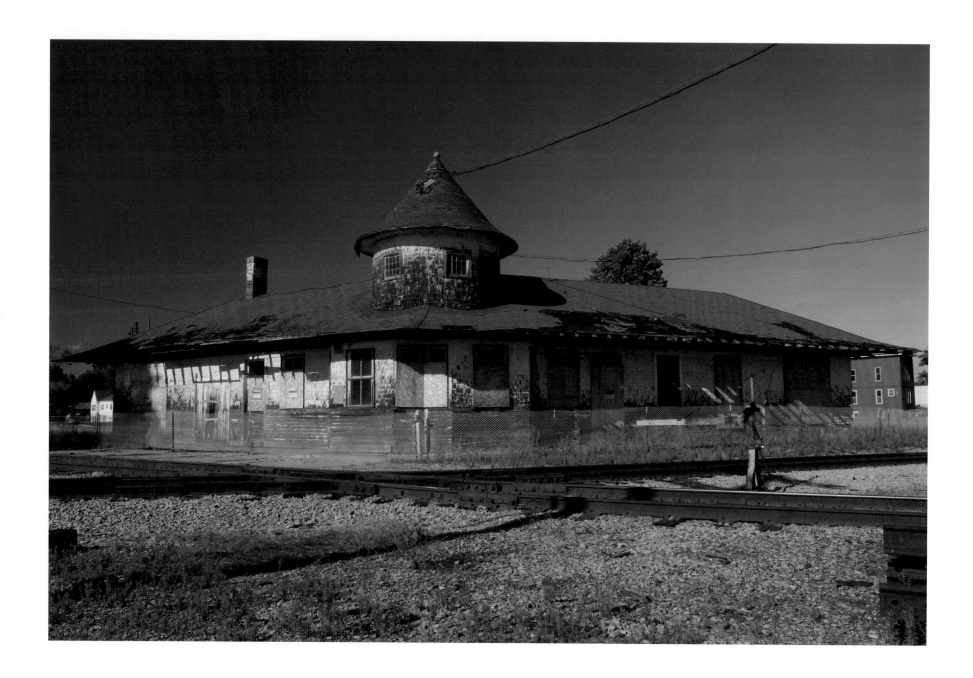

1900s, the Ann Arbor Railroad—successor to the Toledo, Ann Arbor & North Michigan Railway—built a dairy adjacent to the station that supplied the line with all the milk, cheese, and butter its dining cars required until it was sold off in the 1930s (and turned into an ice cream plant).

Passenger service at all Ann Arbor Railroad stations ended in 1950. The Chesapeake & Ohio Railway, which had acquired the Pere Marquette, retired its passenger trains in 1957, though the company used the Clare depot for freight crews and storage into the 1970s. The Tuscola & Saginaw Bay Railway, which acquired the Ann Arbor tracks through Clare, did much the same from the 1980s to 2003, when—after years of negotiation with the newly formed Clare Depot Preservation Corporation—it sold the structure to the City of Clare for $15,000. (The money was contributed by private donors.) In 2011, the Preservation Corporation planned to replace the roof, with the eventual goal of rehabbing the entire station for use by the Clare Art Council and a history museum. Regrettably, one of the depot's most dramatic visual assets—its location right at the rail crossroads—will be lost. Because of liability concerns so close to an active freight line, the Preservation Corporation will move the building about half a mile away to another site, which it hopes to accomplish in the summer of 2012.

Clare Union Depot opened in 1887, designed in a stripped-down, good-looking version of the Queen Anne style that was all the rage in those years—a style enamored of turrets, towers, clapboard, and shingles. And since this was a union station serving two railroads whose tracks crossed in front, there are necessarily two stationmaster's window bays—one on each side of the central tower—that allow for unobstructed views through narrow side windows up and down that particular track. Today the depot sits on the far edge of Clare's downtown, where things begin to give way to woods and fields. It's a little hard to imagine the building at the center of a great deal of bustle, though the undated historic image at bottom right at least suggests how tidy and orderly the station once looked. (Personal collection of Jacqueline Hoist and Ronald Campbell)

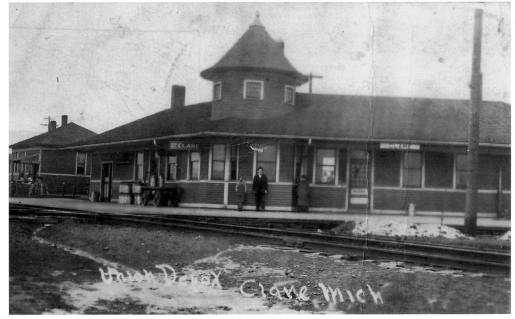

Columbiaville

1893—Michigan Central Railroad
(originally Detroit & Bay City Railway)
4643 First Street

ARCHITECTS: Shepley, Rutan,
and Coolidge

LAST PASSENGER SERVICE: 1964

CONDITION: Fair

USE: Columbiaville Rotary Club

Columbiaville owes its 1893 Romanesque Revival depot to one very powerful and persistent man—local lumber baron William Peter. Dissatisfied with Michigan Central service in the 1890s, Peter made the train company an offer it couldn't refuse. He would build it a fine new station if every passenger train on the line stopped in Columbiaville. Executives at the New York Central Railroad—who by that point ran the Michigan Central—knew a deal when they saw one. They accepted, engaging a Boston architectural firm that had done work for them elsewhere—Shepley, Rutan, and Coolidge. The three had trained under the celebrated architect H. H. Richardson, inheriting his practice after he died. In addition to Columbiaville, the firm designed Boston's South Station and the Art Institute of Chicago. The company also built a twin of the Columbiaville station in Amherstburg, Ontario, now an art gallery. But if the railroad company was clever in accepting the offer, William Peter was nobody's fool either. His brickyard north of town got the construction contract.

Of particular note are the station's round, arched windows, topped by beveled glass prisms in fan-shaped designs. On the outside, some windows sit atop a band of handsome dark red terra-cotta tiles—the same tiles used on a look-alike station in Three Oaks, attributed by some to the same architects. The overall effect is one of a particularly handsome redbrick Victorian cottage—looking very much like something in the English countryside.

As crisp and handsome as can be, Columbiaville's 1893 depot is a satisfying exercise in Romanesque Revival that looks as much like a small-town library as depot. Indeed, for awhile a branch library took up residence—a great reuse of a public building—but has since moved out.

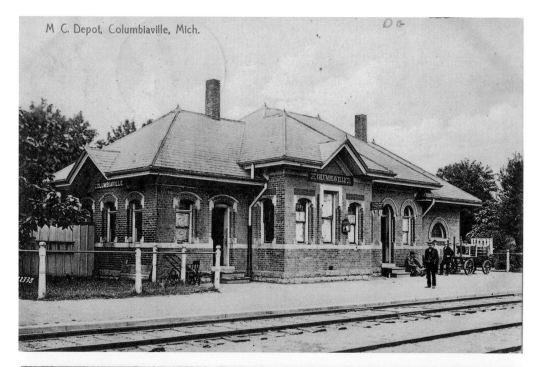

M. C. Depot, Columbiaville, Mich.

Newsworthy events come along but rarely in small, rural communities. This is not to say, however, that Columbiaville didn't see its share. The *Washington Post* reported shortly before Thanksgiving 1898 that a Finnish woman being deported back to her homeland kicked out a window and leapt from a train near Columbiaville, killing herself. As was seemingly the case with all women who committed suicide on trains—a more frequent practice than you would think—the twenty-three-year-old woman was described in the article as "insane." That she might have had good reason to dread a return to Finland doesn't seem to have crossed the reporter's mind.

A happier event occurred in 1952 when General Dwight D. Eisenhower, campaigning for the presidency, passed through town on October 1 en route to Lapeer. The train didn't stop, but it slowed so the former supreme commander of the Allied Forces could wave to the crowd from the back of his private observation car. It is, according to the official town history, the one and only time that a president—or president to be—passed through Columbiaville.

In 1960 the local Rotary Club acquired the building. For awhile a small library branch took up one end, but it has since moved. The Rotarians still meet at the depot.

Stations as elaborate as Columbiaville were usually one-off exercises. It's unusual to bump into duplicates. Yet Columbiaville's depot appears to have near-twins in both Amherstburg, Ontario, as well as Three Oaks near the Michigan-Indiana border. The fact that all three were Michigan Central stations (later New York Central) built at about the same time suggests they were the work of the same architecture firm, Boston's Shepley, Rutan and Coolidge. (Among other commissions, the firm did Stanford University's master plan and built several Mission style campus buildings later destroyed in the 1906 earthquake.) In any case, you can read local affection for the Columbiaville station, perhaps, in the surprising number of signatures (*bottom left*) etched over the decades into the red brick. "Paul" would likely be shocked to learn that his May, 1953 inscription is still visible nearly 60 years later. (*Top left:* Personal collection of Jacqueline Hoist and Ronald Campbell)

Detroit

1913—Michigan Central Railroad
Michigan Avenue at Roosevelt Park

ARCHITECTS: Warren and Wetmore;
Reed and Stem

LAST PASSENGER SERVICE: 1988

CONDITION: Ruined

USE: In private hands

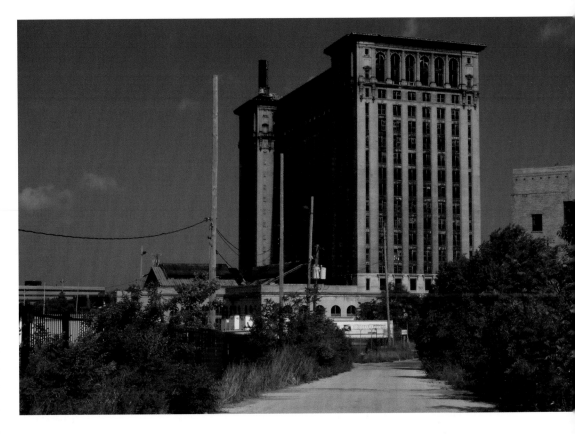

The long-abandoned Michigan Central Station looms on the far west edge of Detroit's downtown, eighteen stories of shattered glass and vanquished hope that has become perhaps the most widely recognized ruin in a town sadly known for its abandoned monuments. The $2.5 million building opened in December 1913, the result of a collaboration between the two architecture firms that had designed New York's Grand Central Terminal the year before, Warren and Wetmore in New York and Reed and Stem in St. Paul, Minnesota. In an opposites-attract sort of design, architects Whitney Warren and Charles Wetmore seem to have hoped that planting a relatively "modern" brick office tower on top of a massive, limestone Beaux-Arts train station with heavy Roman overtones would generate the sort of visual fizz that works to the advantage of each.

Local reaction to the new building, a mile and a half from the city center, was mostly enthusiastic, not to say a little boosterish. Dime Savings Bank vice president George H. Barbour, quoted in the *Detroit Free Press* the Sunday after the depot opened, captured the mood: "Detroit can congratulate herself on having the most modern and magnificent station of any city in the world. Why, the place is so far ahead of the times that we can't rightly appreciate it!" Headline writers at the city's three major dailies competed for superlatives, labeling the depot a "credit" to the city of Detroit, a "jewel" in her diadem, and a "first-class" addition to the city's many charms.

On the inside, the depot boasted a women's waiting room complete with rocking chairs, a men's smoking room, a bar-

Detroiters have long been divided on whether the Michigan Central Station, abandoned in 1988, is a treasure or an embarrassment, with impassioned arguments on both sides. Of late, preservationists appear to be getting the upper hand as the building's fame spreads. Seen here from the rear, the depot is undeniably one of the most commanding elements of the Detroit skyline, not least because of its location far west of downtown's skyscrapers.

At the Michigan Central Station, concertina wire vies for attention with classical pilasters topped by acanthus leaves. On nice weekends, the depot is mobbed by photographers and the curious. The way both locals and out-of-staters have taken the spectacular ruin to heart has been unexpected and striking. Some Detroiters, however, chafe at pictures highlighting all the shattered windows.

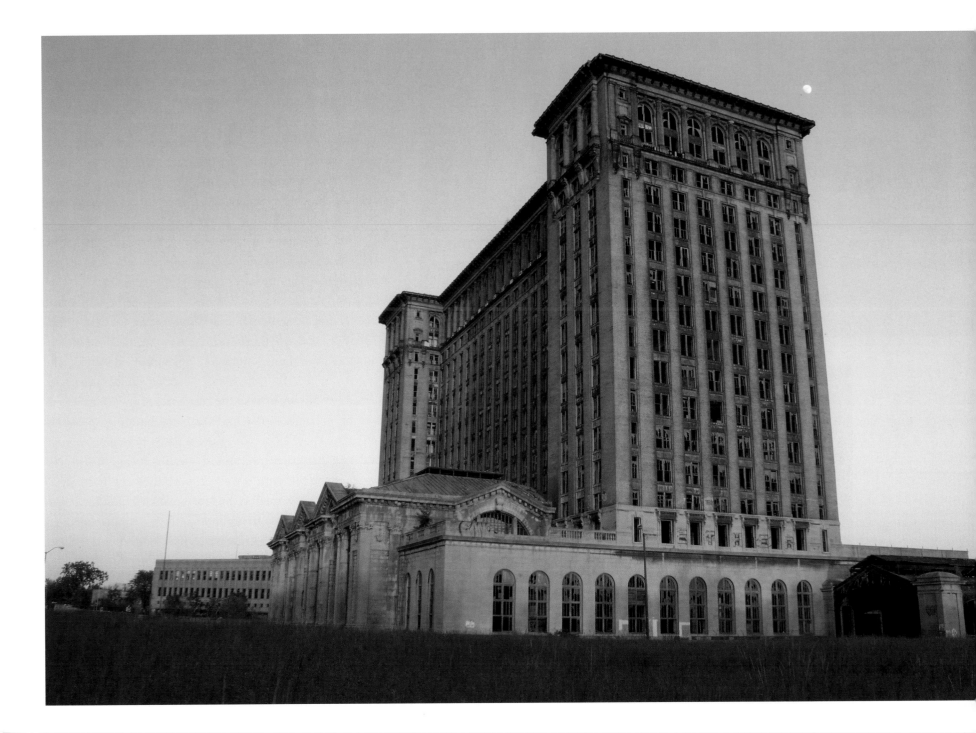

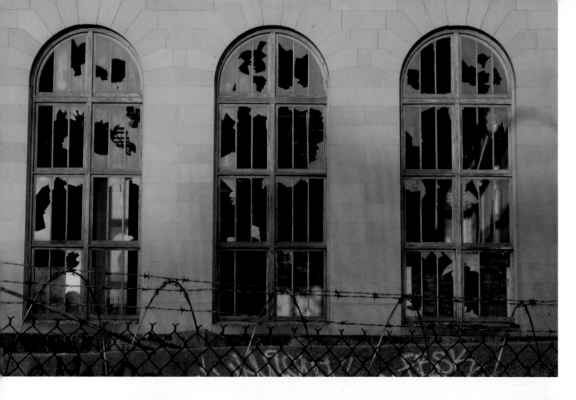

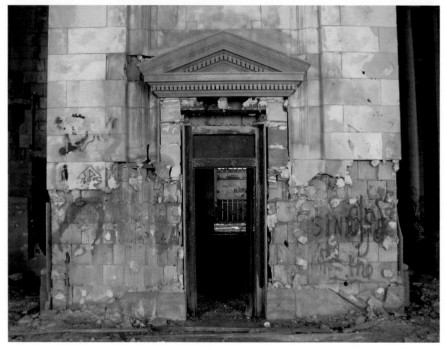

bershop, eight bath-and-dressing rooms for out-of-town male patrons who wanted to freshen up (there were five such rooms for women), a drug store, a cigar stand, a lunch counter, a restaurant, and a café. The men's reading room, according to John A. Droege's 1916 *Passenger Terminals and Trains,* was "exceedingly well fitted and provided with an abundance of good reading material." The roughly sixty-foot high main waiting room was reportedly based on the Roman Baths of Caracalla—the same claim made for the waiting room at New York's Pennsylvania Station.

Despite these amenities, the building left some critics cold. Droege, though on the whole an admirer, observes that "the various station facilities are rather scattered." On the other hand, he applauds the installation throughout of "automatic intercommunicating telephones." Taking aim at the building's station-and-tower heterodoxy, the *Architectural Record* found more mess than monument. "Seen from a distance," the *Record* wrote in 1914, "the casual observer, unless otherwise informed, would never take the two parts of the [Detroit] station to be portions of one and the same building so utterly different are they. Each part taken separately might be good. Joined together, they are architecturally incongruous. The fore part of the building is well proportioned and possesses a degree of classic distinction, but the great wall of office building at the back overshadows and spoils it." It's an argument *Detroit Free Press* architecture critic John Gallagher, author of

The Michigan Central Station looms as a reminder of all that America abandoned when it embraced the automobile. At the depot's 1913 grand opening, no could imagine the devastation that's overtaken the concourse (*opposite*) and the rest of the building. It was 1913 as well when Ford Motor Co. first produced 200,000 cars—in retrospect, a dismal augury of the railroads' coming decline. The station's fate is still unsettled, though its owner has said he'll replace roof and windows to make the behemoth more marketable.

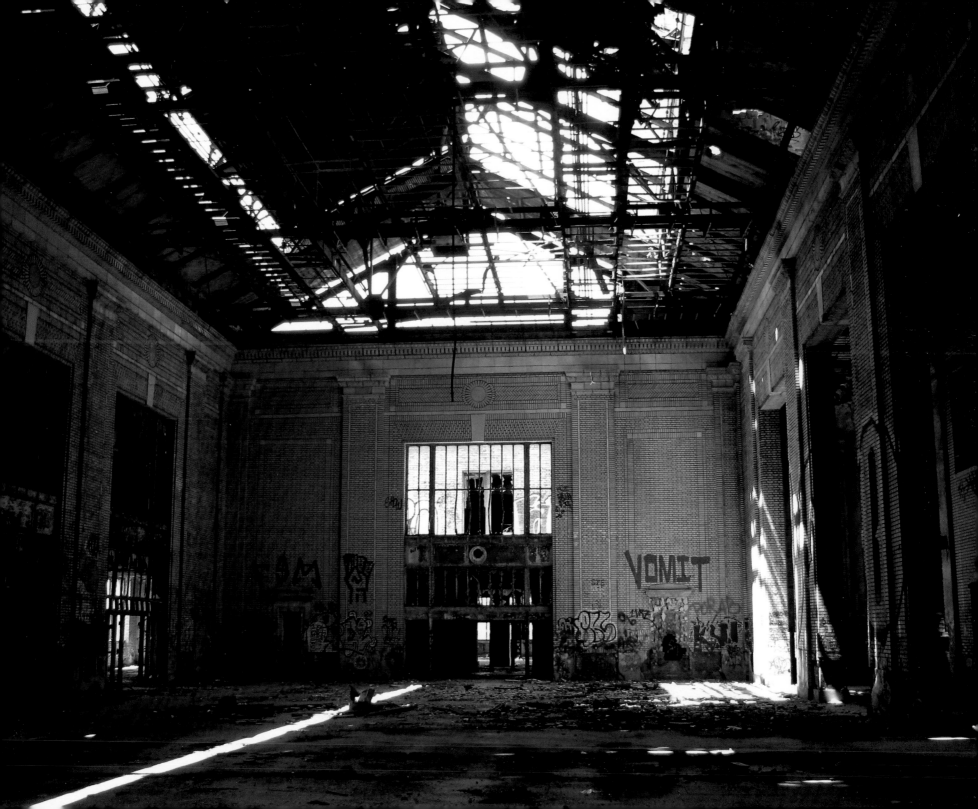

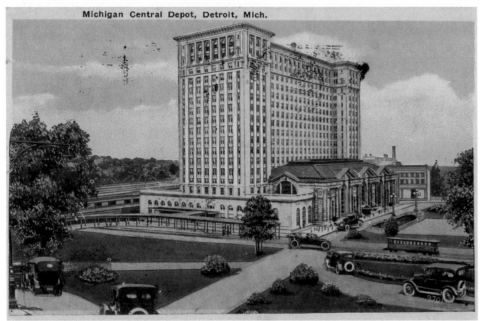

Michigan Central Depot, Detroit, Mich.

Sneaking into the station has gotten harder of late—its owner having finally succeeded in sealing it off. For much of the time after Amtrak's 1988 departure, the building was wide open—and one of the metro area's coolest sites for underground raves. Over that same period, teenaged boys—in the main from the suburbs—seized on the depot as a sort of destructo-Disneyland where they could vent adolescent rage by chipping and smashing every bit of classical detailing they could lay hands on. Graffiti artists (*top left*) also arrived, restyling the former women's waiting room with aerosol cartoons. (*Bottom left:* Personal collection of Jacqueline Hoist and Ronald Campbell)

Reimagining Detroit, echoed in a 2008 assessment: The depot itself is grand. The office tower above and beyond it spoils the picture. (Gallagher suggested that the tower be removed in any future renovation.)

But many would argue it's that very incongruity, mixed with the building's inherent pathos and visual punch, that gives the station its strange and affecting magnetism, a gravitational pull that works on the emotions of Detroiters and visitors alike. How else to explain the train station's emergence as the iconic Detroit image, in all its despair and glory, at the beginning of the twenty-first century? Some Michiganders fret that the attention the depot and the city's other fabulous ruins are enjoying on the national stage only reinforces outsiders' negative judgments of Detroit. They should take heart. At least with the demographic that comes specifically to see the train station—and there are dozens packing cameras every summer weekend—something rather different seems to be happening. Few appear to leave unmoved.

Detroit was not the only city, by the way, to plant a skyscraper on top of a train station. The same approach was used with the remarkable 1929 Buffalo station, and eventually in New York City itself when the Pan Am Building (now MetLife) was inserted—rather successfully, all things considered—on top of Grand Central Terminal.

Since the architectural quartet that built the Michigan Central Station also designed the 1912 Grand Central, the two

are often compared. Here's how they stack up in rough outline: the main waiting room at the Michigan Central Station is 234 feet by 98 feet and 54.5 feet tall at the apex. Grand Central's main concourse is somewhat larger at 275 feet by 120 feet, and it rises 125 feet.

The two stations are strikingly similar in functional design. In each case, the architects labored to separate inbound and outbound traffic to encourage the smoothest possible pedestrian flow, and substituted gently sloping ramps—the one leading to Detroit's train platforms was tilted at a 7 percent incline—for stairways wherever possible.

The fates of the two stations in the modern era provide an interesting study in sharp contrast. Grand Central never stopped being a functioning train station, while the last Amtrak train pulled out of the Michigan Central in 1988. And despite a decline from the 1960s to the early 1980s, Grand Central has since been magnificently reinvented as a commuter-rail hub and retail and tourist destination, fancy restaurants and all. (The celebrated Oyster Bar downstairs, of course, has been there for decades.)

By contrast, the closure of the Michigan Central Station followed decades of neglect, and the building has since been pistol-whipped and stripped of most of its interior ornamentation by vandals—in the main young suburban boys out on a lark. If Grand Central is as good a symbol as any of New York's rebirth, then the Michigan Central Station stands as a potent symbol for everything that's gone wrong in auto-obsessed Detroit.

The Michigan Central Station's birth was the product of a forced delivery, required when a large fire broke out the day after Christmas in the old Michigan Central depot. As the *Detroit Free Press* put it a few days later, "[T]he [new] station was cheated of its January 4, 1914 grand opening ceremony, to be

enriched with champagne and senators, by the December 26, 1913 fire at the old Third Street Station." Turning on a dime and opening nine days early was a feat the spanking-new station pulled off with finesse. Newspaper accounts report the switchover was made "without fuss or feathers," and that subsequent arrivals and departures were "on the dot." The first train leaving the grand new building was the 5:20 p.m. to Bay City. "When the call came to get the station ready for business," reported the *Free Press* on December 27, "there was only time to clear away the rubbish and connect the electric lights and phones in that part of the station that was needed to care for the passengers."

The switchover took place on a Friday. Early the next day, perhaps thrilled by that sleight of hand the day before, the public arrived in droves to have a look at the new station, doubtless staring a bit slack-jawed at the immense waiting room, its towering, somber Tuscan columns, and the depot's three great front windows, each four stories tall. With perhaps a little exaggeration, newspapers estimated that one hundred thousand people squeezed through the building that Saturday. Nearby streets were "black with the crowds who took advantage of the fine weather to make the depot their Mecca." Here and there tempers got short. The police had shut down elevators and stopped anyone from going upstairs, since the upper floors weren't yet ready for the public. One testy Peter Cox, described as a laborer, got into it with Patrolman Dan Dilworth and won himself the honor of being the first arrest at the depot.

It wasn't long before the mighty train company was bumping heads with the city administration. In 1914, one year after the depot opened, the Michigan Central Railroad petitioned the city council for a liquor license to open a saloon in the station. Previously, railroad execs had had no objection to a

special zoning around the depot that was designed to keep bars out. But now the railroad not only asked for a liquor license, it also requested that zoning restrictions be lifted at the nearby corner of Eighteenth and Newark streets "so a saloon for its colored porters could open." Neither application would go anywhere. Governor Woodbridge Nathan Ferris weighed in on the question, writing a heated letter to the Women's Christian Temperance Union in which he vowed to crush the petitions.

The station's odd location so far from the center of town—a mile and a half—was the subject of surprised comment by outsiders. It was determined in 1910, three years before the depot opened, by the location of the twin-tube Detroit-Windsor rail tunnel. Until the Michigan Central Station opened, all of Detroit's stations had been "stub-enders"—serviced by dead-end rail offshoots from the main line that required backing trains up to get back on the main road. Although the station was well served by streetcars—indeed, the east entrance was given over entirely to them (the west was for autos), the building's remoteness was still a problem. In 1921, one ambitious entrepreneur at the Michigan Elevated Railway Company proposed building a monorail from the depot to the city's hotel district around Washington Boulevard. Like Detroit's proposed subway system, the project died a-borning, leaving hotel-bound swells to hail a cab or take the streetcar like ordinary folk.

And swells there were. The Michigan Central Station—much like airport first-class lounges today—saw its share of glitter, swank, and celebrity. In her Valentine's Day 1914 "Chatty Column of News and Comment on the Doings of Detroit Society during the Last Seven Days," *Free Press* society columnist Betty Brough advised, "If you want to see Detroit

society, you should perch yourself in the Michigan Central depot, especially at the time that The Detroiter or Wolverine [trains] start on their journey to New York City."

In the years when rail was really the only effective way to travel long distances and trains had little competition, virtually any Detroiter's trip beyond the city would begin at the station. Reports of dense crowds clogging the terminal's half-million square feet have an unreal sound today. The *Free Press* reported that on Christmas Eve 1919, the vast depot was stormed by "an unprecedented crush" of travelers, such that "only the wide expanses of waiting rooms prevented serious confusion. Every inch of the great station was needed to handle the incoming and outgoing crowds."

Among those crowds at the turn of the century, the sharp-eyed might well have spotted auto magnate Henry Ford striding through with young Edsel riding on his shoulders. Martial music king John Philip Sousa arrived with his band in Detroit in 1918—they marched all the way downtown, where they reportedly serenaded the newspaper offices. In 1919, flag-draped caskets bearing the sixty-eight Michigan boys who'd died in the Allied campaign in northern Russia were brought home. An honor guard of six hundred members of the 339th Infantry and thousands of citizens lined the sidewalks to watch their progress on trucks to the Detroit Armory. Two years later, the French hero of World War I Marshall Foch came through and visited the Dodge plant, followed shortly thereafter by the American hero General John J. Pershing.

Despite the blistering it has suffered, the Michigan Central Station's main waiting room—54.5 feet tall at the ceiling—still retains its inherent architectural power. The vast space has been somewhat cleaned up since this picture was taken and was used in 2010 and 2011 as the backdrop for various film and TV productions, including *Transformers 3* and the short-lived cop show *Detroit 187*.

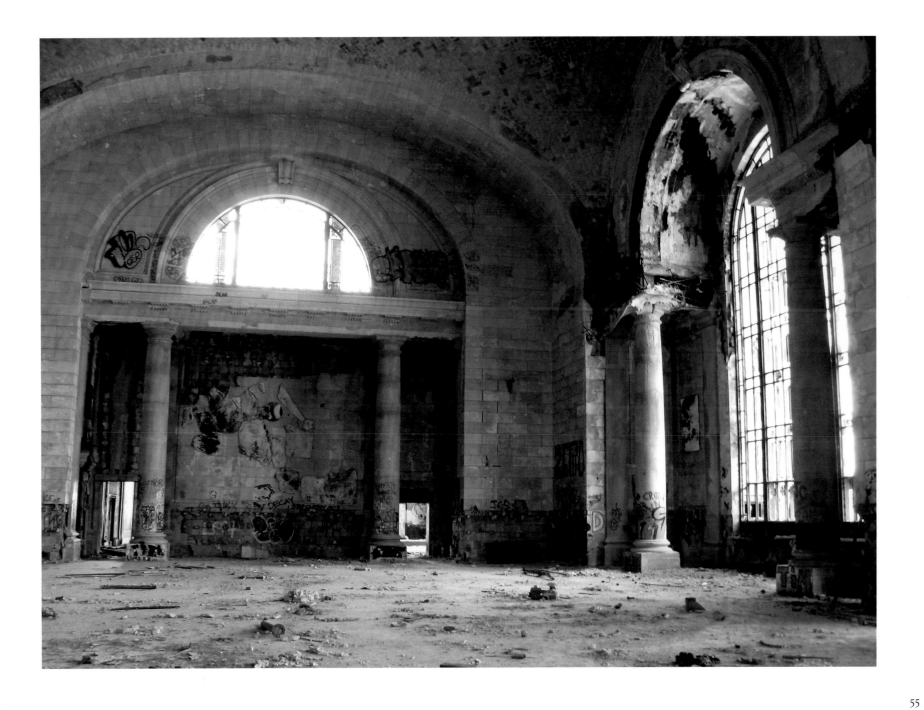

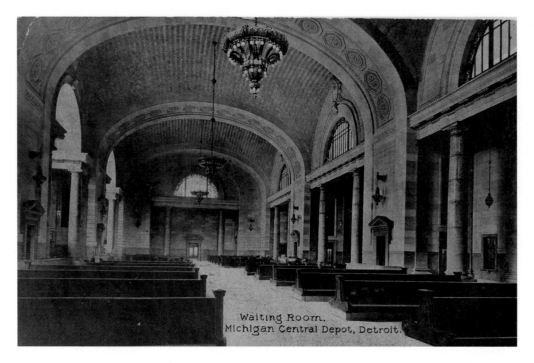

Waiting Room.
Michigan Central Depot, Detroit.

In its day, of course, the station was considered the last word in luxurious refinement. Small wonder it was often compared, favorably, to New York's Grand Central Terminal, built by the same team of architects— Warren and Wetmore, and Reed and Stem—the year before the Michigan Central Station opened. (Personal collection of Jacqueline Hoist and Ronald Campbell)

Then there was the time in the mid-1920s when actor Charlie Chaplin and Secretary of Commerce Herbert Hoover arrived on the platform simultaneously. The former was mobbed, the latter completely overlooked. Among the wealthy, of course, many had their own private railroad cars. African American baseball fans in the 1920s might have recognized the sleek car owned by Rube Foster, founder of the Negro National League and owner of the Detroit Stars and the Chicago American Giants.

For tens of thousands of immigrants, both foreign and domestic, the Michigan Central was their first glimpse of Detroit's fabled wealth and promise of the American Dream. To African Americans arriving from the Deep South, of course, the station's symbolism was even more profound. The depot was more than just the gateway to prosperity for many who might have boarded in Mississippi or Alabama—it was their first contact with the freedoms of the largely unsegregated North.

If the station played host to soaring ambition, it also saw its share of murder and mayhem—such as the early-morning events of September 28, 1920. Detroit police surmised that onetime Sicilian mob boss John Vitale thought he was being driven to the depot when he was abruptly shoved out of a car just short of the station at 3 a.m. He was brought down in a hail of bullets, eighteen of which lodged in his body, according to the *Washington Post*. Just five weeks earlier, Vitale's son, Joe, had been killed in front of the family's home in another fusillade intended for his father—apparent payback for Vitale's bloody reign in 1919, which saw twenty-four gangland murders and a number of bombings. On this particular morning, Vitale seems to have thought, according to police hypotheses reported in the *Detroit News,* that he was meeting gunmen he had imported for protection. Or, police suggested in an alternate scenario, he was going to catch an early train to skip town, knowing his life was in danger. Either way, the betting was that Vitale was betrayed by individuals he trusted. "There can be no other explanation for so crafty a feud veteran allowing himself to be killed in that location at that hour," said the *Washington Post,* adding that residents of Fourteenth Street near Marantette Street, drawn to their windows by the volley of shots, saw two automobiles making a getaway.

Six years later, in 1926, a different cast of would-be felons nearly got away with an early-morning heist at the Detroit Institute of Arts, at its former home on East Jefferson Avenue. Loot from the July 1 robbery included a 1644 Frans Hals

painting, *A Woman,* said to be worth at least $40,000; a bust by Mino da Fiesole, a celebrated Florentine sculptor from the 1400s; and an Oriental rug valued at $75,000 that had been given to the museum by Mr. and Mrs. Edsel Ford. The artworks were taken from the museum's storage room and lowered from the third floor by rope while the night watchman reportedly slept. The interlopers might well have pulled it off had a rope and a torn pair of gloves not been found near the scene. "Sherlock Holmes Could Not Do Better" headlined the July 3 *Detroit News* story detailing how detectives cracked the case by tracing one of the thieves through identifying marks a professional cleaner had left on the gloves. A twenty-nine-year-old Sarnia, Ontario, resident later confessed, implicating a dozen other men said to be in the pay of an unnamed millionaire "antique pirate," as the *Washington Post* put it. All the art was recovered. The Oriental rug turned up in the checkroom of the Michigan Central Station.

The station was also the first staging point for tens of thousands of Detroit men and women off to both world wars. On balance, the generation reporting for duty in 1941 appears to have seen war in much more somber terms than had their compatriots at the time of the First World War, who had staged dizzy, bunting-rich send-off celebrations at the depot when the troops first left for Europe in 1917. Not so in the early 1940s, when war preparations had a grimmer cast.

Decline in train travel set in with a vengeance after the war. Michiganders led the nation in abandoning public transportation lock, stock, and barrel for the charms of private conveyance. In 1956 the New York Central (successor to the Michigan Central) put all its stations, Detroit included, up for sale to try to compensate for annual losses on passenger service of $37 million. The New York Central president suggested Detroit's

depot might be turned into a shopping center (anticipating, perhaps, Washington's Union Station) or giant warehouse. For just $5 million, he said, it's yours. There were no takers.

The downward trajectory is reflected in the train schedules. In 1945 thirty-two trains arrived and departed daily. By 1966 that number had dropped to eighteen. In 1967 the railroad closed the depot's great waiting room and the main entrance opening onto Roosevelt Park and Michigan Avenue. Patrons would enter by the east or west doors, once reserved for streetcars and taxis, respectively. In 1975 Amtrak reopened the waiting room and main entrance, and put some money into renovation. But the funds were never adequate to the task. By the late 1970s, newspaper stories were shouting about the station's dangers—sagging stone, rusted railings, and chunks of balustrade just waiting to ding the unfortunate pedestrian.

The last passenger train—No. 353 to Chicago—pulled out at 11:40 a.m. on January 5, 1988, after which they closed the grand old building for good. The depot has been the object of any number of redevelopment schemes since that time, none of which has taken root. Never adequately sealed, through much of the 1990s the depot's great waiting room played host to illegal raves and wild late-night parties in one of Detroit's most dramatic interior spaces. Nearby Corktown residents could get a killer view of the Fourth of July fireworks if they were willing to scale the eighteen crumbling flights of stairs to the roof. The building is now owned by Manuel "Matty" Maroun, who also owns the Ambassador Bridge to Canada. Maroun has promised to repair the roof and replace the thousands of shattered windows as a means of making redevelopment more likely. As of fall 2011, some work appears to have begun.

Dexter

> **1887—Michigan Central Railroad**
> **3487 Broad Street**
>
> ARCHITECTS: Spier and Rohns
> LAST PASSENGER SERVICE: 1953
> CONDITION: Excellent
> USE: Ann Arbor Model Railroad Club

In the 1880s and 1890s, the Michigan Central Railroad replaced most of its stations along its "main road" from Detroit to Chicago, following years of passenger complaints. In 1887, like its neighbor Grass Lake, little Dexter lucked into a remarkably handsome station built by big-name Detroit architects Spier and Rohns. Grass Lake got an exceedingly likable fieldstone Romanesque depot (that looks as much like a whimsical schoolhouse as a train station). The Dexter depot, by contrast, is a dignified wooden composition in stripped-down Stick style, with a tower beneath a pyramidal roof that juts up proudly. As good looking as this modest structure is, it's almost a pity it finds itself on the edge of a residential neighborhood, rather than right downtown. Assuming you can't have too many good buildings in one locale, its presence there would further gild the low-key urban charms of this nineteenth-century village.

The depot's construction was a quick affair. Work began on November 6, and the station opened for business ten weeks later on January 19, 1887. Of particular interest architecturally are the unusual paned windows that surround the exterior doorways—so starkly simple as to have an almost proto-modern look. A belt circling the building separates board and batten at the base from the clapboard that wraps most of the structure. Together the two help break up the building's mass, and the horizontality of the clapboard subtly underlines what it's really all about—the rush of speeding trains. On balance, the depot has had a relatively happy life. There have been few significant changes in its appearance over the years apart from the roof, which started life with cedar shingles. In time, those gave way to copper, then rolled roofing, and ultimately the asbestos shingles we see today.

Talk to almost any railway enthusiast about Dexter and the Kinnear track pans immediately come up, but it's worth noting they were a couple miles east of the depot. Still, for a modern audience they're deeply intriguing. Steam locomo-

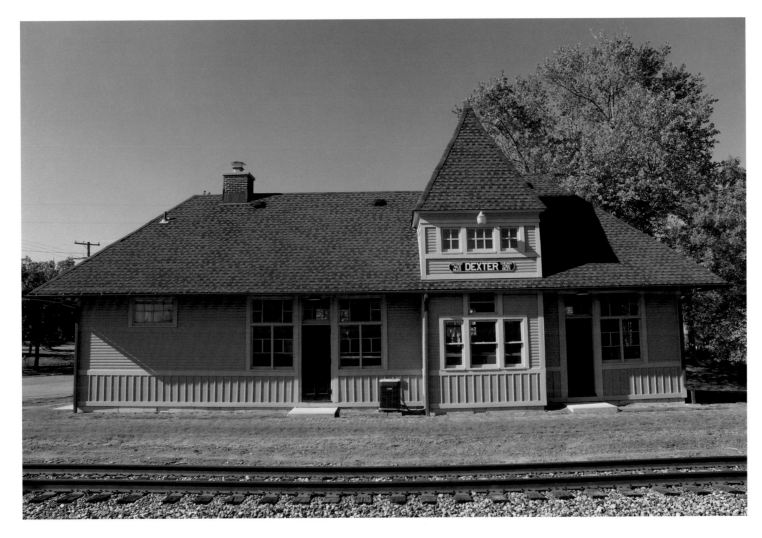

Dexter's Stick style station is a handsome study in horizontals and verticals, once again painted the Michigan Central Railroad's trademark blue-green (like its cousin in Chelsea). The building has been nicely maintained and houses the Ann Arbor Model Railroad Club, which has an impressive model landscape set up inside.

tives ran on water, of course, which needed replenishing at regular intervals—which is why water tanks were found at so many stations. But refilling at a water tank robbed a schedule of valuable minutes in a highly competitive industry. So in 1901 the Michigan Central laid down track pans at Dexter, the only railroad company in the state to ever employ them.

(The company installed another set at Niles.) Heated in winter to prevent icing, the pans held water that a speeding locomotive scooped up as it roared above. The pans were named, by the way, for Wilson S. Kinnear, the Michigan Central engineer who would design the rail tunnel connecting Detroit to Windsor, Ontario, that opened in 1910.

A persistent safety issue slowly getting worked out in the late nineteenth and early twentieth century, however, was the dilemma of train tracks crossing roads that were handling an increasing amount of traffic. Separating the two onto different grades—one above, one below—was one of the great engineering challenges of the age, particularly in large cities like Detroit. But it wasn't a concern limited to dense urban centers, as an incident shortly after the Dexter depot opened illustrates to tragic effect. Dennis Warner had walked to church to pick up his wife, Martha, when the service let out. The two then proceeded down Main Street toward their son's farm. Railroad tracks crossed Main a short distance from downtown, not far

from the depot. The two were apparently surprised by a train coming around a bend. Dennis was able to clear the tracks, but Martha hesitated, and just as she stepped off the track, she was mowed down by the advancing locomotive. She was sixty-two. Her death prompted demands to separate tracks and street, the result being the rail viaduct that still stands today—a small measure of good drawn from deeply unfortunate circumstance.

Laypeople were not the only ones felled by regrettable mistakes. In 1945 Dexter station agent Ira C. Ott—who'd held the job for seventeen years—was killed by a locomotive that was in the process of switching in the rail yard. The wind

Waiting for the train then and now: Members of the Ann Arbor Model Railroad Club greet the evening Amtrak express on its way to Chicago (*opposite page*), while a fancifully dressed crowd in 1946 (*this page*) hail the arrival of one of the streamlined Art Deco locomotives designed by Henry Dreyfus for the New York Central. (Claude Stoner Collection, Bentley Historical Library, University of Michigan)

61

The old Grand Trunk Western depot at Lapeer bears a strong resemblance to Dexter, with the principal difference being the pitch in the tower roof.

grabbed a piece of paper Ott was holding and he, not realizing the train was so close, ran to pick it up from the tracks, where the locomotive struck him.

On a positive note, one of Dexter's favorite sons took his first steps toward international fame when he boarded a train at the depot for New York City shortly after World War I. Lewis James would be discovered in Manhattan by Walter Damrosch, conductor of the New York Symphony Orchestra, when the latter chanced to hear the recent arrival from Dexter in a church choir. Not a year later, James found himself singing a solo at Carnegie Hall in front of the symphony. James would become a key member of several choral groups that won widespread acclaim, including the Shannon Four and, later, the Revelers. In 1926 James and the Shannon Four performed twice for the Prince of Wales.

No station's history, it seems, is complete without a wreck—a reminder of the inherent dangers in this form of transportation (although rail travel has always been far safer than the automobile). On January 8, 1952, the Wolverine passenger train careered off the tracks after slamming into a freight car, itself derailed right in front of the depot. Happily, no one was killed, but seven people were injured, and a number of new automobiles on the freight train were badly damaged. In the darkness and confusion, townsfolk poured out to help the 250 shaken passengers. According to the *Dexter Leader,* firemen's wives brought hot coffee and sandwiches, while nearby residents turned on porch lights to signal that out-of-towners were welcome to come use their phones. One astonished traveler told the newspaper, "I don't even know where this place is, but the people sure are nice."

We tend to think of the 1940s as still part of the high railroad era, with the big crash in ridership and service not coming till the next decade. But as early as 1946 regular stops at Dexter had been cut to two trains daily, one east, one west— and just in the morning, at that. Want to catch the evening train? The station agent would have to flag it down. Passenger service ended altogether in 1953.

The depot was used for years to store civil defense materials, until the mid-1960s when the Dexter Youth Club bought it from the railroad for $1,000. Over time the club found it couldn't maintain the structure, so in 1980 the Huron Valley Railroad Historical Society—organized precisely for this purpose—bought the station and started renovations. With the help of spectrographic analysis (and the removal of seventeen layers of paint), the society was even able to pinpoint the station's original color. The depot was repainted in the Michigan Central's trademark blue-green just in time for the 1987

centennial celebration and the erection of the state historical marker. The society still owns the station. One of its constituent groups, the Ann Arbor Model Railroad Club, meets there every Wednesday evening.

Sometimes the simplest details pack unexpected visual punch. Here, a shadow highlights the interplay of vertical and horizontal.

Durand

1903—Grand Trunk Western Railway
and Ann Arbor Railroad

200 South Railroad Street

ARCHITECTS: Spier and Rohns

CONDITION: Excellent

USE: Amtrak station and Michigan
Railroad History Museum

*D*urand Union Station, with its two turrets topped by witches' hats, is one of the most recognizable stations in the country. Indeed, literature on it frequently asserts that it's the "most-photographed" depot in the United States. If such a distinction seems like it would be hard to quantify—and wouldn't New York's Grand Central Terminal give Durand a run for its money?—it's nonetheless a nice illustration of the strength of local pride in a surprisingly magnificent station.

Whether or not it takes first place, Durand certainly deserves to be high on any list. The depot, which sits right at the dramatic X where the Grand Trunk crossed the old Ann Arbor Railroad, is an exuberant mishmash of architectural styles—and in that, quintessentially Victorian. There's a Flemish inflection to the steeply pitched gable, and something Chateauesque in the two towers that flank it. Richardsonian Romanesque hints are found throughout, but no more than hints—the building isn't nearly as heavy as that style sug-

gests. Note also that the platform roof girding three sides of the building—bulging far beyond the wall to shelter an oval porch at the west end—is far more light and Victorian than Romanesque.

Canada's Grand Trunk Western Railway built the station in 1903 with the Ann Arbor Railroad for $60,000, engaging the same Detroit architectural firm that had done so many stations for the Michigan Central, Spier and Rohns. Its dedication was a "brilliant affair," according to the *Durand Express* on October 8, with 350 invited to a sit-down dinner within, followed by dancing at 9. The grand building couldn't help but excite admiration, particularly in a relatively small town. The *Express* noted that in conversations that evening, "beautiful, handsome, fine and other such expressions were unanimous."

The exhilaration was short-lived. Eighteen months after the station opened to acclaim, a midnight fire erupted in the basement, on April 16, 1905. Human error and misjudgment compounded a problem that at first looked like it would be easily contained. Durand Fire Chief McBride (the *Detroit Free Press* did not give a first name) was at the scene in short order, his men hauling hoses across the track to start dousing the blaze. But railroad officials ordered a temporary pullback so Grand Trunk No. 5, the "fast" passenger train from the east, could roar through unimpeded. (The fire against the night sky must have made quite a sight for passengers.) McBride

Detroit architects Spier and Rohns built Durand's majestic twin-towered station at the X where the Ann Arbor Railroad crossed the Grand Trunk Western line. The station had a tumultuous beginning, burning in 1905. (The two railroad companies quickly rebuilt.) Once one of the busiest crossroads in Michigan, Grand Trunk killed train service to Durand in 1971. But after a restoration, the depot reopened in 1981 as an Amtrak stop. Today the well-maintained building also houses the Michigan Railroad History Museum. Often called the "most-photographed" station in the United States, there's no denying you often come across Durand in picture books on American depots.

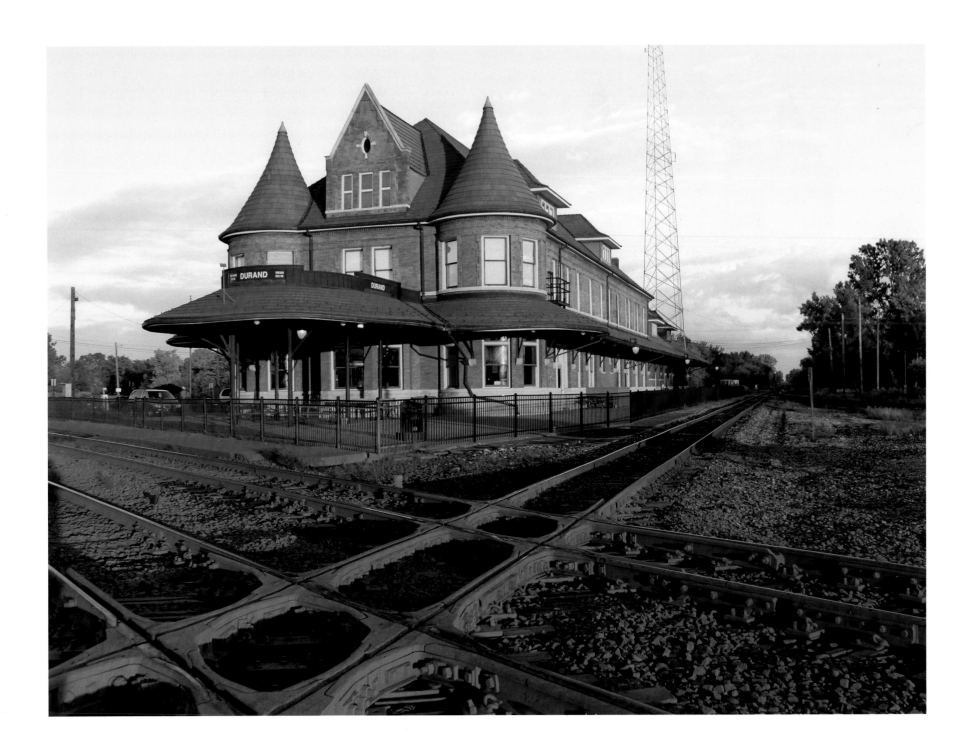

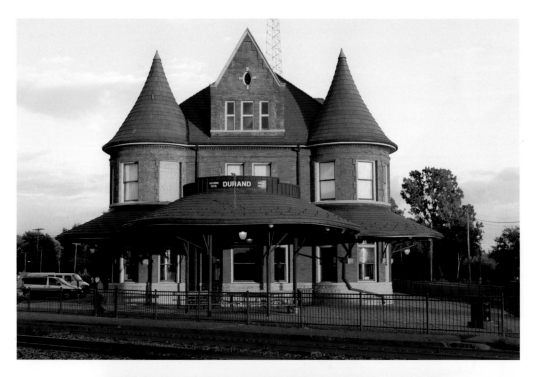

later told the *Durand Express* he thought the interruption would take only a minute, but it was a full ten minutes before hoses were drenching the building again. In that time, flames reached up and engulfed railroad offices on the second floor, and from there leapt to ceiling and roof. At least one employee jumped out a second-story window, and a couple "dining-room girls" had to be pulled bodily through windows onto rescuing ladders. A few quick-witted clerks grabbed their typewriters—a devotion to duty that can only be applauded. Despite the assistance of fire crews from Owosso and Flint— they arrived on special trains—the depot was a total loss, with damage estimated at $75,000. The railroads quickly rebuilt, however, and Durand Union Station reopened in 1905 as essentially the same structure. A few dormer windows changed, and a red-tile roof took the place of the original slate—but it was "a finer and more handsome structure than the former," the *Express* assured readers on September 28.

In the early twentieth century, little Durand was the busiest depot in the state apart from Detroit, with upward of three thousand passengers boarding or getting off trains every day. By 1912 the station was handling forty-two weekday passenger trains, twenty-two mail trains, and seventy-eight freights—more than one every ten minutes.

Given the traffic, it's not surprising the station witnessed at least two spectacular wrecks. When the depot was still under construction in August 7, 1903, one Wallace Circus train

One of the station's elegant touches is the platform that billows out in symmetrical curves from the front of the building to shelter passengers—a nice, delicate touch. The design itself is a hybrid of several competing styles. The roof gable has a Flemish cast, while the twin towers call to mind a French chateau. Constructed of glazed, vitrified brick with a flared, cut-stone foundation, the building is 244 feet long and 49 feet wide. Between passenger and freight service a hundred years ago, a train was pulling into Durand every ten minutes.

rear-ended another that hadn't yet left the Durand station. A red signal light duly warned the approaching train, but in a tragic twist, the locomotive's air brakes failed and, with nothing restraining it, the train plowed into the one before it with stupefying force. The *Owosso Argus-Press* painted the sickening scene, which occurred just after 8:30 in the morning: "The cries and groans from the injured persons and frightened passengers, the roars from the terrified animals and the escaping steam, aroused the whole city, and hundreds rushed to the scene to assist in every way in the sad task of caring for the dead and wounded." Twenty-three people were killed, along with seven animals. Among the latter were an Arabian horse, three camels, one Great Dane, and an elephant named Maud. They were all buried in a common grave near the crash.

Freemasons were victims of the next catastrophe. It was 1923, and western Michigan members were headed from Grand Rapids to Flint on a special train for the sixty-seventh conclave of the Grand Commandery of Michigan Knights Templar. About a mile west of Durand Union Station, the train—later estimated to have been going fifty miles per hour—hit a stretch of split track, derailing and causing the second passenger car to collapse into the first. Five men died.

In 1971 Grand Trunk ended passenger service to Durand. The railroad maintained offices inside until 1974, but at that point shuttered the depot, seemingly for good. Indeed, it would sit empty, gathering dust and vandals, who stripped it of much of its interior finery, for five years. In 1979 Grand Trunk sold the building to the City of Durand for $1, with a twenty-nine-year lease on the property beneath it. A few years before the sale, estimates had suggested that the structure could be restored to full glory for about $150,000. But by 1979 that price tag had risen to $1 million. Durand City

Council stipulated that no tax dollars could be used to bring the station back to life. Instead, a small army of dedicated volunteers held fund-raisers and ultimately restored the main waiting room, which Amtrak moved into in 1981. The depot's reopening in a town long identified with the railroad was celebrated by hundreds of citizens, with the high school band—the Marching Railroaders—providing the music. In 1989 the Michigan Railroad History Museum opened at the other end of the station from Amtrak—a small institution with a handsome exhibit room and a treasure trove of railroad documents, still in the process of being archived.

Durand Union Station's importance was underlined for all to see in this 1904 publicity shot involving a truly remarkable number of trains. (Personal collection of Jacqueline Hoist and Ronald Campbell)

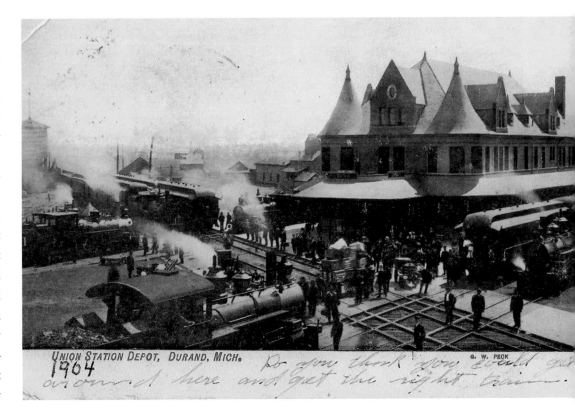

UNION STATION DEPOT, DURAND, MICH. Q. W. PEOK

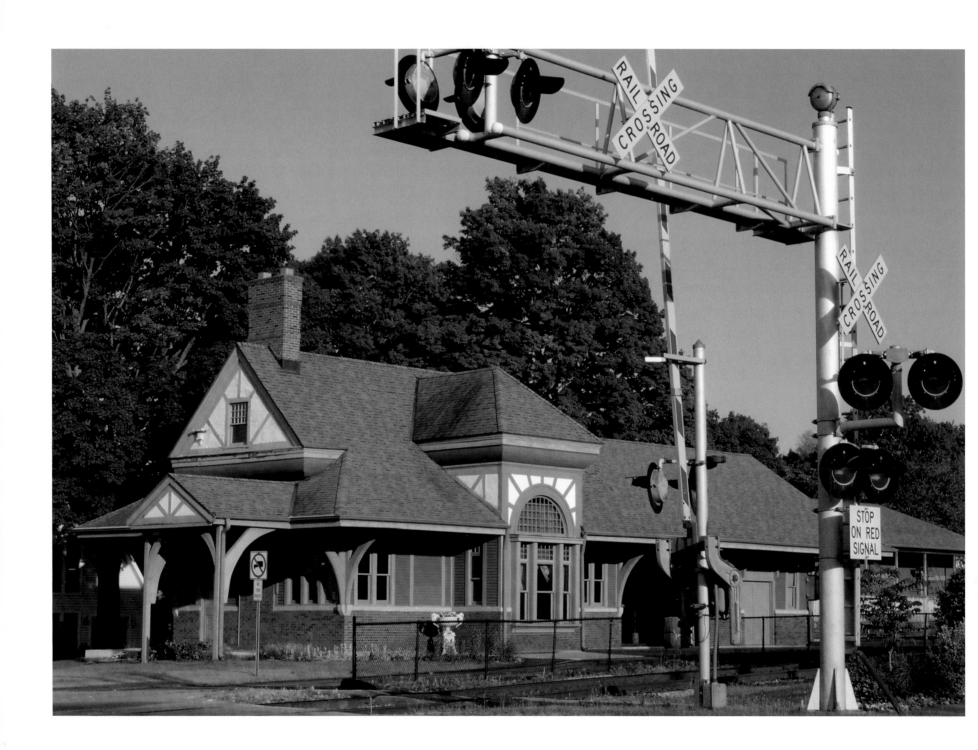

Flushing

1888—Toledo, Saginaw,
and Mackinaw Railroad
431 West Main Street

ARCHITECT: Edward Hubbard

LAST PASSENGER SERVICE: 1971

CONDITION: Excellent

USE: Flushing Area Museum
and Cultural Center

Much like Grass Lake's resurrected station, the 1888 depot just outside Flushing's downtown has over the years endured about as much as one building can, from architectural vandalism to catastrophic fire to years of abandonment and decay. However, against all odds, the station—in 1983 a charred hulk—slowly began to rise from the ashes just short of its hundredth birthday thanks to the Flushing Area Historical Society. Magnificently renovated by architect Ronald Campbell along with the labor of countless volunteers, the building today houses the town's historical museum.

Stylistically, the Flushing station presents the viewer with a cheerful hodgepodge of motifs, painted a handsome dark salmon and olive green. On the one hand, it leans strongly toward Queen Anne, that most whimsical of late nineteenth-century Victorian styles, but with pronounced Stick style ornamentation. Note in particular the elaborate curved bracing beneath the eaves. On the other hand, there's that Classical allusion in the stationmaster's window, with its half-moon comprised of little windowpanes that crowns the whole ensemble. Not content with the merely gorgeous, architect/builder Edward Hubbard further gilded this particular lily with a Stick style sunburst radiating out from the window.

Flushing is another town that, on the surface at least, never should have had a railroad. The small city sits in a deep bowl formed by the Flint River and surrounding hills, well to the east of the direct route north from Durand to Saginaw that the Toledo, Saginaw, and Mackinaw Railroad (later the Cincinnati, Saginaw, and Mackinaw, then the Grand Trunk) was building in the late 1880s. Still, Flushing businessmen had spent twenty-four years lobbying to get tracks through their part of the Saginaw Valley, and in this they finally succeeded by waving $25,000 (over $500,000 today), in front of James Ashley—the head of the Toledo, Saginaw, and Mackinaw and founder of the Toledo and Ann Arbor Railroad. A canny businessman, Ashley quickly saw he very much wanted to pass through Flushing. Local businessmen raised the cash, and the railroad swung east.

In his memoir of a train-obsessed childhood, *The Situation in Flushing,* novelist and playwright Edmund G. Love notes that coming through Flushing meant a detour five miles off the direct Durand to Saginaw road. "Furthermore," he adds, "if that straight line had been followed, the roadbed would have traversed level ground all the way. It would have been easy to build and easy to operate. When the decision was made to detour into Flushing, the railroad left this higher ground and dipped down into the Flint River valley. Having got there, it had to climb out again. This made an uphill and downhill proposition out of an otherwise simple thing. For forty years railroad men cursed the name of Flushing."

Despite a series of calamities (fire, abandonment, exposure to the elements, and a car crash), the fates—with an able assist from the Flushing Area Historical Society—refused to let one of Michigan's handsomest and most idiosyncratic stations disappear. Today the 1888 building houses the Flushing Area Museum and Cultural Center.

The arch with its Stick style sunburst crowning the stationmaster's window (*this page*) disappeared in a clumsy remodeling the Grand Trunk Railroad undertook in the mid-1960s. Happily, the arch was recreated by architect Ronald Campbell in his top-to-bottom renovation completed in 1996. Other exuberant Stick style flourishes are visible in the curved roof struts (*top, opposite*) as well in ornamentation surrounding a gable window (*bottom, opposite*).

Compounding the problem was the fact that almost every train had to stop at the station at basin bottom—passenger trains for obvious reasons and freight trains to take on water. A further complication was the light-gauge track that had originally been laid down could handle only light, weakling locomotives derisively known as "goats" by railroad men.

It wasn't unusual for a train to put into Flushing and then fail to make it up and out of town. This would then entail a humiliating reverse trip, backing up the hill previously descended to a sufficient height for the engine to regroup, get up enough steam, and roar past the depot and up and out of the valley.

The winter of 1917–18 was a particularly bitter, snowy one across southeastern Michigan. It was also the winter budding author Edmund G. Love turned six. On his birthday, of all days, the unlucky boy would suffer the greatest knock of his young life. There was a dramatic train wreck in a snowdrift just outside town that young Love was positively bursting to get to. That very same morning, while the town's attention was focused on the wreck, Love's elementary school burst into flames. Both events were the stuff of boyhood dreams and thrilling to the point of intoxication. Yet Love would miss each calamity. It's hard not to sympathize. The wreck alone could have kept any red-blooded American boy chattering for weeks.

"The snowplow was a caboose-type car made of wood [being pushed by three engines]," Love wrote. "When it hit the drift, instead of knifing through it, the plow crumpled into kindling wood. The first engine behind it ran right through it and slammed into the drift which was packed solid now, like a wall of ice. The second engine climbed right on top of the first engine, hung there for a moment, and then toppled over. The third engine went straight up in the air and stayed there, its cow-catcher pointing to heaven."

Love's parents were dead set against letting the child travel out to the wreck—"No place for little boys," they said. But when the six-year-old played his trump card—"It's my birthday!"—his mother crumbled. Joe Gage, a family friend, was driving out to the wreck and would pick him up. Stand in front of the barbershop and wait, she told the child, and don't move. Implicit in these instructions was the additional message: "You can skip school today"—as good a gift as any little boy could hope for. As it turned out, things were a little confused in town, and Joe was running late. Once the schoolhouse burst into flames, all hell broke loose. Every citizen not

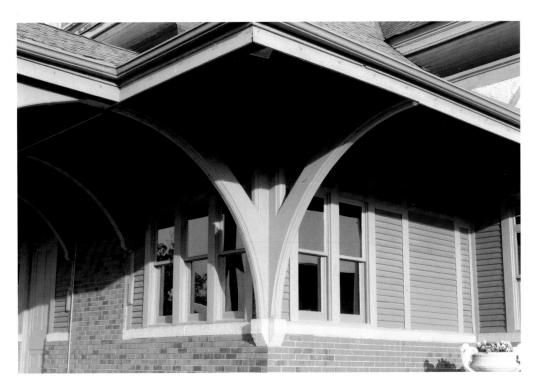

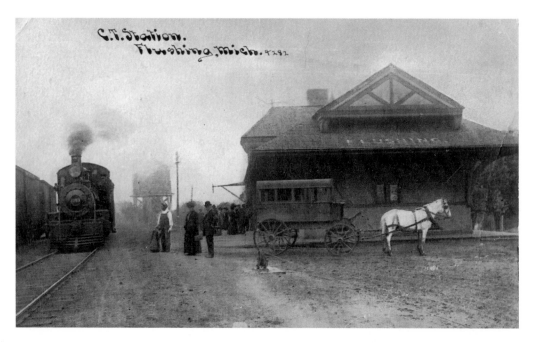
C.T. Station.
Flushing, Mich. 4282

At some point, a clumsy addition was tacked onto the back of the Flushing depot. When architect Ronald Campbell started restoring the building in the late 1980s, he used this undated historic postcard to recreate what the station back originally looked like. (Personal collection of Jacqueline Hoist and Ronald Campbell)

two important things that ever happened in Flushing."

In a 1965 cost-saving measure, Grand Trunk announced it would tear the station down. But the depot survived, largely through the energetic efforts of longtime station agent Clare Fox, who worked for the railroad from 1917 to 1971. Instead, Grand Trunk decided to modernize things—so often the death knell for the look of older buildings. The great arched stationmaster's window was knocked out and all the colored glass panes shattered. In its place, the railroad inserted an off-the-rack, three-section window, and filled in the Classical arch with clapboard. (The sunburst detailing had long since disappeared.) It was a classic case of "remuddling," as the *Old House Journal* calls such ham-handed improvements.

Having lost money for decades, the Grand Trunk killed passenger service through Flushing in 1971. Four years later, the station was converted into the Depot restaurant. In April 1979 an electrical fire that started in the kitchen gutted the building, and most of the roof tumbled in on the interior. And that's the way things stood for four long years.

But in a dramatic leap of faith, the Flushing Area Historical Society took possession of the building in 1983 and launched plans for its reconstruction. Countless fund-raisers and volunteer hours later, the renovation was completed in 1996, though not without tribulations along the way—a corner of the building was lost to a car crash, and there was a bout of flooding due to frozen pipes. In 1997 the Flushing Area Museum and Cultural Center opened inside and has operated ever since. In a nice seasonal touch, the museum sets up three tracks of Lionel trains in December and runs them every weekend through Christmas. Got your own engine? Bring it along.

out at the wreck tore off to the fire, leaving young Love in a largely deserted downtown. Despite his tender years, the young man nonetheless had his priorities straight—marvelous and godsent though the fire might be, the wreck, given his interests, took precedence. Plus, he reasoned, if he showed up at the school and the fire was quickly put out, he might be corralled back inside with all the other students. So Love stuck to his post in front of the barbershop, gradually going blue in the sharp wind. Love had gotten to the corner at 9 a.m. He was still there, distraught but terrified he would miss Joe and his one chance, six hours later when his grandfather happened to drive past. By the time they got to the wreck, there was nothing left—no drift, no helter-skelter locomotives, not even any splinters from the shattered caboose-plow. It was much the same with the fire, which by late afternoon had been put out. "There wasn't much anyone could do to console me for a long time after that," Love writes. "I had missed the only

Gaines

1884—Detroit, Grand Haven
& Milwaukee Railway
103 West Walker Street

ARCHITECT: Unknown

LAST PASSENGER SERVICE: 1957

CONDITION: Excellent

USE: Library branch

The Gaines station is a prized landmark in this hamlet, population about 360, and little wonder. The toy-scale brick station in orange and yellow looks like a Hollywood stage set for "Small Town Depot, Late 1800s," and couldn't be more winning. The style is Victorian cottage, with Stick style overtones in both the gently arcing struts beneath the eaves and in some of the brickwork that mimics wood detailing. It's a modest structure that yearns to be a big stone building but lacked the budget. So it apes a far grander architecture in its detailing. Consider, for example, the yellow brick that frames the first floor under steeply pitched gables—a much stripped-down reference to a Classical entablature.

Even more intriguing, however, is the use of three-dimensional brickwork to echo what in more expensive buildings would be traditional stone. Note the punched-out circular frame around the gable window as well as the upside-down finials that "support" the yellow-brick edging just beneath

the gable roofline, pushed out beyond the orange brick for three-dimensional effect. It's a remarkably graceful conceit on an otherwise very modest depot. The unusual buff-yellow brick, by the way, came from nearby Owosso.

Gaines station started life in 1884, built by the Detroit, Grand Haven & Milwaukee Railway, at that point a subsidiary of the Grand Trunk system. It was the village's second station. The first was a simple wood shack erected shortly after the railroad arrived in 1856. The last passenger train pulled out 101 years later. After that, the depot did time in the 1970s as a store selling stained glass. But for most of the years between 1957 and 1990, the building stood empty, and deteriorated accordingly.

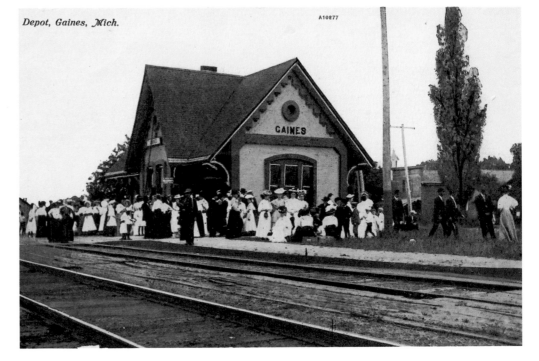

Depot, Gaines, Mich. A10277

Gaines's tidy little cottage station has long been a point of civic pride, and little wonder. The partiers below certainly appear to have enjoyed its charms. (Personal collection of Jacqueline Hoist and Ronald Campbell)

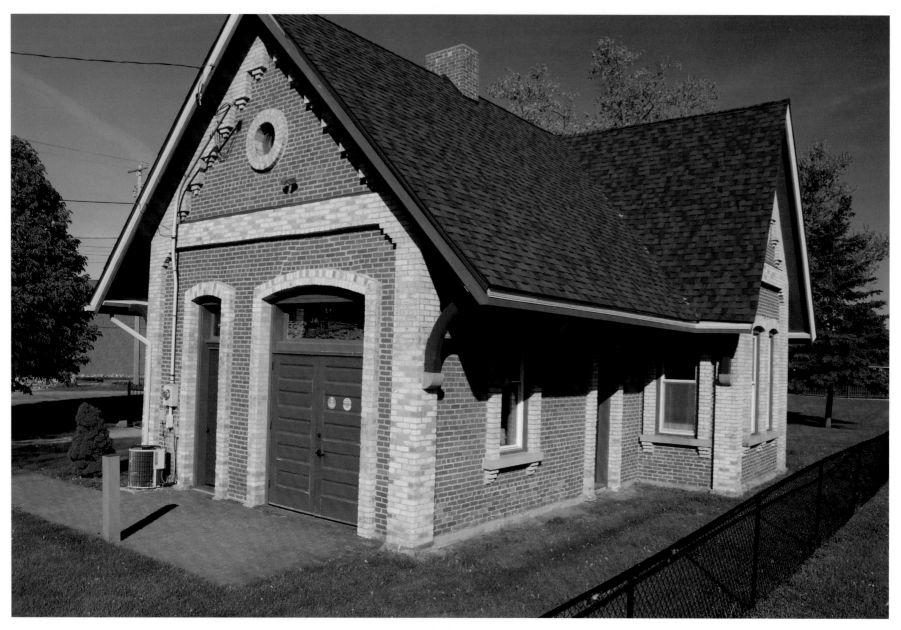

It's the interplay between the warm orange and buff-colored brick that gives the Gaines depot its visual snap, as well as the three-dimensional brickwork around doors, windows, and under the eaves. Today the building houses a branch of the Genesee District Library, open Saturdays.

Architect Reed Kroloff, director of the Cranbrook Academy of Art and Art Museum, calls Gaines "a pretty little Victorian building that wanted to be a big stone building, but couldn't afford it."
Hence, builders employed decorative brick.

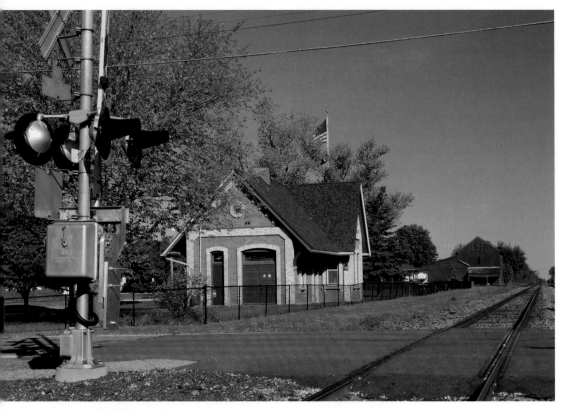

No regular passenger train has stopped at Gaines since 1957—a fact underlined by the fence separating the station from the tracks that once gave it life and purpose.

east. Kimble's family had deep roots in the local railway business, and so he donated the $3,000—asking for no recognition—and the station was saved.

There followed years of fund-raising—T-shirts, sweatshirts, and note cards were all emblazoned with an image of the station and hawked at community events—as well as years of contributed labor and $100,000 in renovations from the roof down. When work was finished in 1998, Gaines Station, Inc. offered the building to the Genesee District Library system, which quickly accepted. At about the same time, the nonprofit sold the building to the village of Gaines for $1. The library was an immediate hit, and once again became—as in the old days—a gathering spot for the community. In the ensuing years, however, the cash-strapped library system has had to cut back the hours the diminutive branch is open. There had been talk of closing the branch for good, but the community wouldn't hear of it. So a compromise was reached: Gaines Station Library is still open every Saturday.

And just because it's a very small place, don't think Gaines hasn't had its share of celebrity sightings at the depot. Diane Nowak, one of the key individuals responsible for saving the station, recalls President Clinton coming though on a special train while campaigning for reelection in 1996. She and many others had gathered at the depot late that evening to watch the train—which didn't stop—rush by. "I actually saw the president run through the train," Nowak recalls. "He was putting on his suit coat to wave to people waiting at our depot. But he was too late—except for me."

When village government started making noises about tearing the station down in 1990, local preservationists sprang into action. By this point, the depot had passed into private hands. A nonprofit group was formed—originally called Save Our Station, later Gaines Station, Inc.—which attempted to get the owner to sell for $1, but his price was $3,000, and the small group didn't have the money. A savior appeared in the form of Robert Kimble, who lived in Linden, about ten miles

Grass Lake

1887—Michigan Central Railroad
210 East Michigan Avenue

ARCHITECTS: Spier and Rohns
LAST PASSENGER SERVICE: 1956
CONDITION: Excellent
USE: Rental space for the nonprofit
Whistlestop Park Association

With the Michigan Central Railroad pushing through Jackson County in 1842, Grass Lake Center had high hopes the tracks would go right through the budding hamlet. Instead, the railroad bought property a mile and a half west, where land was going for $1.50 an acre, not the $2 it was in town. So that's where the line went and the first station was built, and Grass Lake Center was left high and dry. Over the years virtually the entire village migrated west to what would come to be known as just Grass Lake—yet another town whose location was determined by the magnetic pull of the steel rails.

In many respects, Grass Lake won the depot lottery. Not only is the turreted 1887 Richardsonian Romanesque station by the Detroit firm Spier and Rohns impressively handsome, the fieldstone structure is also located right in the heart of the village—and so becomes a defining element in the look of Grass Lake's two-block, turn-of-the-century downtown.

Some might be surprised that such a tiny place got such an elegant station. One explanation might be the simple fact that the Michigan Central, responding to complaints in the late 1800s about tired, dowdy stations, rebuilt most of them along its main road to Chicago in a fashion to impress the traveling public—even those whipping by at express speeds.

But another explanation may be that someone simply messed up. After construction, or so the story goes, a group of Michigan Central officials was passing the station when one shouted for the train to stop and back up so he could get a better look. The fellow took out some blueprints, scanned them intently, and finally exclaimed, "My gosh—they built this depot in the wrong place!"

A small stained-glass dormer window peaks up above the roofline on Grass Lake's old Michigan Central station, one of many grace notes from a thorough renovation that wound up in 1992—just in time for the depot's 105th birthday.

Grass Lake, just east of Jackson, is another village—rather like Three Oaks or Dexter—that lucked into a remarkably classy depot. The Detroit firm Spier and Rohns, with its deft touch for Richardsonian Romanesque treatments, pulled together a remarkably satisfying composition crowned by a distinctive rounded corner and turret.

Opposite: Amtrak's early-evening Wolverine races from Ann Arbor to Jackson, en route to Chicago.

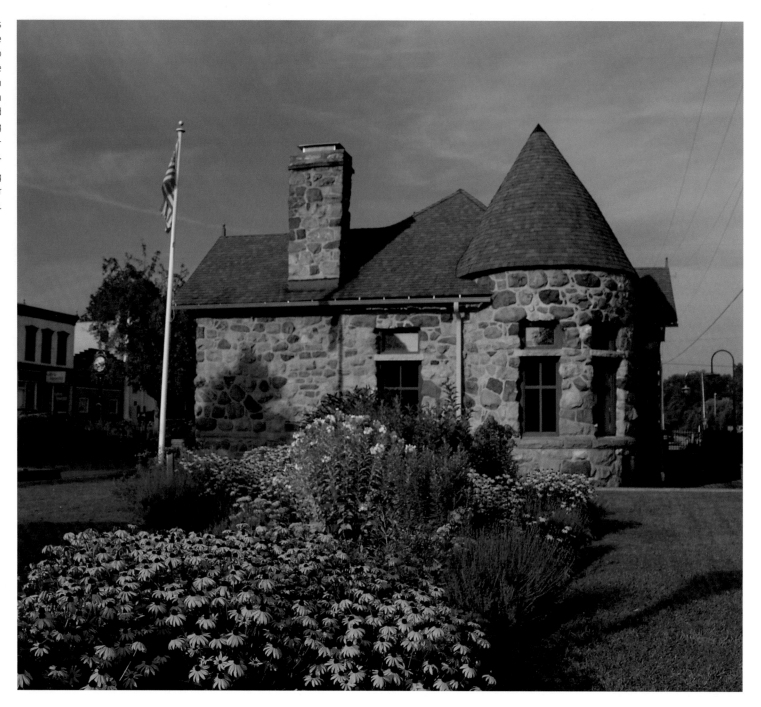

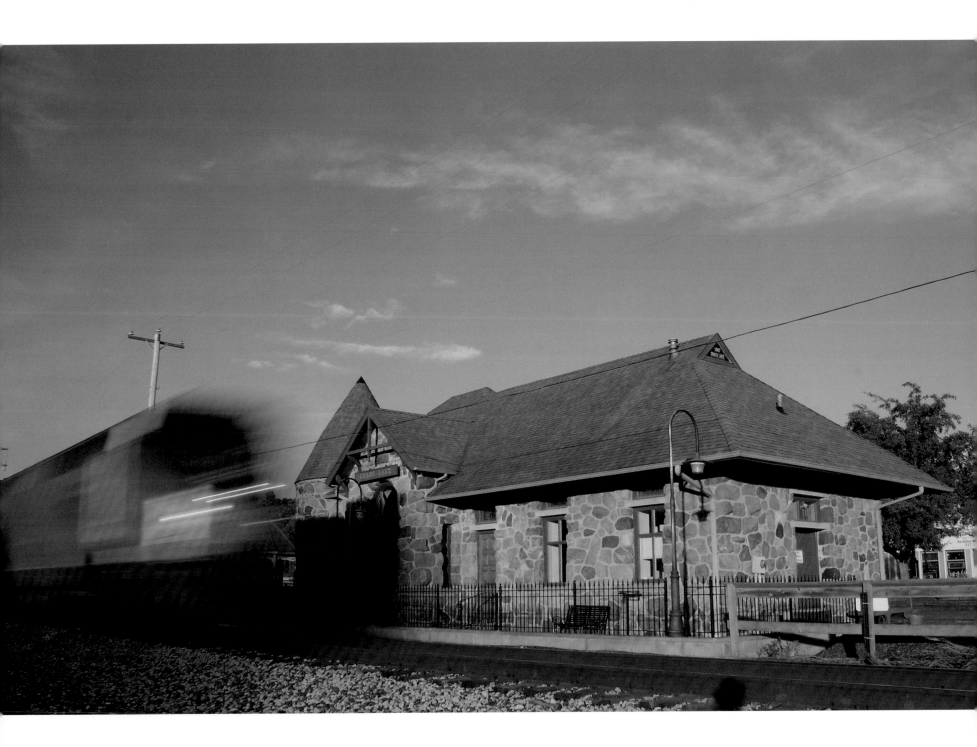

In any case, Grass Lake ended up with a station every bit as handsome as Michigan Central stations in bigger places like Ann Arbor, Niles, and Dowagiac—all Spier and Rohns designs, by the way. Yet despite Grass Lake's fashionable depot, the village's relative insignificance was underlined by the steady drop in service—seven trains a day in 1911, three in 1933, two in 1947, and finally just one in 1953.

Years before that long, slow decline set in, one young man made a rash decision on a "fast train" with dire consequences—a foolhardy act surprisingly common in the early part of the twentieth century, to judge by newspaper accounts. The lad—never identified by age in the papers, but by the sound of it a teenager—leapt out of a moving train. Ed Thompson and his brother had gone on the 1901 Jackson County Sunday School excursion to Detroit, but got separated in the big city. Ed's brother caught the evening local back to Grass Lake. Ed missed it. A practical boy, he boarded a later express, intending to vault from the train near his home west of the Grass Lake station, leading to the next day's doleful headline in the *Detroit Free Press:* "Sad End of an Excursion: Brooklyn Boy Killed on the Railroad."

The last passenger train pulled out of Grass Lake in 1956. That same year, the New York Central—successor to the Michigan Central—put all its stations nationwide up for sale. Grass Lake's was offered for $5,000. There were no takers. The abandoned structure was finally acquired in 1962 by Robert and Bobby Mather, who ran their newspaper—the *News,* serving Grass Lake and Michigan Center—out of the venerable structure for fourteen years. In 1980 a suspicious fire torched the depot—arson has long been assumed, but never proved. For years, the burned-out hulk blighted Grass Lake's good-looking village center. Finally, in 1988 the building was acquired

by the nonprofit Whistlestop Park Association. The organization raised $250,000 and restored the building top to bottom over the next three years. Because the original stone walls had been weakened by the fire, a new, load-bearing structure was constructed just inside them. The stone is now merely ornamental. The magnificently rebuilt station was dedicated in September 1992. One of the distinguished guests at the ceremony was former resident Maritta Wolff, whose 1941 novel, *Whistle Stop,* was that year's literary sensation. Alas, while the plot is clearly set in a small town west of Detroit, much like Grass Lake, the depot Wolff describes in the book bears no resemblance to Grass Lake's small masterpiece.

Grass Lake came very close to losing the stone depot that helps give its appealing downtown part of its character. In 1980, the station suffered a near-death experience when a suspicious fire erupted and ripped through the building. A decade later, when the nonprofit Whistlestop Park Association started work on the ravaged structure, carpenters had to build new support walls within the weakened stone to hold things up. By the way, Grass Lake's design—or something very close to it—appears to have been the model for two other stone stations in the Lower Peninsula, Standish and Harrisville on Lake Huron.

Holly

1886—Detroit & Milwaukee, Flilnt &
Pere Marquette Railways
223 South Broad Street

ARCHITECT: George Mason
LAST PASSENGER SERVICE: Circa 1964
CONDITION: Poor
USE: Empty, undergoing renovation

This late-Victorian depot, a good-looking Italian villa built of orange brick trimmed out in buff-yellow, sits at the junction where the Detroit & Milwaukee Railway crossed the Flint & Pere Marquette tracks. You find it at the end of a short, dusty driveway some hundred feet off South Broad Street, in the heart of Holly's downtown. In its lack of pretensions—and perhaps because of the way the afternoon sun lights up the orange brick—this modest, cross-gabled structure makes a bigger impression than its constituent elements might suggest.

The sturdy station was built in 1886 by the Detroit and Milwaukee's chief architect, George Mason (not to be confused with the Detroit architect George D. Mason), two years after the town's Civil War–era depot burned down. The old station had been an object of scorn for years—"a mass of repairs and patches," according to the February 14, 1886, *Holly Advertiser.* So knowledgeable residents might have had their sus-

picions when it burst into flames one August night in 1884. Holly's fire department arrived promptly, the *Advertiser* notes on August 10, 1884, but "never before or since has it been so difficult to get a stream of water to play on the flames—each hydrant and each particular length of hose seemed either clogged or full of holes." Helpful citizens pulled what they could from the burning edifice, but after that "seemed to consider their duty performed, and stood about in groups watching the flames." The building was a total loss.

The new station must have seemed the height of luxury when it opened two years later in 1886, boasting a separate ladies' waiting room (with a Smith and Owen heater for winter) and a walnut-trimmed lunch counter run by "an experienced caterer," the *Advertiser* promised on February 14, "who will set out a clean palatable lunch, not an average railway 'liverpad' that is often worked off on the unsuspecting public."

Much like Gaines, Holly ended up with a good-looking cottage designed in the functional brick style that in Great Britain or Europe is alternately called "railroad style" or Italian villa, based in part on simple brick buildings in the Italian countryside. (Personal collection of Jacqueline Hoist and Ronald Campbell)

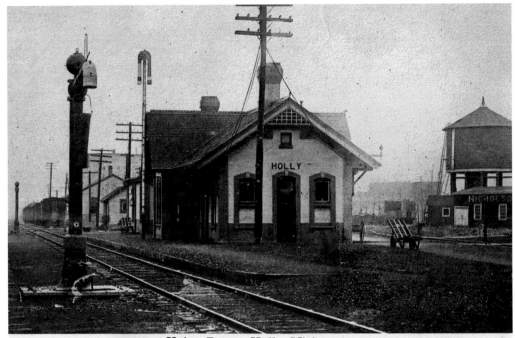

Union Depot, Holly, Mich.

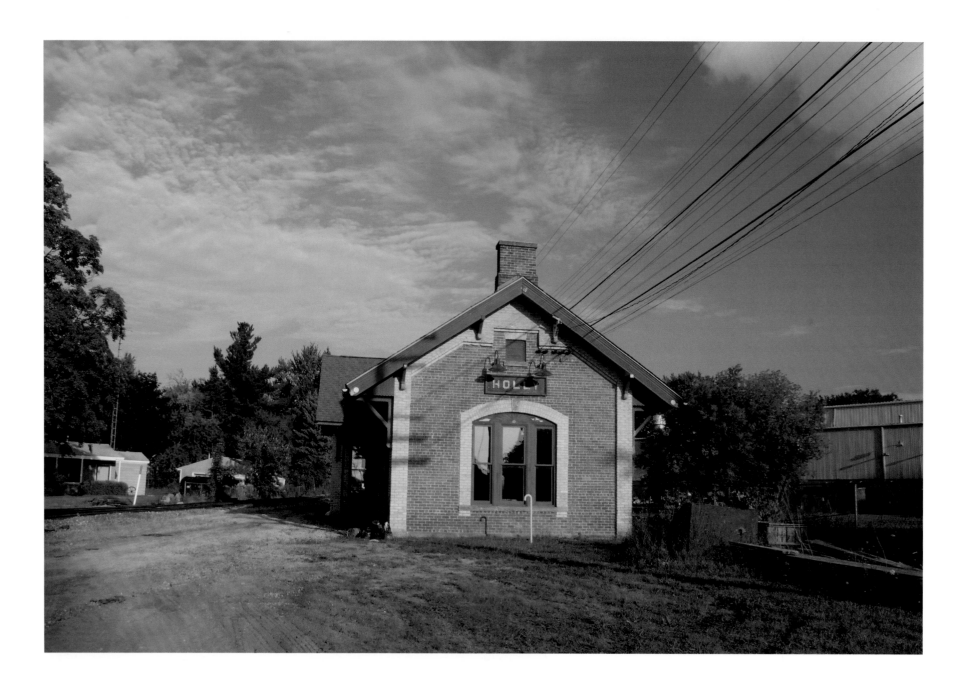

While there are plans to renovate the Holly station, its air of polite dilapidation lends the simple building an unexpected romance, at least in sunset light. While this is a simpler station than Gaines, it still boasts flourishes—like the decorative woodwork on the eaves (*below*).

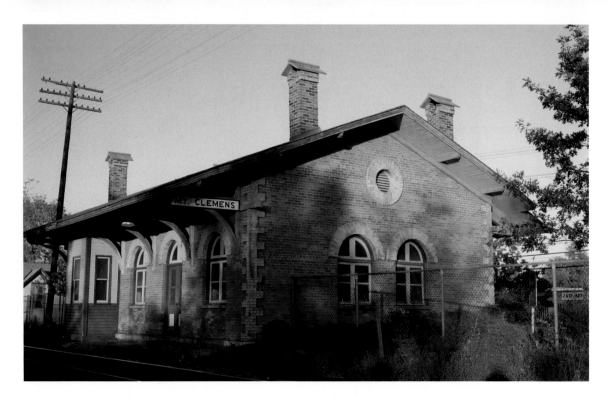

Another "railroad style" or Italian villa station that bears some resemblance to Holly's is Mt. Clemens—one of Michigan's oldest depots, built in the late 1850s. Note in particular the stationmaster's bay window at far left. The fact that it's wood on a brick building signals it was a later addition.

Holly's had its share of famous visitors, perhaps none more dramatic than Carrie A. Nation in 1908. The anti-drink firebrand stepped out of Holly Union Depot for a full day of attacking unsuspecting saloons like an avenging angel. The local head of the Women's Christian Temperance Union, Winifred Mott, had invited Nation to challenge the widespread existence of bars in a supposedly "dry" county. Nation's first stop? The Holly Hotel bar.

Once inside, Nation deployed her umbrella to good effect, sending liquor bottles flying. Enraged, the hotel owner threw her out, but far from chastened, Nation marched down Martha Street—now, appropriately, "Battle Alley"—smashing up every saloon she could find. After that, she trained her eyes on Michigan governor Fred Warner and the Oakland County sheriff, both of whom were to be campaigning in town the next day. Considering both hypocrites for not enforcing the county's dry status, Nation lost no time accosting the governor. "Fred Warner," Nation shouted, "how can you ask these people to vote for you when you are not upholding the law?" Warner executed a perfect political pirouette: "Better ask the sheriff about that," he said, and melted into the crowd. In 1973, Holly launched an annual summer festival in Nation's honor.

Holly lost regular passenger service about 1964. But while campaigning for reelection in 1992, President George H. W. Bush and wife, Barbara, came through town on a special train and stopped to eat lunch, unmolested, at the Holly Hotel. While the depot appears abandoned, covered with "No Trespassing" signs, its current owner—the City of Holly—has long-standing plans for renovation.

Iron Mountain

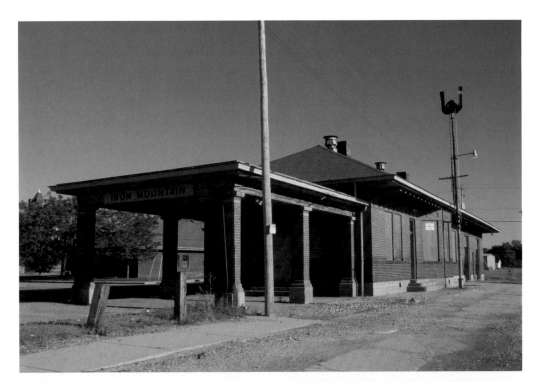

> 1914—Chicago, Milwaukee
> & St. Paul Railway
> West B Street at Carpenter Avenue
>
> ARCHITECT: Unknown
> LAST PASSENGER SERVICE: Circa 1955
> CONDITION: Poor
> USE: Railroad property, boarded up

*T*he great virtue of this utilitarian, brick building is its covered portico at the north end, an open-air platform with six solid, redbrick piers holding up the flat roof. It's a handsomely framed space to look through as well as an oddly formal footnote to an otherwise strictly functional building. This is not to say that this little depot, built in 1914 by the Chicago, Milwaukee & St. Paul Company (part of the Milwaukee Road), is without its charms. Brown brick rises from the foundation to the windowsills, turning red from there to the eaves. And the rounded steps leading up to at least a couple entrances have an unexpectedly Art Moderne, ocean-liner swoopiness to them.

In part because of the late-nineteenth-century mining boom, the Upper Peninsula ended up with a remarkable number of railroad lines, to say nothing of rail ferries from the Lower Peninsula. But as the mines went, so too did the railroad companies, which navigated a steep decline over the course of the twentieth century, with the loss of countless depots. Happily, one survivor is Iron Mountain's sturdy Chicago, Milwaukee & St. Paul station.

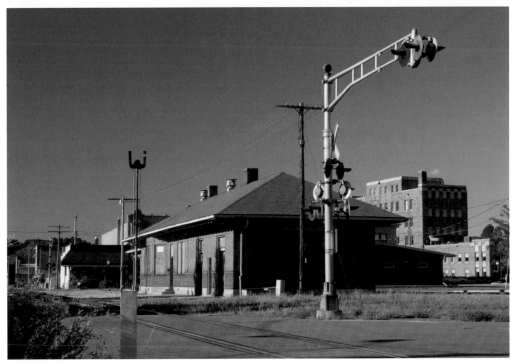

The Iron Mountain station is not, in fact, at the edge of a deep forest, never mind what those looming shadows suggest.

There don't seem to be any immediate prospects for reusing this Iron Mountain depot, though with its no-nonsense good looks one is tempted to say it'd make a fine school or public library.

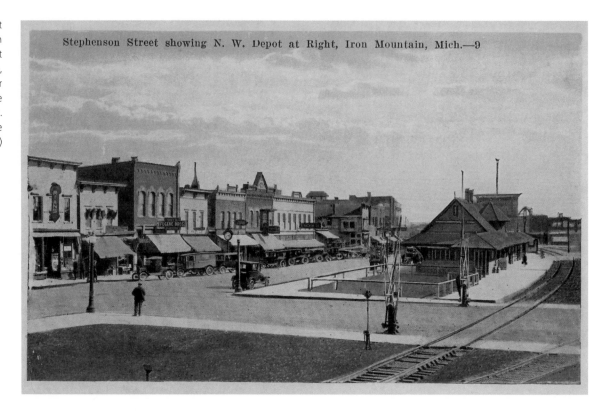

Stephenson Street showing N. W. Depot at Right, Iron Mountain, Mich.—9

Iron Mountain has seen its share of visits from the great and the good, including William Jennings Bryan, the Democrat who brought his 1896 presidential campaign here, as he seemed to do with virtually every other town in the state. Unfortunately, in Iron Mountain he arrived at the other station in town—owned by the Chicago & North Western Company. Lore has it that pro-McKinley forces on the railroad (William McKinley was the Republican candidate and ultimate winner) arranged it so that a train would pass by during Mr. Bryan's speech, drowning out the man known for fiery eloquence. There's no confirmation as to whether that actually happened. Surely anyone with a sense of humor would pray that it did.

The mining boom that poured wealth through Iron Mountain from about 1890 to 1925 was clearly on the skids by the 1930s. Happily, in 1923 Henry Ford had established a woodworking concern in nearby Kingsford—making wood trim and other wood products for cars—that ultimately employed seven thousand. One by-product was charcoal briquettes— "Ford Charcoal," as it was known. In the early 1950s, the business was spun off as the independent Kingsford Briquets, countless billions of which were shipped out on the town's two railways. Shipping out as well were Ford-manufactured military gliders also made in Kingsford, some of which were used to land troops at D-Day in the Second World War.

Jackson

1873—Michigan Central Railroad

501 East Michigan Avenue

ARCHITECT/BUILDER: Henry Gardiner

CONDITION: Excellent

USE: Amtrak station

One of the handsomest stations in Michigan—indeed, it's no stretch to say the nation—sits on the dusty western edge of the center of a once-great railroad town, Jackson. It was Jackson where the Michigan Central Railroad located its locomotive repair shops in the early 1870s, and in part because of that, the corporation decided in 1873 that the town deserved a glorious station, somewhat out of proportion to its population at the time.

That glory is bound up in a design of considerable elegance and simplicity. Jackson's depot, a union station that once serviced six different lines, is a one-story building with a two-story tower at each end. It is, in effect, an Italian villa—or, to be more precise, a palazzo in the Italianate style, confirmed by its tall, narrow windows, conspicuous eaves, and symmetrical outline. Of course, compared to anything European, this is a stripped-down palazzo in the American fashion—all business with just a few ornamental touches. But those include cast-iron columns on the platform, sandstone lintels, and sand-

stone window surrounds. Note, however, that the latter frame only the very tops of the windows—underlining once again this building's relative lack of fuss.

No architect per se had a hand in this. Henry Gardiner was master builder for the Michigan Central who spent most of his time constructing the vernacular, strictly functional sheds that dotted every great depot complex. This change of pace seems to have brought out the best in the man, who clearly had a gift.

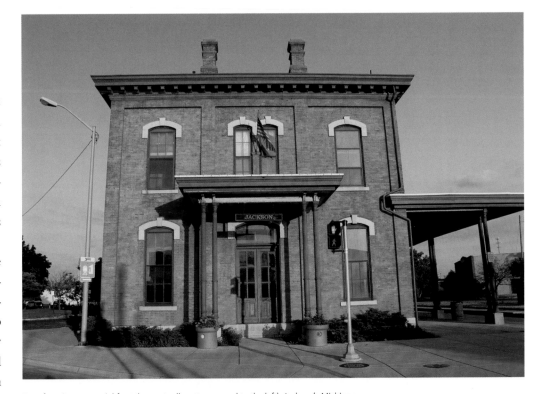

Seen from its ceremonial front (one actually enters around to the left), Jackson's Michigan Central depot might well be a spiffy little 1870s hotel. One of Michigan's most attractive stations, its design is distinguished by restraint, fine proportions, and an excellent choice in using twinned iron columns for the entry portico.

The interior, well maintained by Amtrak, is good looking and has been well restored. (More on that in a moment.) For decades the depot boasted a formal restaurant at the east end as well as space for wedding receptions, both long gone. To protect the gentle and the small in a rougher era, there were separate men's and women's waiting rooms, a custom that took hold with new depots nationwide after the Civil War. Throughout the interior, all was (and is) trimmed in gleaming ash, black walnut, and oak.

When it opened on Labor Day 1873 (or March 1874—the date is the object of some contention), the Jackson Michigan Central Railroad depot was said to be the finest on the line. But architectural fashions come and go—and once gone, they're generally held in contempt by the next generation. By 1905 newspapers were already calling the Italianate station hopelessly out of date and shabby, pointing enviously to the new Richardsonian Romanesque depot the Michigan Central

Railroad built at Kalamazoo and calling for the demolition of Jackson's station. We can only be grateful that such pinhead-edness—so often deployed in the name of "progress"—didn't get its way.

Just before the depot's grand opening, the *Jackson Weekly Citizen* paid a visit and pronounced the structure "much more imposing and attractive [in] appearance than was at first supposed possible, and notwithstanding it is but one story high for the most of its length, the architectural effect is very pleasing."

As befits a great depot, Jackson's Union Station has had its share of intriguing visitors and momentous events. In 1878 William H. Vanderbilt, president of the mighty New York Central Railroad, paid a visit to the Michigan Central shops east of the depot. Vanderbilt had inherited the New York Central the year before from his father, "Commodore" Cornelius Vanderbilt, and the Michigan Central was a small part of that empire. En route from Detroit to Jackson, the younger Vanderbilt and several male relatives—all millionaires and top New York Central execs—dined on an exquisite breakfast prepared by Vanderbilt's Ethiopian French chef. The meal was served on fine china with a Renaissance pattern, according to a breathless *Detroit Free Press* reporter whom the grandees let tag along as an observer. (He was not invited to eat.) Once at the Jackson shops, the New Yorkers were struck by the industry of the toil within, and perhaps also by the imposing brick and glass shed that housed them. (It burned in 1976.) "Beautiful, beautiful," the elderly Captain Jacob Vanderbilt reportedly said. "Didn't think 'twas possible to find such a place out West."

Other significant rail visitors included President William McKinley in 1899 and former president Grover Cleveland, who passed through in 1900. Candidate Dwight D. Eisenhower

Jackson is an Amtrak stop on the Detroit-to-Chicago road—a happy example of a spectacular depot still used for its original purpose. In design, it's a long, symmetrical building with identical, two-story towers at each end (*opposite*). Like Durand, Jackson was a key railroad town for decades. The undated historic postcard below gives some sense of the congestion and bustle that used to surround the depot. (Personal collection of Jacqueline Hoist and Ronald Campbell)

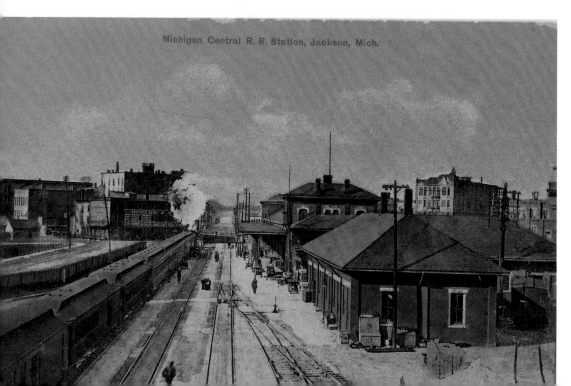

Michigan Central R. R. Station, Jackson, Mich.

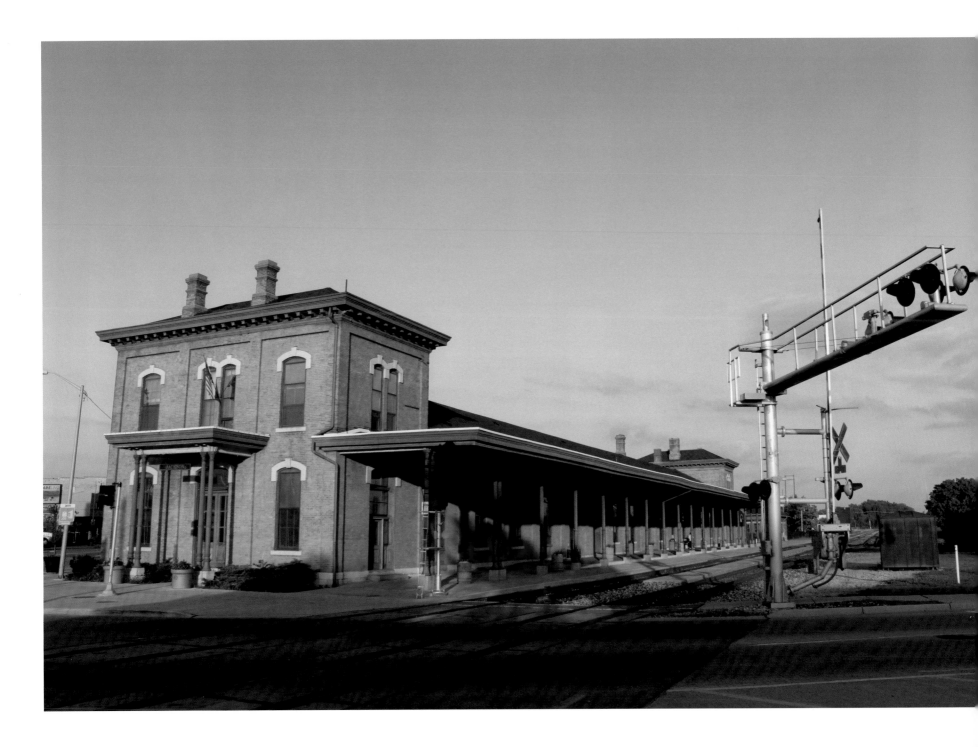

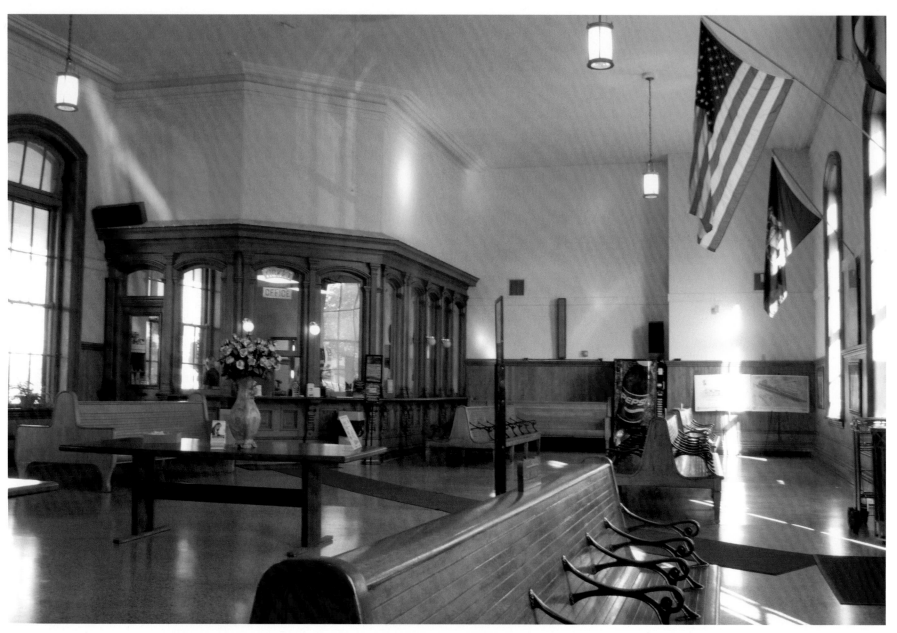

When Amtrak announced in 1978 that it would renovate the Jackson station and paint the interior red, white, and blue, Jackson County Geneaological Society stalwart Genevieve Harvey went into overdrive. With other preservationists, Harvey raised $10,000 and wrested an agreement from Amtrak that she could handle redoing the interior. Instead of slapping yet more paint on long-suffering woodwork (at the time, reportedly an unfortunate sea-foam green), Harvey restored the 1873 depot interior to its original grace and simplicity.

A fire escape in early-morning light casts a mesmerizing shadow on the Jackson depot's east tower.

stopped in 1952 to give his stump speech. Wife Mamie had initially planned to stay on board, but seeing the vast crowds, decided she should put in an appearance with her husband. While Eisenhower spoke under the oaks, engineers turned the train around. The party had come in from the west, but was headed next to Grand Rapids. Two presidential elections later, candidate John F. Kennedy came to Jackson in 1960, but not via the train. He did, however, speak near the depot.

In 1898 the Jackson station was the staging point for a spirited farewell to Companies D and H of the First Michigan Infantry, off to fight the Spanish-American War. Veterans of the Grand Army of the Republic and the Jackson Elks, some 250 strong, escorted the soldiers to the station the morning after they'd treated them to a feast complete with dancing into the wee hours. Perhaps it was the prospect of a war easily won, in stark contrast to the Civil War, that drew exultant crowds all across the state. In any case, that anticipation appeared to work on Michiganders like a tonic. Happy crowds mobbed departing troops in many railroad towns, a ritual widely reported in the newspapers. (By contrast, there were fewer reports of such popular manifestations at the start of World War I, and almost none when America entered World War II.)

You can't talk railroads at the turn of the twentieth century

without touching on labor unrest, of course. Jackson, because of the shops and the large number of men employed there—some twenty-four hundred by the 1920s—was a tinderbox of labor agitation. In 1877 National Guard troops were brought in to protect nonunion railway workers and were quartered right inside the depot. During a 1922 strike, a mob of about fifteen hundred—a considerable number of them women—stormed the locomotive and repair shops next to the depot at quitting time, swarming the streetcars as nonstrikers tried to board, harrying them with sticks, stones, eggs, and red pepper flung in the eyes. Police Chief John Hudson tried to disperse the crowds by riding his horse through, but for his pains, he was repeatedly struck "by flying missiles and eggs," according to news accounts.

There were a couple dreadful crashes in the early years. Eighteen people were killed in 1879 when a speeding Pacific Express slammed into a poky switch engine (used to push other trains around the yards) in dense fog at 1:20 a.m. Fourteen years later, a similar catastrophe played out right in the station. An 1893 excursion train bound for the world's fair in Chicago unexpectedly caught up to the excursion train that had preceded it. (The latter had initially been a good forty-five minutes ahead.) Still, disaster might have been averted had the air brakes on the speeding train not failed. Thirteen people died. The date was Friday the 13th.

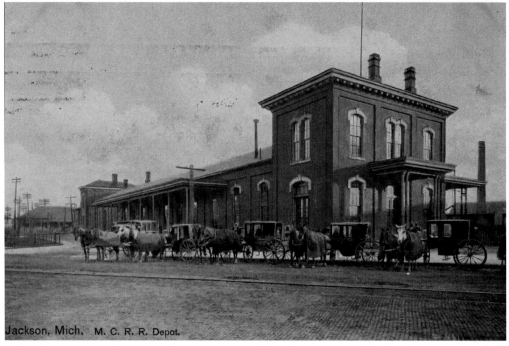

Jackson, Mich. M. C. R. R. Depot.

According to local historian Ed Rutkowski, Jackson may have the oldest continually operating depot designed for that purpose in the United States. In any case, like many stations, Jackson's has seen its share of social upheaval. In 1877, National Guard troops were brought in to quell labor strife, and quartered right in the depot. There have also been a couple nasty train wrecks, including one in 1879 (eighteen dead) and another in 1893 (thirteen). Every bit as dismal, on New Year's Eve 1978, an embittered former railroad employee with a shotgun burst into the station's staff room and killed two firemen and one conductor. (*Bottom left:* Personal collection of Jacqueline Hoist and Ronald Campbell)

In the modern era, tragedy struck on New Year's Eve 1978, when a former Penn Central employee burst into the crew quarters at the east end of the depot and twice unloaded his shotgun—killing fireman Robert Blake and conductor William Gulak. Wheeling back out onto the platform, the assailant, Rudy Bladel, shot and killed fireman Charles Burton, who was just getting to work.

The backstory is that Bladel had lost his seniority and then his job when Michigan trainmen were brought down to Indiana years before. For fifteen years he was obsessed with the idea that Michigan men were stealing Indiana jobs.

Two of the families of the dead men sued Conrail in a case that went all the way to the Michigan Supreme Court, arguing that the freight company had adequate reason to be concerned about Bladel, who had been connected to—but never charged with—four other rail-worker murders over the previous fifteen years. Serving time on a weapons charge in the mid-1970s, Bladel walked out of prison just six weeks before the 1978 massacre at the depot. Shortly after his release, a Conrail officer in Jackson noted in a report that "Rudy Bladel is back in town," according to court documents, and that he was still mad at anyone connected to the railroad.

Bladel was convicted of first-degree murder and sentenced to three concurrent life sentences, but his conviction was thrown out on a technicality by the Michigan Supreme Court. The defendant had asked for counsel several times after his arrest, but no lawyer was present to advise him when two officers took his confession. He was retried in 1987 and again sentenced to three consecutive life sentences, which this time stuck. Bladel died of cancer in prison in 2006.

It was in 1978 as well that Amtrak announced it would renovate the station, ultimately sinking $192,000 into the effort. Interior plans called for drop ceilings and painting the woodwork red, white, and blue. That was all Jackson County Genealogical Society member Genevieve Harvey needed to hear. In short order, Harvey raised $10,000 to take the interior restoration out of Amtrak's hands. The railroad consented, and Harvey organized a meticulous renovation that uncovered all the wood detailing, hidden for decades by sea-foam green paint, and ripped out walls added in the decades after the depot's construction. The result is an Amtrak station with a remarkably handsome waiting room and ticket office. The judgment of the *Jackson Daily Citizen* after its sneak peek in 1873 is as true now as it was then—Jackson has no cause to "hang her head in shame at the meagerness of her depot accommodations."

Kalamazoo

1887—Michigan Central Railroad
459 North Burdick Street
ARCHITECT: Cyrus L. W. Eidlitz
CONDITION: Excellent
USE: Amtrak station

Simply put, Kalamazoo—like its neighbor Jackson—won the depot lottery. This 1887 red and pink sandstone Romanesque station with its multipeaked roofline is a honey of a building—fun to look at, warm and inviting, and a striking civic monument. It's the sharp contrast between the red and pink stone that pushes this Romanesque structure in a Victorian, not Richardsonian, direction. (The style's namesake, H. H. Richardson of Boston, rarely worked with bright color. And Kalamazoo is bright.) The design is by New York architect Cyrus L. Eidlitz, who's probably best known for the old New York Times building, the little triangular skyscraper that holds the Times Square countdown clock on New Year's Eve. In Kalamazoo, it would appear that Eidlitz just wanted to have fun. From the commanding semicircular arches at the main entrance, ponderously edged in enormous pink sandstone blocks, to the steep, red-tiled roof, this is a building with character and style. The overall look is Romanesque, but some of the detailing, particularly the green woodwork above the main entry arch, is Stick style—an interesting blending of two of the most popular architectural styles of the 1880s.

Kalamazoo has long been a must-do stop for presidents and aspiring presidents alike. Teddy Roosevelt blew through briefly while he was still governor of New York State, and both Dwight D. Eisenhower and running mate Richard M. Nixon visited in 1952—in the former's case, probably shortly

No other Michigan station plays with color and texture as enthusiastically as the Michigan Central's 1887 Kalamazoo station—a striking monument in a significant railroad town. Cyrus L. W. Eidlitz was the architect, best known for the old New York Times building—the one where the ball drops on New Year's Eve. Eidliz also built Chicago's Dearborn Station with its spectacular brick tower, now a part of the Printer's Row redevelopment. With Kalamazoo, Eidlitz mixed the rounded arches and overall "heaviness" of the Romanesque with unexpected Stick style detailing that lightens the whole mood. Throughout, the architect exults in the visual tension set up by the smooth red brick and rough-cut pink sandstone.

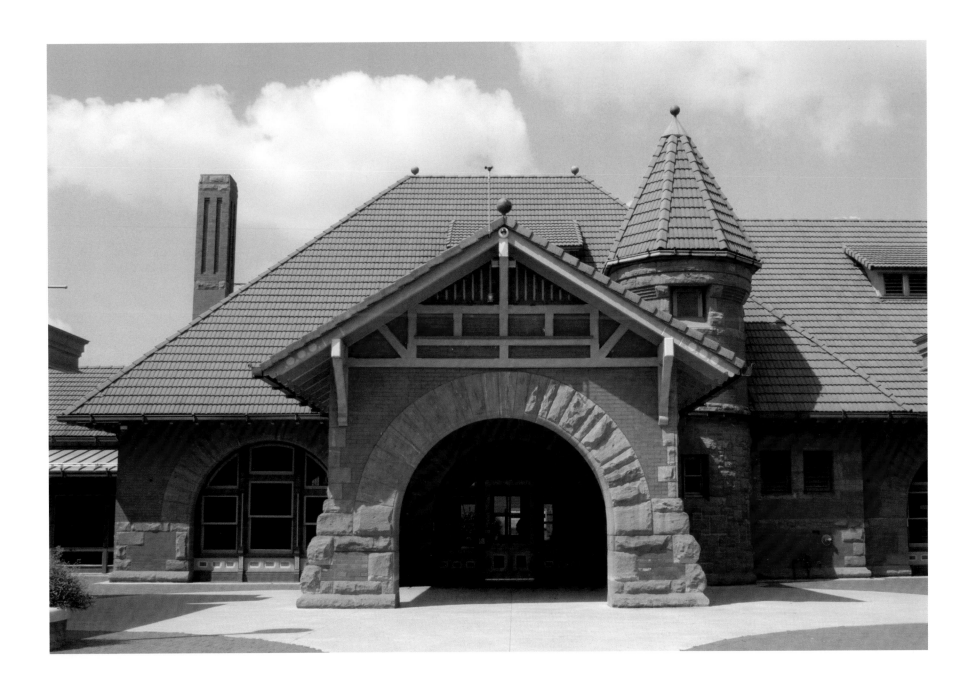

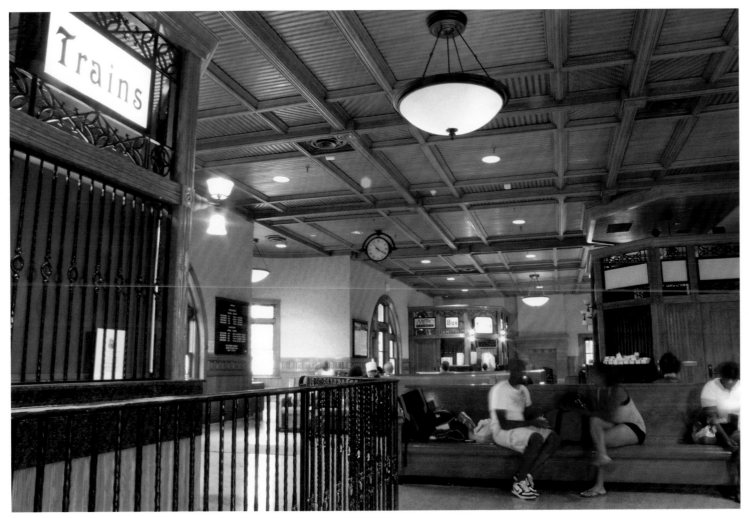

Like many old Michigan stations, Kalamazoo's Michigan Central depot—now an Amtrak stop—had suffered a raft of "improvements" over the years. But in 2006, the depot underwent a top-to-bottom renovation. Architect Brendon Pollard at Kalamazoo's Kingscott Associates had one aim in mind—restoring the venerable building to as close to the original design as possible. This meant clearing out interior clutter and restoring the ticket booth and waiting room with its magnificent coffered ceiling, as well as replacing deteriorated sections of exterior sandstone detailing. The original Portage Creek sandstone came from the Upper Peninsula, but that is no longer quarried. Happily, Pollard was able to find a near twin in Utah sandstone with similar blond veining that did the trick.

Kalamazoo is unusual in that it's done the sensible thing—locating its bus station right at the depot, for ease in switching from one form of mass transit to another. Purists might grumble that the modern bus sheds flanking the station's main entrance are inappropriate and, more to the point, partly block the view of the depot. That overlooks the elegance of their design and the lengths that the architects went to mimic the old station's Romanesque arches, setting them up in excellent repetition (*opposite*). The arches aren't sandstone but a concrete artfully colored and textured to resemble the real thing. Seen from West Kalamazoo Avenue (*this page*), the canopies and depot entrance frame one of the city's most-impressive public spaces.

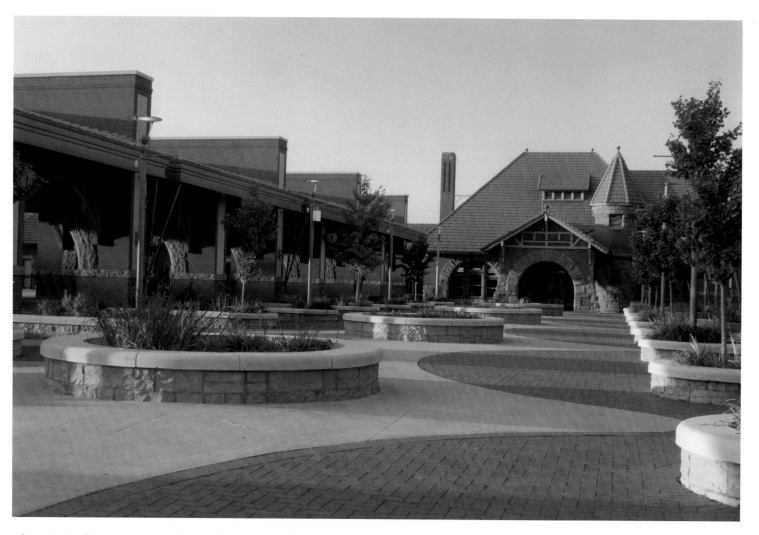

after giving his stump speech at Jackson. Presidential candidate Nixon also campaigned here in 1960, speaking to a crowd estimated at ten thousand from the back of an observation car at the depot.

But it was President William Howard Taft—the first sitting president to visit Kalamazoo—who really did the town proud.

On September 21, 1911, "Big Bill" laid the cornerstone of the new YMCA and visited Western Michigan Normal, Nazareth College, and Kalamazoo College. He rode back downtown in the elegant Pierce Arrow owned by Alfred B. Connable, a Republican later elected mayor. To majestically light the way for these potentates, residents up and down their route organized,

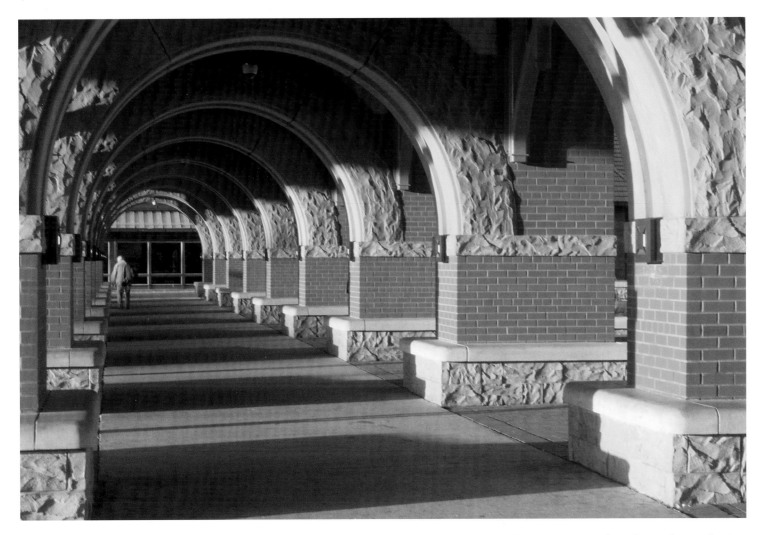

parking their cars at the ends of their driveways so that their headlights flooded the street. Taft wound up his day at the grand opening of the New Burdick Hotel, where he declared Kalamazoo "one of the nation's most progressive towns" and its denizens "some of the nation's most progressive citizens," according to the *Kalamazoo Gazette*.

Perhaps it was that reputation that drew deposed King Paul of Greece and the ailing Queen Frederika to stop on their way to Chicago in 1953. For reasons a little hard to pinpoint, a town without a huge Greek population nonetheless turned out three thousand enthused citizens to welcome the royals. King Paul spoke to the crowd on the platform, although the

crowd's disappointment at the queen's absence was palpable. (She had the flu, the king explained.) Police had to hold back the throngs as Mayor Glenn S. Allen Jr. and his wife arrived to extend the official welcome—which the mayor did in practiced Greek. A voice in the crowd shouted, "How do you like America, King?" to which the smiling ex-monarch responded, "Very much, indeed." None of the other passengers on the crack Twilight Limited to Chicago were even aware that they had a king, queen, and entourage on board with them before the king got out to speak in Kalamazoo.

Today the station is a fully functioning Amtrak stop, but the building is owned by the City of Kalamazoo, which has made the "Kalamazoo Transportation Center," landmark station included, a key element in its downtown development

plans. In 2006 the depot underwent a spectacular renovation, both inside and out, by Kingscott Associates. Extensive repairs were made on the sandstone exterior. Inside, you find an interior changed only gently from the original. The coffered ceiling is remarkable, as are the huge arched entryways, their doors framed by handsome windows all the way around.

Modern bus canopies in front of the station were built at the same time by Buffalo's Wendel Architects and Engineers—imaginatively designed structures that are both jarring and surprisingly appropriate. The common complaint is that they block the principal view of the old station—although for most of its history that view was interrupted by a building, now gone, between the depot and West Kalamazoo Avenue. One can imagine, in one's mind's eye, the station set at the far edge of a handsome open plaza. It's a nice picture—but one that has never existed. To its credit, Wendel's crisply designed canopies all share a central arch that mimics the great arch around the depot's entryway—built with pink concrete that's almost a perfect match with the sandstone detailing on the station itself. Stand at one end of the sheds, and you look through a telescoping series of identical arches—as satisfying an architectural experience as you could hope to get, and surprisingly elegant for a bus station.

The "other" station in town was Kalamazoo's old Grand Rapids & Indiana depot. The platform and its columns are gone, but the building has been handsomely renovated into upscale office space—a considerable gift to a city justly proud of its railroad heritage. (Personal collection of Jacqueline Hoist and Ronald Campbell)

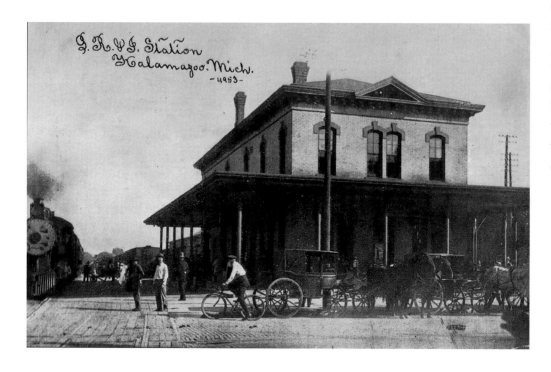

G. R. & I. Station
Kalamazoo. Mich.
-4953-

Lake Odessa

1888—Detroit, Lansing &
Northern Railroad
1117 Emerson Street

ARCHITECT: Claire Allen

LAST PASSENGER SERVICE: 1971

CONDITION: Excellent

USE: Lake Odessa Area Historical Society

*M*ichigan's most idiosyncratic depot sits in tiny Lake Odessa, population 2,206 in the last census. This remarkable Stick style confection with the Russian-inflected tower was built in 1888 by Claire Allen, a prolific Ionia architect who also designed county courthouses across western Michigan, including ones in Ionia, Jackson, and Gratiot counties. Perhaps more famously, Allen was the architect behind most of the village of Chelsea's remarkable buildings—the Victorian Clock Tower Building and the Welfare Building, to name just two (but not its marvelous depot).

You can read the depot's Stick style characteristics in the pronounced framing around doors and windows. With its wide, sloping eaves, the hip roof, however, has a vernacular-Hawaiian lilt. And then there's the folly that makes the station so likable in the first place—the octagonal Victorian tower with its quasi–onion dome roof, the pinnacle topped by a large gold ball. The station is painted a delicate pastel green

with butter-colored trim, and is as frankly beguiling as any you'll find.

Intriguingly, the station preceded the town. Ionia investor Humphrey R. Wagar bought and platted land for a settlement, and then contracted Claire Allen to build him a showpiece so people would think the unbuilt town was a place with real prospects. To that end, Allen also designed the new town's high school (now gone) in similar style. Seeing the writing on the wall, the residents of the nearby hamlet of Bonanza ended up moving, lock, stock, and barrel, to be closer to the railroad. Thus was Lake Odessa born.

The parade of the great and famous through Lake Odessa starts with Admiral George Dewey, who spoke there in 1898. President Truman followed in the late 1940s, but he did not

In the idiosyncratic-depot department, Lake Odessa, southwest of Lansing, takes top honors. While there are a few other offbeat stations scattered across the state—Battle Creek's Grand Trunk depot comes to mind—none quite reaches the whimsy Lake Odessa carries off so effortlessly. (Personal collection of Jacqueline Hoist and Ronald Campbell)

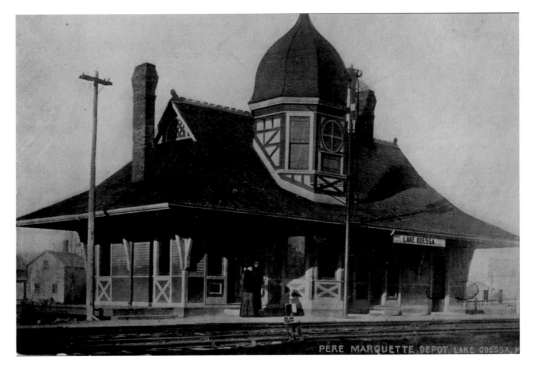

PERE MARQUETTE DEPOT, LAKE ODESSA, M

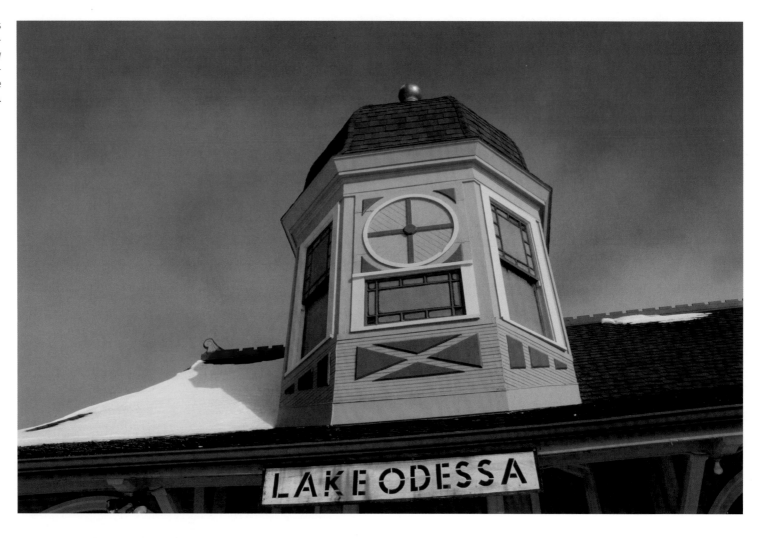

The octagonal tower and its tapered roof—not quite a Russian onion dome, but clearly meant to gesture in that direction—play on the Russian theme suggested by the town's name.

LAKE ODESSA

stop. (According to local historian John Waite, the newspaper's puckish headline the next day, above a photo of a speeding train, was "President Truman Comes through Lake Odessa.") Also passing but not stopping were Presidents Theodore Roosevelt and John F. Kennedy, the latter campaigning for a second term in 1963, not so many months before his assassination.

Perhaps the most celebrated incident in the vicinity, however, was the near-tragic case of little Naomi Cooley, a little girl whose family home in 1904 was only yards from the tracks. On August 20 of that year, the child—who seems to have been three or four—pushed her baby doll's carriage onto the track and then froze, apparently mesmerized by the train barreling in her direction. Inside the locomotive, the engineer and fire-

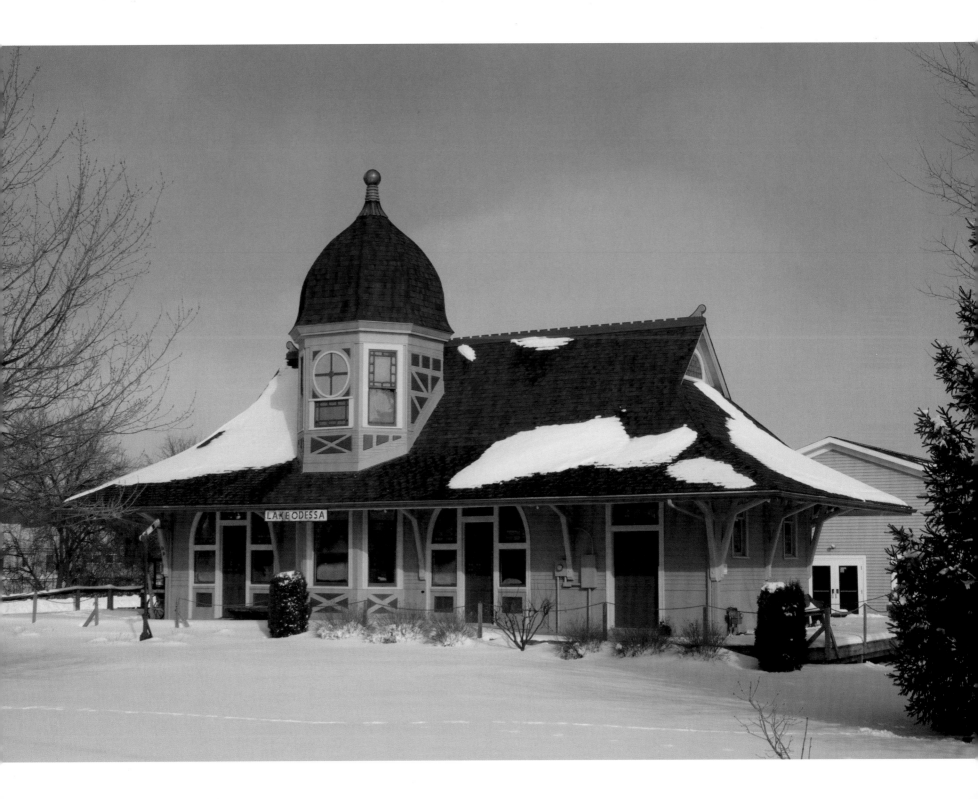

man initially thought the black spot far ahead was a dog. A couple seconds later they made out the blond, curly head. The whistle blared, loud and urgent. Engineer George P. Gossett later told a church newspaper, the *Watchword,* that he tried every trick in the book to slow that train down—slamming it in reverse and braking for all he was worth. "But I had a heavy train," he said, "and going down the grade the cars would chuck me ahead in spite of myself."

The engineer bellowed and his fireman crawled through the window out onto the cowcatcher at the head of the locomotive. There he found the brakeman, who was, the paper noted, accustomed to riding "in that perilous position." Both fireman and brakeman leaned out and down in the same direction, as close to the rushing, murderous rails as they could without tumbling off. Brakeman Leonard Green, arm outstretched, grabbed Naomi before the train struck her, his purchase strong enough to swing her up onto the cowcatcher, where she reportedly wrapped tiny arms around his neck and wouldn't let go. Of all the men involved, the engineer up in the cab probably had the worst of it, since he couldn't see either man once they were on the cowcatcher, and for several minutes had no idea whether the train had crushed the child—and perhaps also the two valiant men trying to save her. The *Watchword* reported that the child's father was in town the next day attempting to pay Naomi's rescuers, but they wouldn't take a dime. All they wanted, each said, was a picture of the child to remember her by.

The last passenger train passed through town in 1971. Thereafter, the Chesapeake and Ohio used the building for storage. The Lake Odessa Area Historical Society tried for years to acquire the landmark, but the railroad insisted they'd have to spring for a replacement building—with air-condi-

tioning, no less. But once the company was taken over by the CSX Corporation, the new owners told the historical society it was free to take the building and do what it liked.

In 1988, one hundred years after its construction, the depot was raised up on moving equipment, turned around 180 degrees, and then slowly hauled to its new home in a municipal park. The society has worked to restore the building, and maintains a historical museum within.

Despite the name, Lake Odessa has no Russian connection. The town is named for the jurisdiction in which it sits, Odessa Township. The township was established in the 1830s, about fifty years before the station and town. One of the early pioneers' wives was a woman "fond of Russian nomenclature," says Lake Odessa Area Historical Society member Elaine Garlock, hence the Russian name. Once located between Fourth and Fifth Avenues, the wooden station was given to the historical society and moved a few blocks away in 1988, its centennial.

Lansing

1903—Grand Trunk Western Railway
1203 South Washington Avenue

ARCHITECTS: Spier and Rohns

LAST PASSENGER SERVICE: 1971

CONDITION: Poor

USE: Lansing Board of Water and Light

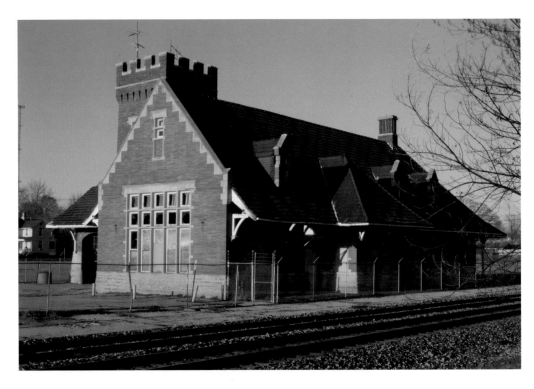

The British-owned Grand Trunk Western Railway opened its new Lansing station in January 1903—a compact, orange-brick English castle in the Tudor style—to nearly rapturous praise from the city's newspapers. "Nothing in Michigan can compare with it," declared the *Lansing State Republican* on January 3, 1903, "for richness of material, completeness of detail and effective decoration." And in the boilerplate that always seemed to accompany the introduction of any new depot involving considerable investment (this one ran the Grand Trunk $40,000), railroad officials assured everyone that while they had larger stations along their route from Portland, Maine, to Montreal and Chicago, none was handsomer. Interestingly, the impetus for building the station at this particular site was the announcement in 1902 of plans by Lansing auto magnate Ransom E. Olds to build a new factory directly across the tracks.

Lansing's Grand Trunk depot is another small masterpiece by the Detroit firm of Spier and Rohns, who designed far more

Michigan stations than anyone else. Other Spier and Rohns commissions include the Michigan Central depots at Niles, Grass Lake, and Ann Arbor (now the Gandy Dancer restaurant)—each and every one gorgeous. But they were all built in varying hues of Richardsonian Romanesque, so popular in the last few decades of the nineteenth century. Only two Spier and Rohns stations involved a style switch to Tudor Revival (sometimes called Jacobethan Revival, a term uniting the style associated with Elizabeth I with that of her successor, James I). Spier and Rohns's other Tudor station is the dramatic gray-brick depot at Dowagiac that's still in use as an unstaffed Amtrak stop. The firm also built a Lutheran church on Detroit's West Grand Boulevard, now the Messiah Church, that's a near twin to the Lansing station.

Looking very much like a modest castle in Tudor Revival style, Lansing's Grand Trunk station—abandoned for years—suddenly has a bright future ahead of it. The Lansing Board of Water and Light acquired the building as part of a larger real-estate deal in 2011 and plans to renovate the venerable landmark into meeting space for their commissioners and community groups.

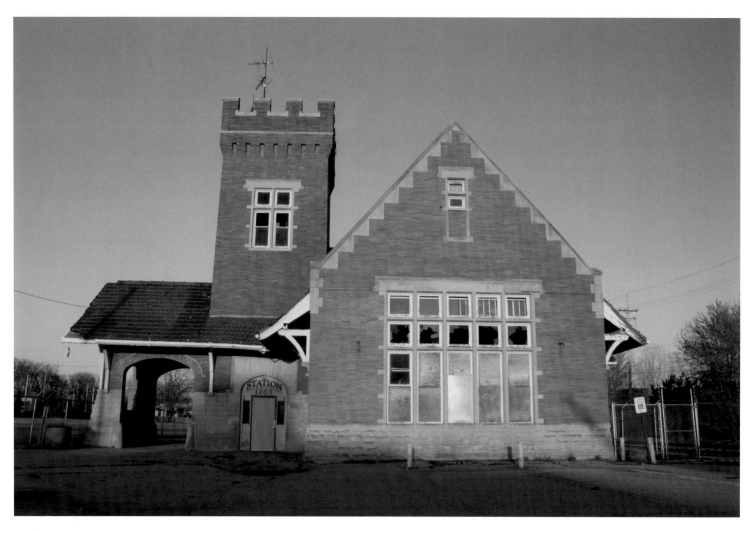

Defining elements of the station in Lansing's REO Town neighborhood include a four-story battlemented parapet from which it's easy to imagine seventeenth-century archers with crossbows aiming at peasants below. Perhaps the handsomest detail, however, is the vast square window on the central gable, comprised of twenty large panes—a severe, almost geometric treatment that's both classically Elizabethan and oddly modern.

The main waiting room was housed beneath a barrel-vault ceiling with dark oak support beams. At the east end was what the *Lansing State Republican* in the same article called a "magnificent fire place . . . set off by pillars." The ladies'

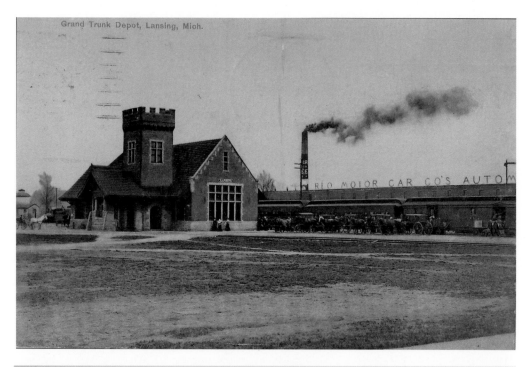

Grand Trunk Depot, Lansing, Mich.

waiting room contained "a lounge of leather" and comfortable rocking chairs. A bench ran along the perimeter of the men's circular smoking room, with a circular group of seats in the center. "Elegant" electric lights were deployed throughout, while the waiting room's oak benches boasted cane seats.

Perhaps the most dramatic event in the station's entire 108-year history was a spectacular train wreck at 4:12 p.m. on October 7, 1941, that injured at least twelve and killed one unhappy newsboy. An eastbound Grand Trunk express freight train with fifty cars carrying cheese, apples, grapes, melons, butter, and meat was traveling about seventy miles per hour, according to witnesses, when a wheel on the eighteenth boxcar fractured. The crippled car jumped the tracks just short of the station, starting a chain reaction that caused its successors to jam up, accordion-style, in a great heap. Eventually, twenty-three cars left the tracks, including one that ripped through the southwest corner of the depot and several that crushed cars parked in the adjacent lot. The one fatality was James R. Smith, age thirteen, who was selling magazines to passengers waiting for the Maple Leaf express bound for Chicago, due just eight minutes after the freight derailed. Only the quickest action by Grand Trunk officials prevented the Maple Leaf from plunging into the chaos. Had the trains been

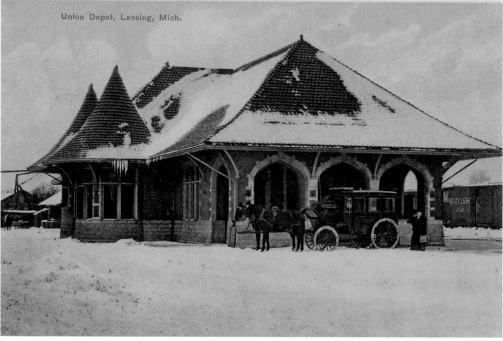

Union Depot, Lansing, Mich.

Ransom E. Olds's 1902 announcement that he'd build an REO Motor Car plant along the Grand Trunk tracks (*top left*) convinced the railroad that a passenger station on the other side might be a great investment. It made for an interesting juxtaposition—the stylish depot just yards from the factory belching smoke—perhaps a sign of different attitudes a hundred years ago about heavy industry. Like Battle Creek, Lansing is another town where Detroit architects Spier and Rohns enjoyed a monopoly, designing as well Lansing's Union Station (*bottom left*), which also opened in 1903. After passenger service stopped in the 1970s, Union Station was converted into Clara's Lansing Station, a restaurant that operates to this day. (Personal collection of Jacqueline Hoist and Ronald Campbell)

anything less than eight minutes apart, the loss of life could have been dizzying. Grand Trunk had two hundred men out under arc lights that night clearing the wreckage and relaying rails that had been ripped off their ties. Both freight and passenger service resumed the next day.

Grand Trunk ended its passenger service through Lansing in 1971. In 1972 the station—at the time described as well preserved—reopened as the Depot restaurant. Four years later, then president Gerald R. Ford dined at the Depot during a whistle-stop campaign for reelection. (He ordered the steak sandwich with mushrooms.) The restaurant went through a couple iterations, the last as the Capitol Hill Station Restaurant and Blues Club, which shows up in city directories as late as 2000. It's unclear when that business failed, but the remarkable Tudor Revival structure has clearly sat empty and abandoned for years, despite winning both state and federal historic designation. While a good-faith effort was made to seal the building, windows not covered by plywood have been shattered, leaving the elegant old building partly exposed to the elements.

Happily, this architectural Cinderella is about to be rescued by a most unlikely prince—the Lansing Board of Water and Light, which unintentionally acquired the depot when it bought property for a new gas cogeneration plant. The plant will be built a short distance from the station, which the board intends to renovate both for its own meetings and for use by neighborhood groups. Some are bound to worry about an industrial plant being built so close to a historic landmark. But it's useful to recall that for much of its history, the station sat right across the tracks from an auto plant. In the present instance, Water and Light submitted architectural drawings of the new facility for municipal approval. The good news is

that Water and Light has an unusually distinguished architectural track record. Its now-decommissioned Ottawa Street Power Station is one of Michigan's great Art Deco industrial landmarks and a defining element of Lansing's city center.

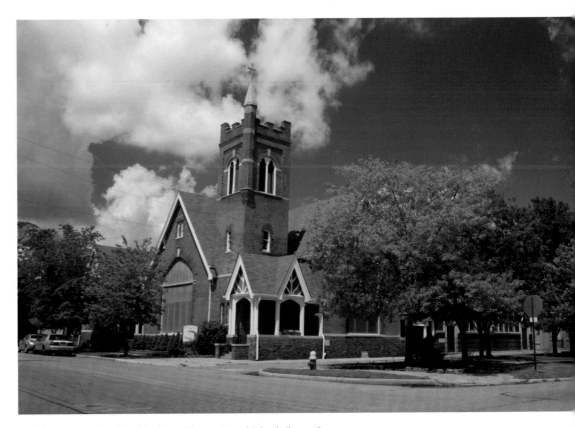

Aside from Lansing's Grand Trunk Station, architects Spier and Rohns built more Romanesque buildings than Tudor. Still, they knew they'd stumbled on something good. The depot they built in Dowagiac echoes Lansing's Tudor spirit, though it's built of gray brick, not orange. A stronger look-alike, however, can be found on Detroit's West Grand Boulevard where Spier and Rohns in 1902 designed a Lutheran Church in the battlemented Tudor fashion they would use the next year in Lansing. Messiah Church is undeniably handsome, its tower capped by a copper cross and its entry porch more English-cottage than English-fortress.

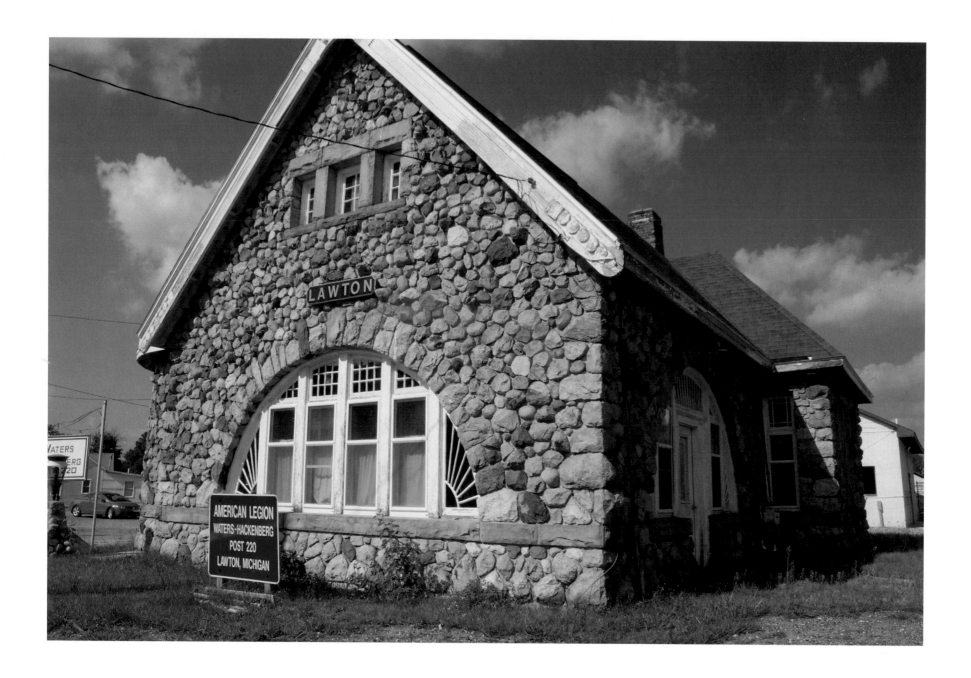

Lawton

1890—Michigan Central Railroad
404 North Main Street

ARCHITECT: Unknown

LAST PASSENGER SERVICE: 1968

CONDITION: Good

USE: American Legion Waters-
Hackenberg Post 220

*L*awton's depot, built in 1890 by the Michigan Central Railroad, marries Richardsonian Romanesque massing and heaviness with Queen Anne detailing for an exceedingly happy union. The building's weight, stone walls, and repeated use of arches point to the style refined by Boston's H. H. Richardson in the late nineteenth century, when it was all the rage. Heavy stone lintels and identical sills frame small square windows, or ribbons of windows, with a satisfying horizontal emphasis. But the delicacy of the Arts-and-Crafts woodwork within the window arches has little to do with

Arched windows star in this Richardsonian Romanesque fieldstone cottage (*opposite*) on the Detroit-to-Chicago Michigan Central line. The quarter-sunburst window (*top right*) has an almost Arts and Crafts quality—its delicacy a welcome contrast to the stone. It almost seems as if the carpenter, recognizing the relatively small role he'd play in a stone building, decided to make his details sing—from expressionistic windows to the milled circles at the eaves (*bottom right*). Lawton's use of uncut fieldstone is echoed in few Michigan stations. One of the only other examples is Suttons Bay, likewise built with whole stones.

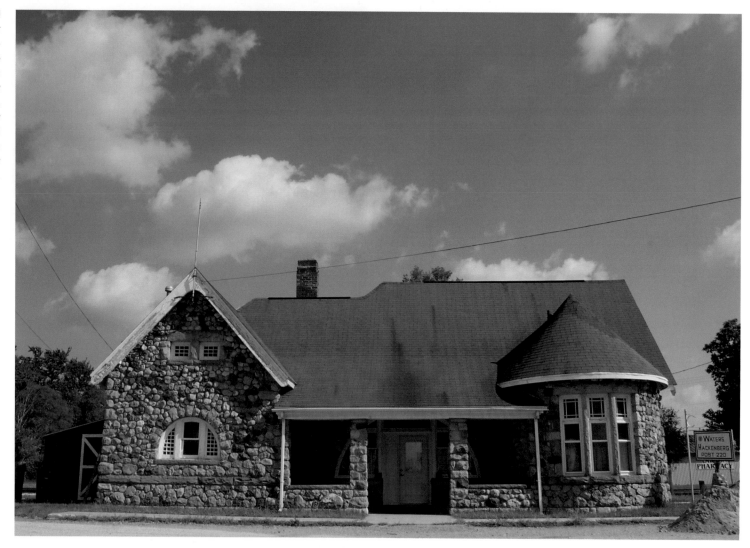

Lawton's front door may be shielded from the sun and rain, but other elements have to be more problematic. It's not hard to imagine the stationmaster cursing the design every time he had to shovel snow drifts out of the recessed porch. Charlevoix also had a recessed entry at first, famous for getting clogged in snowstorms. Despite being a good-looking design, the entryway was rebuilt to correct the problem.

Richardson, and as such, offers a refreshing visual contrast with the rest of the building. The most striking details are the quarter-moon windows flanking their double-hung cousins. The quarter moons are either filled with a grid of small square panes or, more impressively, a radiant sunburst pattern.

Lawton is deep in Michigan's grape belt, and when you step out on a late-summer night, locals say, the air is heavy with the scent of the fruit. In 1911 farmers shipped out 1,132 carloads of grapes—the equivalent of 4 million eight-pound baskets. To accommodate needs during the fruit-shipping

season, the Michigan Central maintained large icehouses at Lawton for their refrigerated cars. The small town also was something of a manufacturing hub, and many of the freights stopping at the station were hauling iron from Michigan City to be refined at the Michigan Central Iron Company in Lawton.

When famous figures came calling, they often slighted Lawton for its grander neighbor to the northeast, Kalamazoo. All the same, "cross of gold" firebrand William Jennings Bryan visited in the 1890s—probably in 1896, when the Democratic presidential contender campaigned at whistle-stops all across southern Michigan. Teddy Roosevelt also stopped to address crowds from the back of his observation car in 1912 while running for the Republican presidential nomination. (After losing to William Howard Taft, Roosevelt ran on the just-invented Bull Moose Party ticket and came in second in presidential balloting.)

The last time that Lawton appears on New York Central timetables is January 26, 1968, listed as just a "flag stop" (if there were passengers, the station agent would flag the passing train) for eastbound Nos. 366 and 50. No westbound service was listed. Later that year, the local branch of the American Legion bought the station for its post. Interestingly, had somebody not screwed up in 1890, the good Legionnaires would have been meeting on the other side of the tracks, site of the village's Railroad Park. That's where the Lawton depot was actually supposed to be built, before somebody misread the blueprints.

Even the smallest windows get the full-arch treatment (*top right*), complete with quarter-moon grids of little panes. Lake Odessa takes much the same approach, albeit wrapping the arched windows around a door, rather than other windows. It's remarkable that neither station saw its idiosyncratic arches punched out and filled in with inappropriate replacement windows. *Bottom right:* A traveler passing through gets right to the point on the postcard. (Personal collection of Jacqueline Hoist and Ronald Campbell)

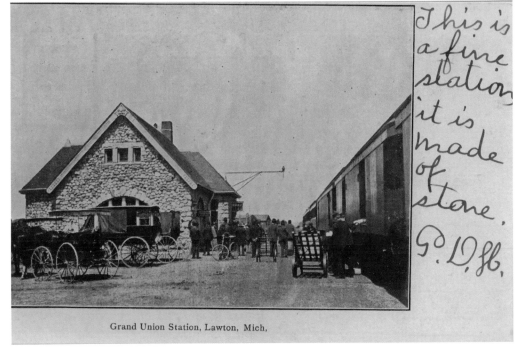

This is a fine station, it is made of stone. Go. D. Sb.

Grand Union Station, Lawton, Mich.

Mayville

1881—Port Huron & Northwestern Railway
2112 East Ohmer Road

ARCHITECT: Unknown
LAST PASSENGER SERVICE: Circa 1962
CONDITION: Excellent
USE: Mayville Area Museum of History
and Genealogy

For a modest board-and-batten structure, this little depot is a carpenter's love song, a memorably crafted architectural experience where you least expect it. (The minty Caribbean hue doesn't hurt, either.) From its swooping eave supports to the formal Italianate windows with their peaked woodwork frames, this is a winningly low-key building richly evocative of its time. Built in 1880 by the Port Huron & Northwestern Railway, it's one of the oldest stations still standing in Michigan. (The oldest was built in 1850 and is now a hair salon in Coldwater. Ypsilanti's 1864 station comes in second, while Jackson takes third place at 1873.)

For over a century it was apparently the custom to sign one's name on the walls of the old freight room at one end of the Mayville depot. One individual signed a most distinctive name in 1881—Jesse James. As it happens, the notorious

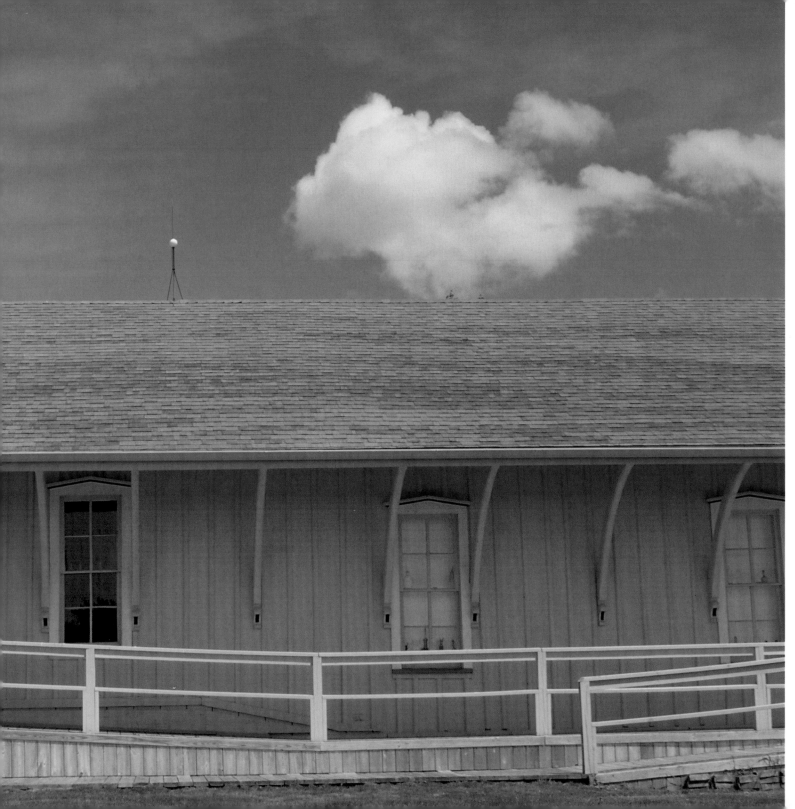

Sometimes the simplest buildings pack unexpected visual punch, like this shed with its graceful detailing that once served the Port Huron & Northwestern Railway before being moved a short distance from the train tracks to its present location.

bank robber wouldn't be assassinated until the next year (by a member of his own gang), so in theory, at least, the John Hancock could be the real deal. But Frank Franzel, president of the Mayville Area Museum of History and Genealogy, is skeptical. "I actually think it's somebody from this area with the same name," he said, "but it's interesting to see."

Mayville was the site of a 1903 train wreck that killed a baggageman and like as not left an indelible stain on the life and reputation of the conductor in charge—a reflection of the dangers inherent in a moment's negligence when dealing with thousands of tons of rushing iron and steel. William Beal was "generally recognized as one of the most careful conductors on the Pere Marquette system," the *Detroit Free Press* wrote on May 10. But an inquest determined that baggageman Gus Plager died because Beal failed to read the last of three orders handed to him when his eastbound train pulled into Mayville. The unread instructions were to hold the train at the station to let another one pass. When Beal failed to do that, he caused the ensuing collision and death. Plager's relatives, according to the paper, were planning to sue the Pere Marquette.

In 1985 Franzel bought the building for $100 from the grain-elevator company in town, which had been using the depot for storage. Franzel moved it a short distance to its present home. It is one of two buildings housing the Mayville Area Museum of History and Genealogy.

The power of repetition is abundantly clear in the parade of arching roof struts (*opposite*), with their delicate milled bases. Take away the struts—and the window frames with their formal little crowns (*top right*)—and you're left with a board-and-batten shed, nothing more, nothing less. But the addition of those low-key elements (and to be sure, the great paint job) lifts this 1881 depot into the realm of architecture, however modest. (The wheelchair ramp [*bottom right*] clearly came later.) For all its charm, however, as with many small-town stations across the state, passengers looking to board at Mayville would have had to jostle for space with piles of freight—and, as was the case with Suttons Bay, probably took a back seat to the more pressing demands of commerce.

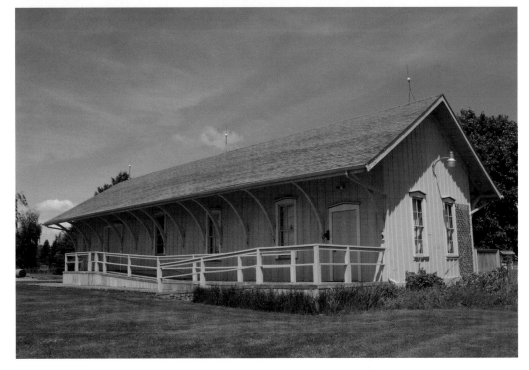

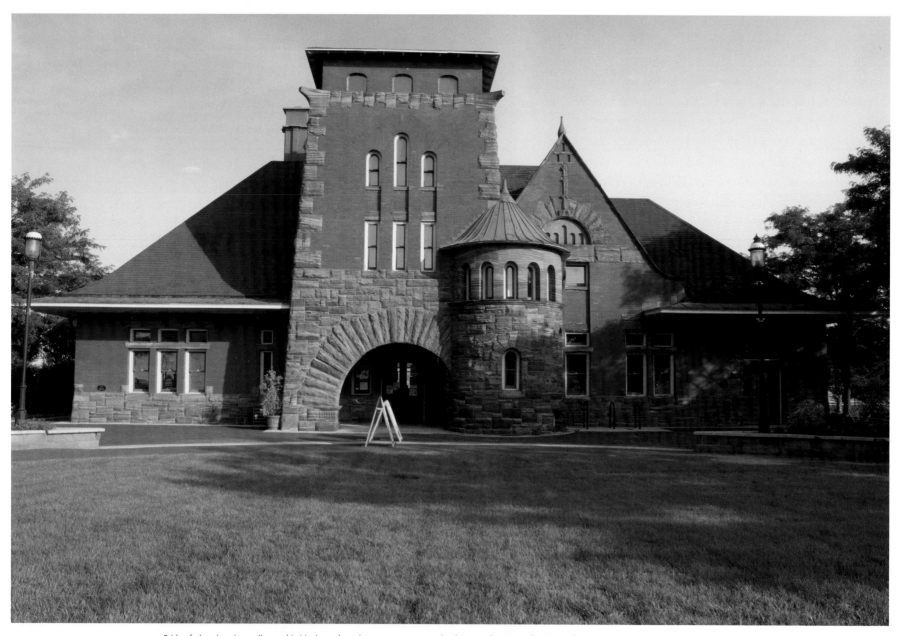

Pride of place is written all over this Muskegon's exuberant monument to the drama and majesty of train travel. Note in particular the visual power of that great, three-quarters arch that shelters the entrance—a remarkably distinguished Richardsonian Romanesque flourish.

Muskegon

1895—Chicago & West Michigan;
Muskegon, Grand Rapids and Indiana; and
Toledo, Saginaw & Muskegon Railroads
610 West Western Avenue

ARCHITECTS: Sidney J. Osgood and
Amos W. Rush

LAST PASSENGER SERVICE: 1971

CONDITION: Excellent

USE: Muskegon County Convention
and Visitors Bureau

The early 1890s were not kind to Muskegon. Michigan's once-abundant forests had just about been depleted, and Muskegon, the "lumber capital of the world," as it liked to call itself, was facing the end of its livelihood right in the middle of a worldwide financial panic. City fathers knew they had to diversify to survive, and statistics gave them extra incentive. In just the two years from 1893 to 1895, the city's population dropped 26 percent. The board of trade, precursor to the chamber of commerce, decided something big was needed to boost Muskegon's sagging image. An admirable replacement for the rickety old wooden depot on Third Street, they argued, would cast the town in a newly favorable light. Officials approached three railroad companies (Chicago &

West Michigan; Muskegon, Grand Rapids and Indiana; and the Toledo, Saginaw & Muskegon) with financial incentives to build a new union station. The companies agreed, and the new Muskegon Union Terminal opened in 1895. Cause and effect are hard to prove, but it's undeniable that the depot was built right about the time that a struggling city began to turn its fortunes around—in part by moving into heavy industry as the auto age dawned, eventually becoming a major supplier of piston rings and other engine parts to the Big Three car companies.

The Muskegon depot is one of the most striking stations in the state of Michigan, a two-story structure with a tapering four-story tower and exuberance to spare. It's a triumphant exercise in Richardsonian Romanesque design, with its char-

With its location on Muskegon Lake, this union station appears to straddle two modes of transportation. This corner of Muskegon isn't quite as bustling nowadays as it was when this picture was taken, but the spectacular job done in renovating the depot ought to help stimulate redevelopment over time. (Personal collection of Jacqueline Hoist and Ronald Campbell)

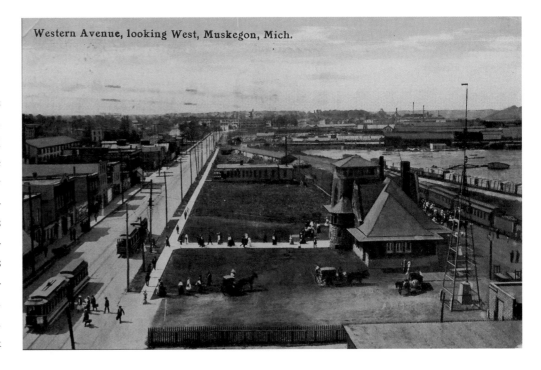

Western Avenue, looking West, Muskegon, Mich.

Early skyscrapers consciously invoked religious themes to exalt the businesses housed within. (Think of Detroit's 1929 Guardian Building, instantly dubbed the "Cathedral of Finance.") In like manner, a Gothic arch crowning a pair of double doors (*top right*) subtly underlines the nineteenth century's reverence for the technology that freed humanity from the crushing limits of overland travel at animal speed. With its lavish ornamentation (*bottom right*), architect Amos W. Rush's 1895 composition is an unending feast for the eyes.

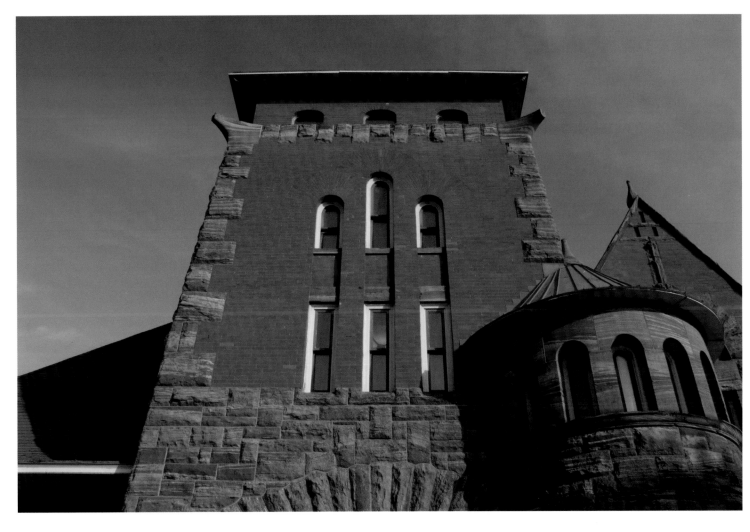

acteristic stone archways, complex and heavy massing, rough textures, and multiple towers and pinnacles that puncture the sky without dwarfing the building. Grand Rapids architect Sidney J. Osgood drew up the original plans, which appeared in newspapers in 1893. But the actual execution fell to a Grand Rapids architect of lesser renown, Amos W. Rush, who apparently simplified Osgood's original scheme with what can only be called happy results.

True to its Romanesque origins, the depot boasts a heavy base of variegated, red and cream Marquette sandstone, a highly textured contrast to the smooth, baked-red brick above. The main entrance lies within a portico framed by a massive, sandstone three-quarters arch, while the building façade is broken up into several large geometric elements—the four-story, tapering tower, with a setback at the very top; a huge gable with a stone arch inset; and a round, squat stair

tower—entirely done in sandstone—topped off by a metal roof rising to a sharp pinnacle. In all, it formed a dramatic backdrop for innumerable arrivals and departures as well as for odder events that made the newspapers.

A case in point: what most reasonable people would probably call a negligent mother left her baby on the train in 1906 while she dashed into the station to make a phone call. When the 8:10 a.m. pulled out for Grand Rapids without the young St. Johns woman, she ran shrieking up the platform, throwing herself on the station agent, who called ahead to the next station, Muskegon Heights, asking workers there to safeguard the baby and wait for the mother. The two were happily reunited.

In 1910 a massive blizzard incapacitated the whole coastline, cutting Muskegon off from communication with the outside world for thirty-six hours. A local theater had to cancel its Thursday night performance because the cast—arriving by train from out of town—was buried for forty hours in a

snowdrift some twenty-five miles south of the city in West Olive.

And silent-film star Buster Keaton would presumably have come through the station any number of times in the early twentieth century. Keaton's father, Joe—a vaudeville performer—founded the Artists' Colony Club, later known as the Actors' Colony, on Lake Muskegon in 1908. It became a popular summer retreat for traveling performers, and the elder Keatons had a cottage there until the 1920s, when they moved to Hollywood to be close to their famous son.

Muskegon hosted a fairly steady parade of national politicians over the years, including William Jennings Bryan in 1896. The Great Commoner gave a speech before breakfast, then got back on the train to stump that same day in four other southwest Michigan towns. (When the train stopped near a rural schoolhouse east of Muskegon, Bryan had a bouquet of roses sent to the schoolmarm.) In 1952 outgoing president Harry S. Truman campaigned at the depot for two-time losing presidential candidate Adlai Stevenson. And both Senator John F. Kennedy and Vice President Richard M. Nixon addressed crowds from the station in 1960.

The last passenger train pulled out on May 1, 1971, bound for Chicago. Freight service continued for two more years and then it stopped as well. The building stood empty and deteriorating from 1978 until the early 1990s, when the last private owner, the Knoll Group, donated it to Muskegon County. A 1995 restoration with $1 million in federal and local funds rebuilt the building from top to bottom, restoring it to the condition of one century before. Since 1996 the sturdy edifice—one of the town's best looking—has housed the Muskegon County Convention and Visitors Bureau, a good use that preserves the public character the building was meant to have.

Niles

1892—Michigan Central Railroad
598 Dey Street

ARCHITECTS: Spier and Rohns
CONDITION: Excellent
USE: Amtrak station

If Niles, a relatively small town at the time, got one of the grandest stations along the Michigan Central Railroad, it can thank its friends in Chicago. The railway built the station, one of the last passenger stops in Michigan, allegedly to impress the tens of thousands of tourists it expected to travel to the 1893 Columbian Exposition in Chicago. The building appears to have succeeded admirably with fairgoers, and it continues to surprise and delight visitors who hadn't suspected there'd be such magnificence at this particular stop. Hollywood certainly seems to agree. Three films have used the depot as a handsome backdrop, including *Continental Divide* (1981), *Midnight Run* (1988), and *Only the Lonely* (1991).

Detroit architects Spier and Rohns designed the 1892 station in the Romanesque style they'd adopted for a number of stations, not least Ann Arbor's Michigan Central depot, built five years earlier. But in its use of heavy stone arches and a restrained color palette—all pinkish-brown sandstone—Niles stands as one of the better examples of true Richardsonian Romanesque. The station epitomizes the visual movement that Professor Carroll L.V. Meeks argues in *The Railroad Station: An Architectural History* is one of the defining elements of nineteenth-century architecture, an explosion of revival styles that he groups together under "picturesque eclecticism." The picturesque is "concerned with the rising and falling, advancing and receding, with the convexity or concavity and other forms of the great parts," Meeks writes—a fair visual description of the trackside façade at Niles, broken into three or four distinct visual planes joined by recessed segments.

The difficulty keeping clocks running on time is probably one of the reasons they don't appear on more train depots. At Niles, however, architects Spier and Rohns adorned the 60-foot-tall station tower with four clock faces manufactured by Howard Brothers of Boston—better known to most people in the late 1800s for their pocket watches.

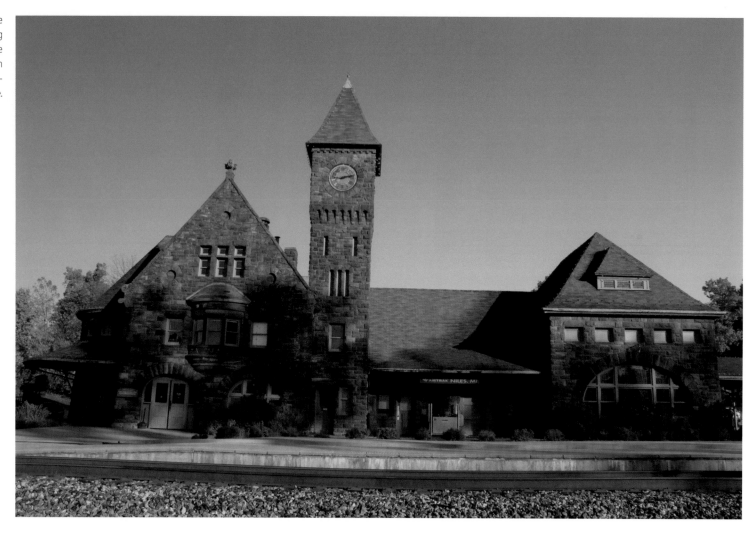

After their first station burned down in 1873 and was re-
placed by a temporary shed, the good people of Niles would
wait almost twenty years for the grand, new $35,000 gateway
to their city. Small wonder, then, that jubilant crowds and the
Niles Brass Band braved lightning and lashing rain to wel-
come the first passenger train, pulled by engine No. 88 on
February 8, 1892. For its part, the *Niles Weekly Mirror* got
right to the point. Conceding that the Michigan Central had
built a number of handsome new stations in recent years, it
nonetheless argued that the hometown example was "superior

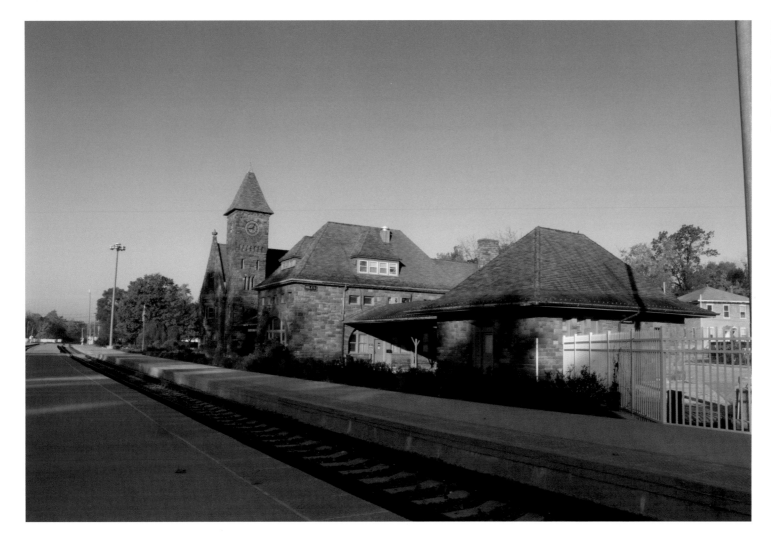

to the rest in its excellent combination of graceful and pleasing design with convenience of arrangement and perfection of interior finish."

That perfection included a women's waiting room at the west end, terminating in a semicircular apse with closely set, tall windows topped by stained glass. Directly across from the adjacent ticket office, with its polished oak counter and brass fittings, was a "broad and massive" fireplace made of red terra-cotta and a polished oak mantle surmounted by a large framed photo of Niagara Falls (with a Michigan Central

passenger train rushing past). The newspaper applauded the extensive kitchen arrangements at the building's east end and the handsome dining room and lunch counter lighted by "broad windows daintily hung with fresh muslin curtains." Not all was frivolity and tasty snacks, however. On the tower's second floor overlooking the tracks sat the town's command center, the telegraph office. In 1892 the honors were carried out by one Rebecca Bracken, "who taps the brass keys that send messages in every direction."

In 1899 President William McKinley—who apparently knew how to butter up an audience—told the throng waiting for him at the station, "The name of your town is a very familiar one to me. It is the name of the town in which I was born in Ohio." (That Niles no longer has its depot.)

The station grounds outside excited comment as well as the architecture, graced with extensive gardens and a trout pond to the east of the station. Beyond that were two greenhouses—one for roses, one for carnations—where flowers were grown year-round for use on passenger trains. The gardens were the work of a German immigrant, "Old John" Gipner, who had a touch for the dramatic. In one bed visible from trains he fashioned a flowery American flag, while in another he spelled out "Niles" in capital letters. The bucolic scene was the subject of admiring comment up and down the line, and passengers used to crowd the windows to get a glimpse of this unexpected Eden. For years Gipner employed half a dozen little boys whose job was to hustle through stopped trains, presenting each woman on board with a boutonniere. In 1891–92, just before the station opened, Gipner's crew gave out ten thousand such floral tributes. The gardens, along with those in Ypsilanti, met their end when the New York Central took full control of the Michigan Central in 1935 and pulled down the greenhouses. The new era of cutthroat rail competition apparently would not involve ladies' corsages. The erasure of his life's work might have been too much for Gipner, who started to go progressively blind shortly thereafter. Today the grounds are maintained by the Niles Four Flags Garden Club in a fashion that would make Gipner proud. And every December, the City of Niles lights up the station in white lights outlining the walls and roof, a tradition borrowed from the Christmas scene that ends the film *Only the Lonely*.

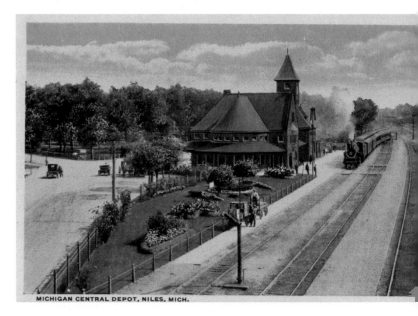

MICHIGAN CENTRAL DEPOT, NILES, MICH.

The postcard above shows the elaborate gardens that made Niles one of the most talked-about depots on the Michigan Central line. The work of horticulturalist John Gipner was so impressive that passengers on passing expresses were said to rush to station-side windows to drink in the view. Niles was one of two sites where the Michigan Central maintained greenhouses to grow the corsages for many years given to women passengers and the bouquets that once graced dining-room tables. The other garden center was Ypsilanti, which had its own extensive set of greenhouses. (Personal collection of Jacqueline Hoist and Ronald Campbell)

Petoskey

PERE MARQUETTE STATION, PETOSKEY, MICHIGAN

With Petoskey's 1892 station right on Lake Michigan, the Chicago & West Michigan Railway appears to have played much the same marketing card as they did with their Charlevoix depot, one stop south. In each case, the first thing tourists would see upon getting out was sparkling blue water—an advertising leg-up that couldn't have been lost on railway executives or town fathers alike. Additionally, the Shingle style architecture used on each station (even though they're very different designs) summons up pictures of lazy summers at country clubs or stylish cottages. The Petoskey depot, however, has changed some over the decades. In the postcard above, note that the roof originally extended over open platforms at each end. In a subsequent renovation, the station interior expanded to fill those spaces. (Personal collection of Jacqueline Hoist and Ronald Campbell)

*P*etoskey's hilly, good-looking downtown sits on a high bluff overlooking Lake Michigan and Pioneer Park. The city's 1892 Chicago & West Michigan Railway depot is tucked right at the base of that vertical rise. As such, the building—now the Little Traverse History Museum—is not visible from the center of the city, owing to the steep drop and tall trees. And that's a shame, because we are talking about one of the handsomest structures in a town with, granted, more than its share of fanciful architecture—a town, as the admiring *Charlevoix Sentinel* noted on October 29, 1891, replete with "domes and minarets."

The arrival in 1874 of the Grand Rapids & Indiana Railroad, followed eight years later by the Chicago & West Michigan Railway, transformed a remote village dependent on a timber and fish economy into an upper-end resort. For fifty-three years, starting in 1904, Petoskey was one of the last stops on the Resort Special—Pullman sleepers that made the overnight run from Chicago and Detroit to the northwestern tourist retreats. On August 5, 1917, the *Washington Post* society columnist reported that Vice President Thomas R. Marshall and his wife, Lois, were two such Petoskey-bound passengers. It's

unclear, however, what route the Marshalls took to get Up North. It could have been the Pere Marquette—the successor to the Chicago & West Michigan—or the Grand Rapids & Indiana, which had its own attractive station right in downtown Petoskey.

The Chicago & West Michigan depot sits on the edge of Little Traverse Bay, just a hundred feet from the marina and its gently rocking forest of sailboat masts. Built the same year as Charlevoix's, the Petoskey depot is an impressive Shingle style building with a distinct Victorian cast, visible in the impossi-

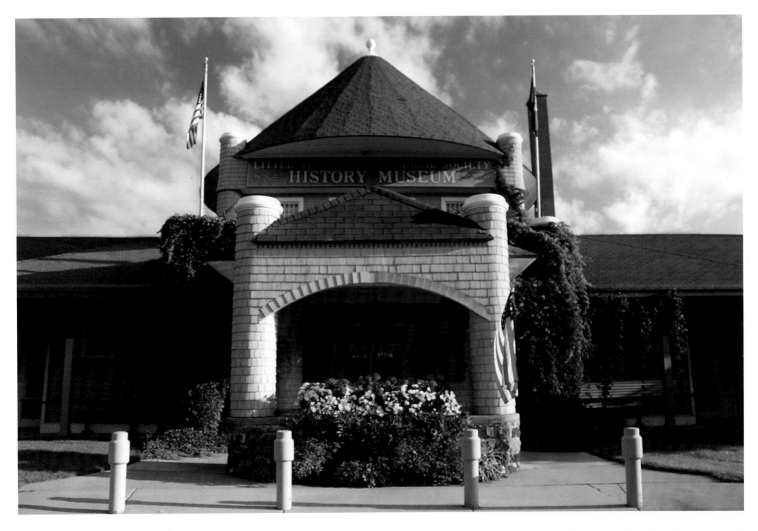

bly tall, narrow brick chimney on the right, the porte cochere in front, and in the element that ends up defining the look of the entire structure—the enormous, if somewhat squat, conical roof that sits on the building like an Easter bonnet. If Charlevoix's station, also Shingle style, looks like a grand cottage, its Petoskey cousin conjures up a sprawling lakeside pavilion.

That impression got a boost the year after the depot opened when the Chicago & West Michigan Railway got around to landscaping the depot grounds, "handsomely laid out [and] covered with shade trees and flower beds," according to the July 17 *Petoskey Daily Resorter.* "Walks have been laid out," it added, "and a well-patronized pagoda now stands on the

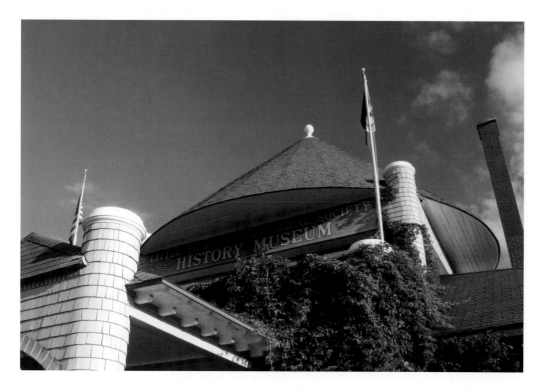

One of the Petoskey station's defining elements—indeed, the one that dominates the whole building—is the squat, conical roof that one architect likened to a great, big hat.

A hundred years ago, blizzards roaring into Little Traverse Bay could leave Petoskey in thrilling isolation. In 1910, for example, the 9:45 p.m. from Grand Rapids spent the night wedged in a snowdrift just short of town, while as late as 1920, a massive late-winter storm crippled train service for a full eighty-eight hours—almost four whole days.

The station's early years were colorful. In 1895 brakeman Harry Bigler opened the door to an Alanson-bound car where someone had stashed a large bear carcass. As Bigler entered, the bear fell on him "head foremost," as the *Evening News* helpfully explained. "Bigler uttered a yell, struck the bear squarely between the eyes, and then ran for dear life."

A rather grimmer incident—and one not all that uncommon, to judge by news reports—occurred in 1917 when a thirty-five-year-old maid working for a Chicago family "eluded the vigilance of her nurses, and lifting the screen of her window in her Pullman berth, leaped to her death. She had suffered a complete nervous collapse." The paper added the sort of grisly detail unlikely to make it into print today: "It is believed she was only stunned by her leap and that she deliberately placed her neck on the rail"—an explanation that sounds more lurid than feasible.

In September 1917, five months after America's entry into the First World War, a vast throng crowded the depot "as loving farewells are said to those ordered to the defense of the nation's honor and of world democracy," according to the *Petoskey Evening News*.

Unlikely to have been at the 1917 celebration was one of the region's most famous seasonal residents, Ernest Hemingway. On that same September day, the eighteen-year-old reported in a letter to his grandfather that he'd dug up half an acre of potatoes on the Hemingway property near Walloon

hill at the rear of the depot"—a fanciful grace note. But, as always in the age of the steam locomotive, particularly in its rough-and-ready earlier years, the delicate illusions created by stations, gardens, and pagodas—designed in part to allay passenger anxiety—stood in sharp contrast to the violent, rushing nature of rail transportation. A quick scan of the headlines over one hundred years ago turns up grim reminders of just how dangerous this business could be. When a Chicago & West Michigan Railway "fast" (express) train encountered cattle and ran off the rails on September 5, 1894, both engineer and fireman were killed—"badly scalded to death," as the *Petoskey Evening News* noted.

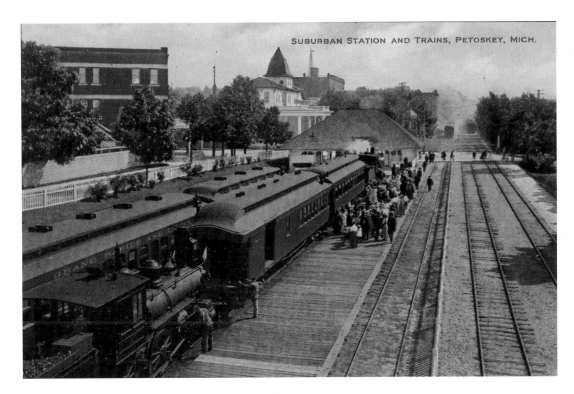

SUBURBAN STATION AND TRAINS, PETOSKEY, MICH.

The other station in Petoskey was built by the Grand Rapids & Indiana Railroad some years before the Chicago & West Michigan Railway made it to town. While the latter chose to locate right on the water, the Grand Rapids & Indiana built their station right in the center of town, up the hill from the lake. Those who know Petoskey well will recognize the Perry Hotel poking up just left of center. (Personal collection of Jacqueline Hoist and Ronald Campbell)

Lake. (The young man added that he expected to get back to Chicago in time for the World Series.)

The Hemingway family often took the Grand Rapids & Indiana Railroad, an easy trip north from Chicago with a change of trains in Grand Rapids. But it's clear they often used both railroads. On September 3, 1917, Hemingway wrote his grandfather, abbreviating the names of both lines, that he would be coming home to Chicago that Thursday "on the P.M. or the G.R." Three days later, he wrote a letter to his parents sympathizing with difficulties they had getting back to Illinois: "The GR and I is rapidly getting in the Pere Marquette class."

Hemingway immortalized one of Petoskey's two depots in *The Torrents of Spring*, his semiautobiographical novella;

it would have been nice had it been the Shingle style station on the beach, but it was not. The honor apparently fell to the Grand Rapids & Indiana depot, its platform in Hemingway's description piled high with deer carcasses from Michigan's Upper Peninsula.

By the 1950s, the Pere Marquette had passed into the hands of the Chesapeake & Ohio Railway, which ended passenger service to the northwest resorts in 1962. Eight years later, the abandoned building was offered to the Little Traverse Historical Society, and two Ford Motor Company executives—Ernie Breech and John R. Davis—helped finance an extensive renovation by architect John Wooden. Today the handsomely maintained depot houses the Little Traverse History Museum.

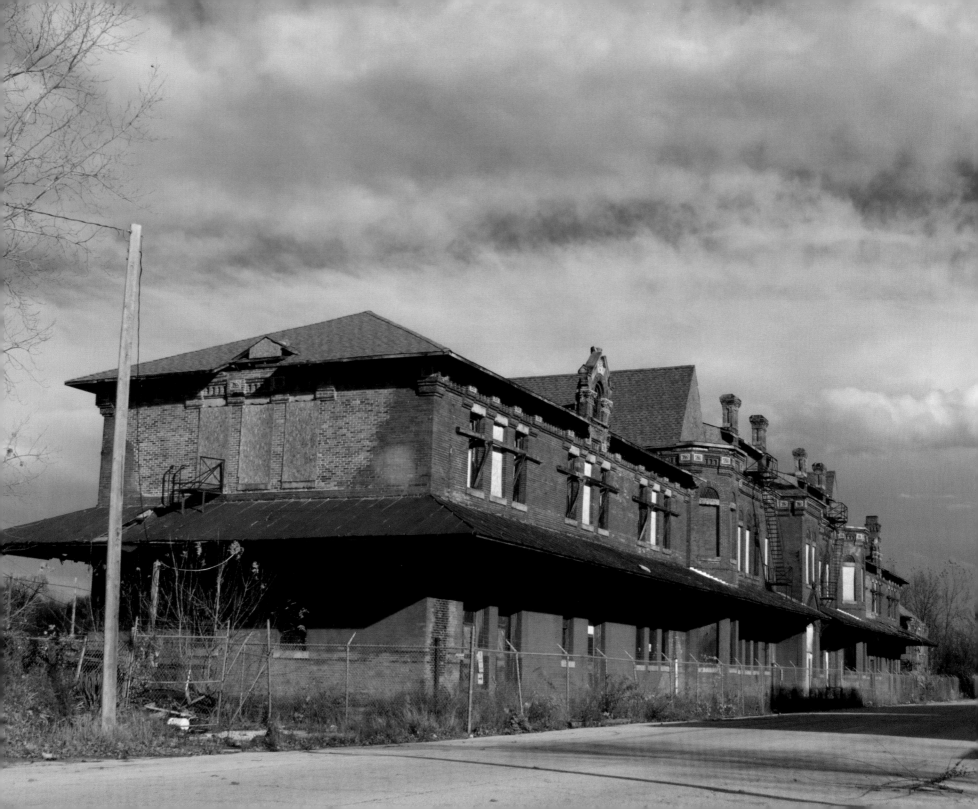

Saginaw

1881—Flint & Pere Marquette Railway
515 Potter Street

ARCHITECT: Bradford Lee Gilbert

LAST PASSENGER SERVICE: 1950

CONDITION: Very poor

USE: Abandoned

The massive bulk of Saginaw's ruined Potter Street Station—it stretches almost an entire city block—dominates a once-bustling street on the city's east side. Today that urban scene could hardly be more desolate. The late-Victorian depot looks, for all the world, like some great public building in London, temporarily patched and sealed after a direct hit by the Luftwaffe during the 1940–41 German blitz. The difference is that buildings in London were repaired, while this landmark has been mostly left to rot since it was abandoned for good in 1986. Those who think Detroit's Michigan Central Station is the last word in urban collapse should take a drive by the majestic wreck at Potter Street and North Washington Avenue. But much like its cousin in Detroit, this orange-brick behemoth radiates a strange, mesmerizing power. Only the hard-hearted could stand before it unmoved.

The Potter Street Station—officially the East Saginaw depot, as the carved letters facing the tracks announce—was thrown up at the height of Saginaw's lumber boom, when dollars showered the town like so much sawdust. Built in 1881 by the Flint & Pere Marquette Railway (later just the Pere Marquette), the station was designed by Bradford Lee Gilbert of New York, who also built Chicago's 1893 Romanesque style Illinois Central Station (demolished in 1974). The Saginaw depot is a sort of architectural triptych, with identical wings flanking a three-story central section once crowned by a seventy-five-foot tower (the figure is disputed—some sources say sixty feet), all done in the warm reddish-orange brick that built so many Michigan stations, from Jackson to Holly.

An October 25, 1881, preview in the *Saginaw Daily Courier* shortly before the building opened described the station as "practical, substantial and businesslike," adding that its de-

Vast and brooding, Saginaw's ruined Potter Street Station (originally "East Saginaw") keeps a silent watch over what used to be a bustling commercial district, one that now echoes with the same emptiness as the depot. Plans to repair the red-brick Victorian station have fallen through time and again.

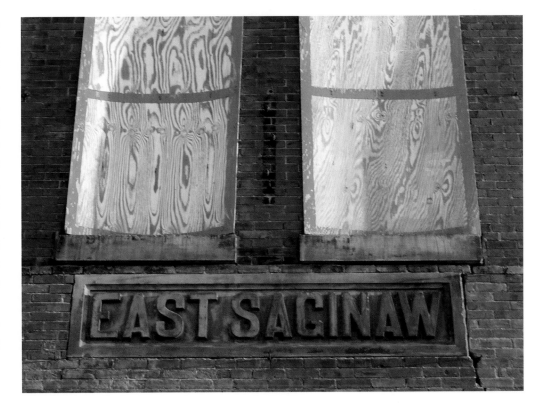

Opposite: Blue sky now pokes through an arched window whose dormer was destroyed in a spectacular fire that swept through Saginaw's Potter Street Station in 1991, destroying much of the roof. Two years later, grants totaling about $225,000 from the State of Michigan and the National Trust for Historic Preservation allowed the Depot Preservation Corp. to repair the roof and install plywood in the windows (*above*). Still, keeping a building properly sealed is an ongoing challenge, and some of the empty window frames are once again open to the elements.

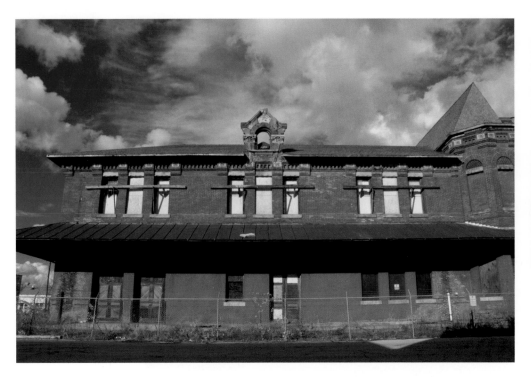

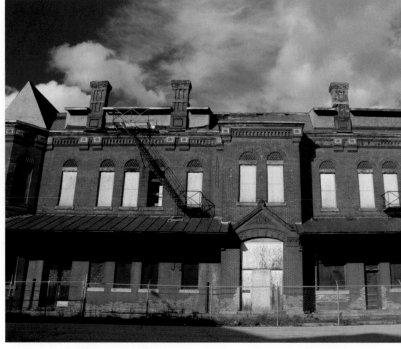

sign included "nothing for mere ornamentation"—an amusing characterization of a structure that looks heavily laden with Victorian ornament to modern eyes. The article went on to praise the oak wainscoting within, "dials" that would announce train arrivals and departures, and the massive fireplace, its opening six feet wide and five feet high, in the ladies' waiting room. On the trackside platform, gas jets were mounted every twenty feet. Hungry travelers could repair to the dining room inside—"leased by that prince among caterers, Farnham Lyon of the Bancroft House," at the time Saginaw's premier hotel.

The last passenger train pulled out in 1950. Five years later, the Froeber Casket Company set up shop in the dining room (one imagines the "prince among caterers" spinning in

his grave), with gray metal caskets, according to the *Saginaw News,* filling the space "like so many tombstones." That same year, the Chesapeake & Ohio Railway—which had acquired the Pere Marquette—announced plans to raze the building and replace it with offices and a warehouse. ("Doomed to the Wrecker's Hammer" the *Saginaw News* headlined on February 8, 1955.) But nothing came of it, which must have been a considerable relief to the coffin businessman.

And that's pretty much been the pattern ever since. Like the famous heroine of silent films, forever strapped to the railroad track, speeding locomotive in the distance, Potter Street has been repeatedly threatened with annihilation, only to beat the odds time and again. The railroad finally shuttered Saginaw's grande dame for good in 1986. Two years later, the

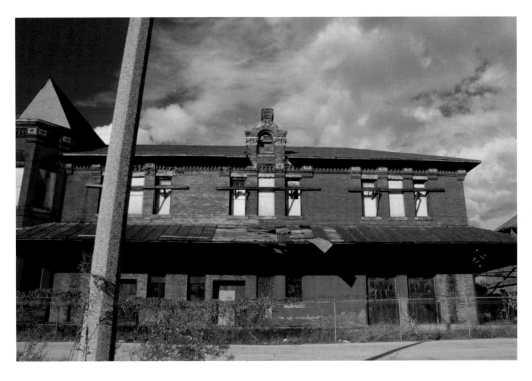

Another consequence of the 1991 fire, five years after the fact, was the collapse of the several-story square tower that loomed for generations over the station's main entrance (*center, at left*). Rigorously symmetrical in composition, Potter Street offers an interesting contrast to the rigorously asymmetrical approach of the many Romanesque stations, like Niles or Ann Arbor, that would be built across the state just a few years later.

city ordered CSX Transportation—which had acquired the Chesapeake & Ohio—to pull it down by the end of the year. Again, nothing happened. In 1990 the Saginaw Depot Preservation Corporation, a recently formed nonprofit, bought the structure from CSX for $10,000.

Still, bad luck has dogged the organization's every step. In April 1991 a fire, long put down to arson (the perpetrators were never caught), destroyed much of the roof and upper story. The city, invoking the dangerous buildings ordinance, gave the group a month to repair the damage or the depot would be demolished. Preservationists initially blocked that order in court, only to lose on appeal the following year, with the city getting the go-ahead. Still, no action was taken, and in 1993 the Depot Preservation Corporation won a $181,600 state grant for renovation—presented at the station by Republican governor John Engler—and a $45,400 loan from the National Trust for Historic Preservation. The roof was repaired and the windows boarded up with plywood.

At that point, progress froze—despite the depot's addition in 1996 to the National Register of Historic Places. As if to mock that honor, the rest of the fire-damaged tower crashed into the depot in 1997, ruining the newly repaired roof. In 2007 the Department of Housing and Urban Development approved a $1 million grant for renovations, but that figure was subsequently cut in half, and in any case, nobody's seen a dollar of it yet. Saginaw's ruined queen still presides over the ruined street, as graceful in her dilapidation as ever, a herald—one hopes—of future glory.

For anyone who's seen Potter Street in recent years, the bustling scene at right (*top*) is hard to believe. Were there really impressive commercial buildings stretching down the other side of the street as far as the eye can see? Today that same vista is mostly empty. Note as well the station's complex roofline—all lost to flames eleven years ago. As befits what was once a wealthy timber town, Saginaw appears to have had a thing for extravagant depots. While not as regal as Potter Street, the long-gone Grand Trunk depot (*bottom*) nonetheless cut a stylish figure. (Personal collection of Jacqueline Hoist and Ronald Campbell)

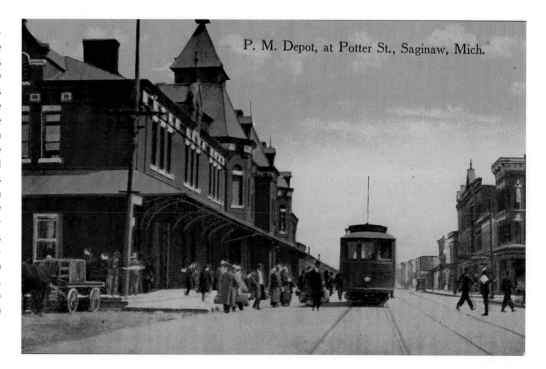

P. M. Depot, at Potter St., Saginaw, Mich.

GRAND TRUNK DEPOT, SAGINAW, MICH.

St. Johns

1920—Detroit, Grand Haven
& Milwaukee Railway
107 East Railroad Street

ARCHITECT: Unknown

LAST PASSENGER SERVICE: 1960

CONDITION: Excellent

USE: Clinton Northern Railway Museum

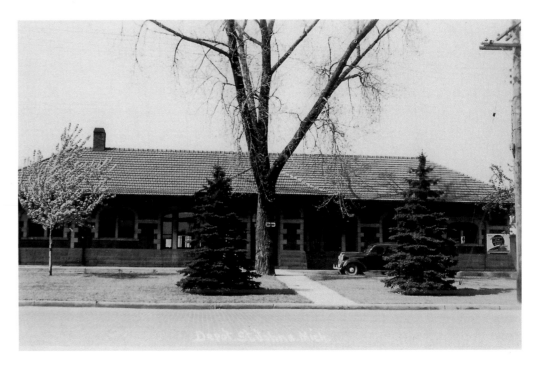

Judging by the car, this undated historic photo would seem to hail from the 1930s or early 1940s. In any case, for anyone who's ever visited the St. Johns depot, the first question is likely to be—where'd the agricultural silos that tower over the station go? (Turn the page to see how they loom.) (Personal collection of Jacqueline Hoist and Ronald Campbell)

It isn't very often that a tornado gets to play the hero, but that's sort of what happened in 1920 in St. Johns, an agricultural town that for decades billed itself as the "Mint Capital of America." Townsfolk had long grown cranky on the subject of their 1869 train station. When the Detroit, Grand Haven & Milwaukee Railway went and gave nearby Ionia an admirable new depot in 1910 (one that strongly resembles what would be built in St. Johns in 1920), it was just about more than some upright citizens could bear. Community leaders descended upon railroad officials, stressing the town's urgent need for a snappy, up-to-date station. Despite promises, however, all they got was a fresh coat of paint and electric lights. The editor at the *St. Johns News,* for one, was fit to be tied. When the railroad was still deciding whether it would build St. Johns a new depot or no, one of its conditions had been that certain grain elevators—too close to the additional tracks the railroad wanted to lay down—would have to move. Local businessmen paid good money for the relocation, only to find that the company dropped its end of the bargain. "Now to have them come on with a gang of men and fix up that antiquated old trap," the *St. Johns News* editorialized on September 17, 1914, after the fresh paint started being applied, "to say the least, they have their guts with them."

The 1920 Palm Sunday "cyclone," as it would be called, solved everything. Part of a vast eruption of tornadoes that stretched from the Gulf of Mexico to the Great Lakes on March 28, 1920, the twister struck St. Johns at 5 p.m., clearing the way for the new station later that year. Happily, nobody was at the depot. Stationmaster Harry W. Buck would have been there at that time a few weeks earlier, but his hours

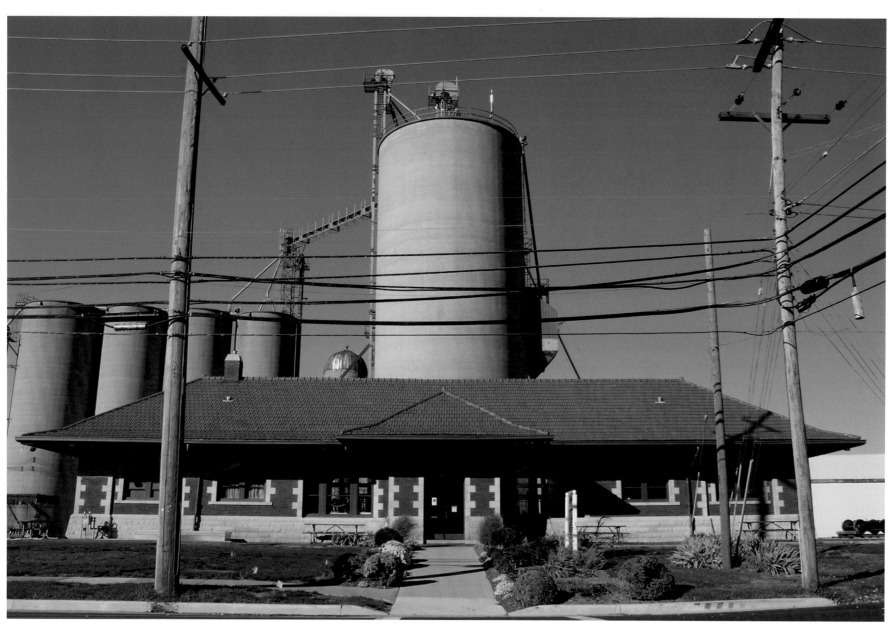

Caught in a veritable forest of poles, lines, and agricultural towers, St. Johns's 1920 Tudor Revival depot—well renovated by architects Ronald Campbell and Jacqueline Hoist—still retains a dignified reserve.

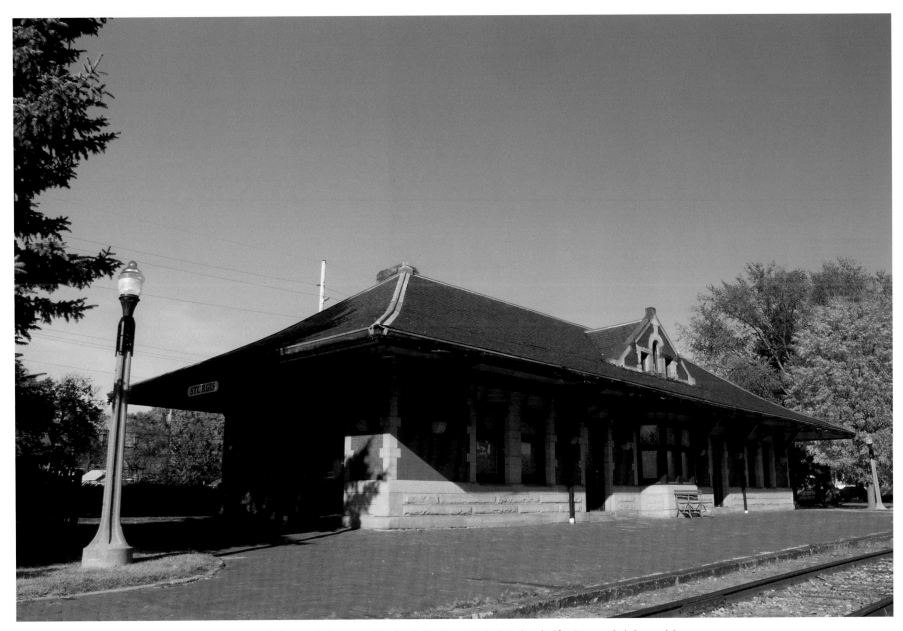

A close cousin to the St. Johns station can be found in Sturgis, which shares much the same roofline, foundation skirt, and Tudor Revival notched framing around windows and doors.

Looking a bit as if its entrance were in danger of being squashed by the silo above it, the St. Johns depot now houses the Clinton Northern Railway Museum.

[at this point a division of the Grand Trunk] be required to build a new passenger station and depot at St. Johns, Mich."

Virtually the only thing left unscathed that fateful Sunday at the St. Johns station was the safe. After the building was flattened, the safe was moved to Tawas City. Many years later, in 2003, with the Tawas depot about to be torn down, the safe was returned to its original home, albeit in the new 1920 building.

St. Johns's station is a brown-brick Tudor Revival building with off-white sandstone detailing that frames windows and doors and forms a pronounced skirt that circles the base of the building, rising to the bottom of the windows. Strikingly similar to the extant Ionia station, it's also reminiscent of Sturgis's 1896 depot.

In 1998, the City of St. Johns bought the depot for $85,000. The building was well restored in 2002 with $325,000 in grants from the state. For awhile it housed the Clinton County Arts Council, but when the interior subsequently needed replastering, the council moved to other quarters. The city now rents the building to the Clinton Northern Railway Museum, which is open from May to October.

In a reminder how central the depot was in any town when it still housed the telegraph office—which it typically did—the museum displays a number of telegrams from World War II bearing doleful news to local parents. One, addressed "Mrs. Harriet Lapham—works for Pipe Line St. Johns Mich," is characteristic of the genre. In officialese typed on brown paper and signed by the adjutant general, it reads, "The Secretary of War desires me to express his deep regret that your son First Lieutenant Gale G. Lapham was killed in action on fourteenth June in France. Letter follows."

had been changed. Called in after the disaster occurred, Buck managed to salvage a telegraph key—the instrument operators tapped to send the code— from the wreckage. But with wires down all across town, there was no way to employ it. All the same, it was imperative that someone alert the railroad lest the next train come roaring in to a demolished station with debris strewn all over the tracks. Buck commandeered a handcar, and with another railroad employee pumped all the way to Shepardsville, the next depot east. Finding that station closed and locked, Buck broke in, found the telegraph key, and promptly tapped out his urgent message of warning.

When it was all over, the tornado had demolished the depot, its freight house, and fifty-odd houses and barns. On April 1, just four days after the depot was flattened, city fathers filed a petition with the Michigan Public Service Commission "praying that the Detroit, Grand Haven & Milwaukee Railway

Shepherd

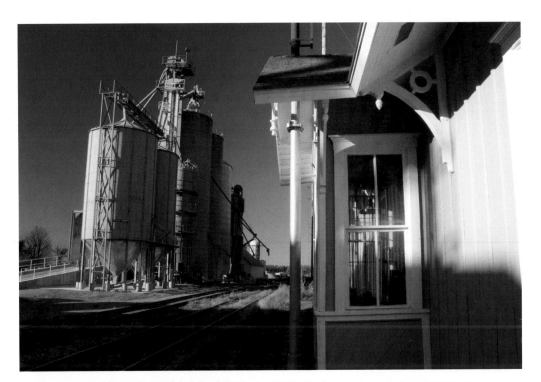

Circa 1890—Toledo, Ann Arbor
& North Michigan Railway
West Wright Avenue at North First Street

ARCHITECT: Unknown

LAST PASSENGER SERVICE: 1950

CONDITION: Good

USE: Railroad Depot Museum

Shepherd's board-and-batten depot, a classic of small-town railroad architecture, was built in the early 1890s, according to the Shepherd Area Historical Society, by the Toledo, Ann Arbor & North Michigan Railway, later the Ann Arbor Railroad. (There's some contention over the date the station opened. The usually authoritative *Inventory of the Railroad Depots in the State of Michigan* says 1884.) More than anything, this station represents a tour de force on the part

Located almost in the geographic center of the Lower Peninsula, Shepherd, just south of Mt. Pleasant, is a classic Michigan small town built on a largely agricultural base—hence the dramatic silos (*top right*) that give drama and punch to views of the town's little board-and-batten depot. As such stations go, Shepherd's is one of the handsomest, with a wealth of wood detailing—milled struts beneath the eaves, bead board under the gables, and crisp detailing around windows—unexpected in such a modest depot. One imagines some carpenter over a century ago, pouring his artistic ambitions into the simplest of buildings, and by his effort lifting it well above the ordinary. In this, Shepherd bears some resemblance to Mayville's board-and-batten station, which also comes with unexpected grace notes. The Shepherd station, built about 1890, today houses a small railroad museum.

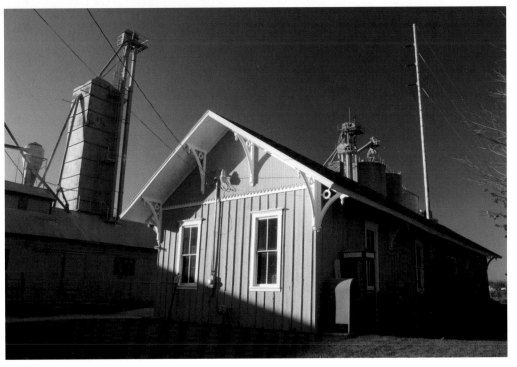

of some unsung carpenter, whose embellishments give this simple shed its considerable zing. The design is partly Stick style, partly Carpenter Gothic, with narrow vertical battens, repeated at short intervals, that lend the building a verticality and lightness. Note also that beadboard replaces board and batten at the base of the building's three gables, a nice, delicate touch. But the architectural stars here—without which this would be a much less charming structure—are the delicate, arched struts beneath the eaves, skewed triangles with a small, carved circle suspended at their center. Completing the composition, rather like an exclamation point, is a small downward-pointing finial.

Much as at St. Johns, most of the visual drama at the Shepherd depot comes from the juxtaposition of a feminine little building overshadowed by hulking, masculine grain silos and other agricultural towers—a sight repeated over and over at rural railroad stations across Michigan. (The contrast is particularly striking at Pigeon, in Michigan's Thumb, where truly astonishing silos form a complex that feels just a little Manhattanesque in its mass and looming scale.)

Shepherd, population about fifteen hundred, is yet another example of town location being dictated by the railroad, not the other way around. The first settlement in the area, named Salt River, sat east of the present village. But in 1885, Isaac N.

The last regular passenger train pulled out of Shepherd in 1950, ending roughly sixty years of service. By 2012, the little depot had gone seventy-two years stripped of its original purpose—longer than its active life as a depot.

Shepherd—nobody's fool—platted the land west of Salt River where the railroad had laid down its tracks and began to erect buildings. Two years later, a fire consumed most of Salt River. Bowing to the inevitable, residents mostly moved west and rebuilt in Shepherd.

Sitting almost at the geographic center of the Lower Peninsula, tiny Shepherd was of little particular interest to the Ann Arbor Railroad. Instead, it was just a means to an end—part of the track that took a straight northwest path from Ann Arbor to Frankfort on Lake Michigan. There the company estab-lished its most profitable transportation unit—the rail ferries that sailed across to Kewaunee, Wisconsin, and nearby towns. Long after the railroad itself was deep in the red, the lake crossing continued to make money. The ferries were eventually overhauled to carry cars as well, which allowed them to survive the end of the Ann Arbor Railroad passenger service in 1950. The Frankfort-Wisconsin ferries themselves were finally killed in 1968. As for the Shepherd depot, it was acquired by the local chamber of commerce and houses the Railroad Depot Museum, organized by the Shepherd Area Historical Society.

South Lyon

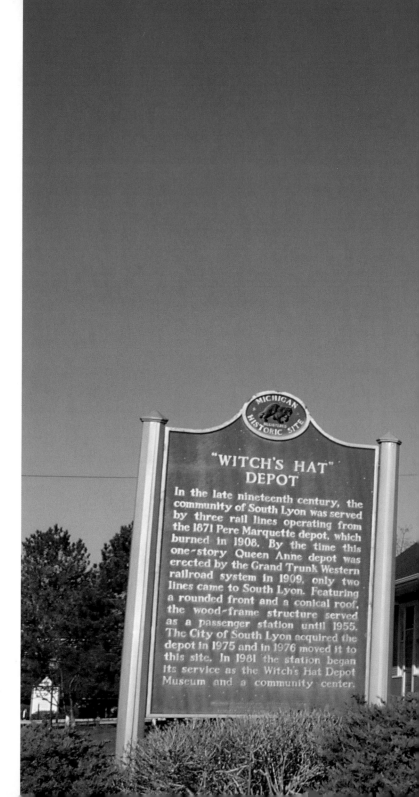

1909—Grand Trunk Western Railway

300 Dorothy Street

ARCHITECT: Unknown

LAST PASSENGER SERVICE: 1955

CONDITION: Excellent

USE: Witch's Hat Depot Museum

*T*he original South Lyon depot burned in 1908, yet another casualty of the sparks that were such a part of the age of steam. The Grand Trunk Western Railway built this upgraded, wooden replacement in 1909. Modest though it may be, it nonetheless was a union station—the Pere Marquette also made stops here, and each company maintained a ticket window inside. Known as the Witch's Hat Depot, this cheerful building is completely defined by the tower at one end, its conical roofline topped off by a golden finial. This is clas-

South Lyon's previous station—like so many in the ash-belching era of steam locomotion—burned one fine Sunday in 1908. The fire—depending upon whom you believe—was variously caused by sparks coming off the wheels as the train shrieked to a stop, igniting dust in an adjacent granary and spreading quickly through dry grass until it reached the depot. Or, alternately, the fire started with sparks escaping from the locomotive's smokestack that landed on the station's shingled roof and took off from there. Whatever the case, South Lyon ended up with a station finer by leaps and bounds than its predecessor, designed in a fashion that would attract envious notice from towns all around the area.

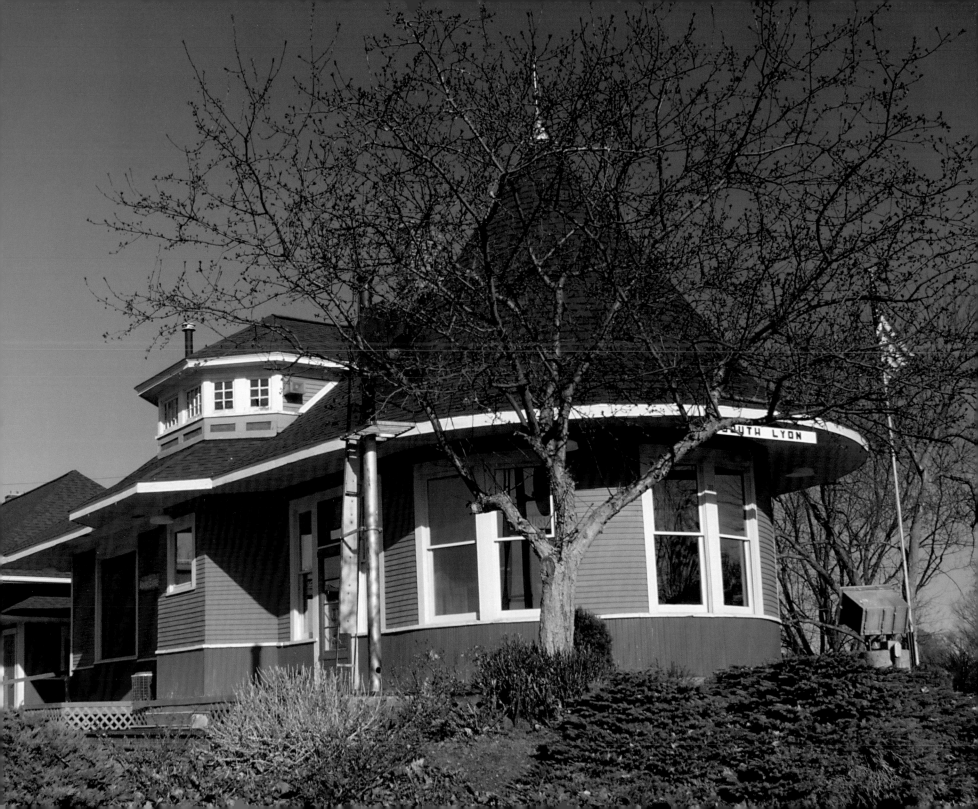

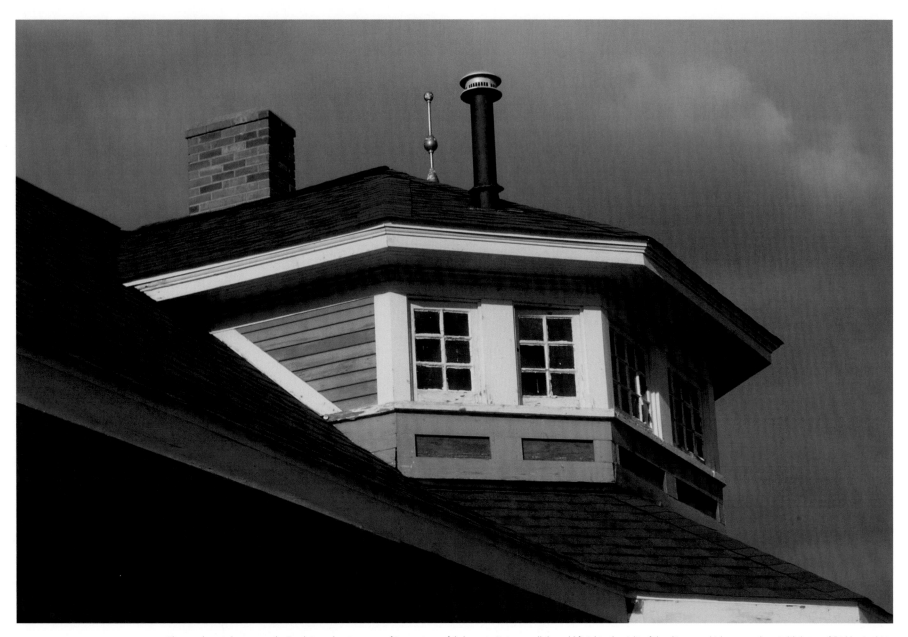

The crow's nest dormers on the South Lyon depot are one of its most graceful elements. Note as well the gold finial to the right of the chimney, which crowns the witch's hat roof (hidden in this shot).

sic Queen Anne, the exuberant style popular around the turn of the twentieth century—a style mad for turrets, complex rooflines, tall chimney stacks, and bays of all descriptions. Note the unusual dormer windows—crow's nest bays wearing a necklace of multipaned little windows.

The architect is unknown, but this station type was surprisingly common across Michigan, also appearing in Saranac, Fowler, Clarkston, and Corunna. That repetition—not found with most other designs—may suggest origins in a builders' stylebook, much like the early twentieth-century catalogs that offered complete house plans. Interestingly enough, the Witch's Hat Depot, relocated in 1976 to McHattie Park, shares

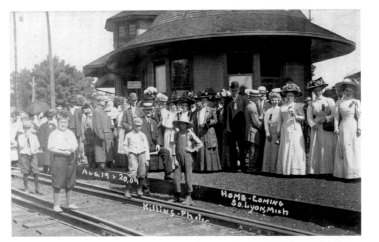

Top: Folks in their Sunday best gathered at the spanking-new depot for South Lyon's 1909 Homecoming fair—as good a picture of small town pride as you'll find. (South Lyon Area Historical Society)

Bottom: The Witch's Hat Depot was moved sixty-seven years later to its present site in McHattie Park, along with other railroad equipment— a signal lamp (*left*) as well as a caboose.

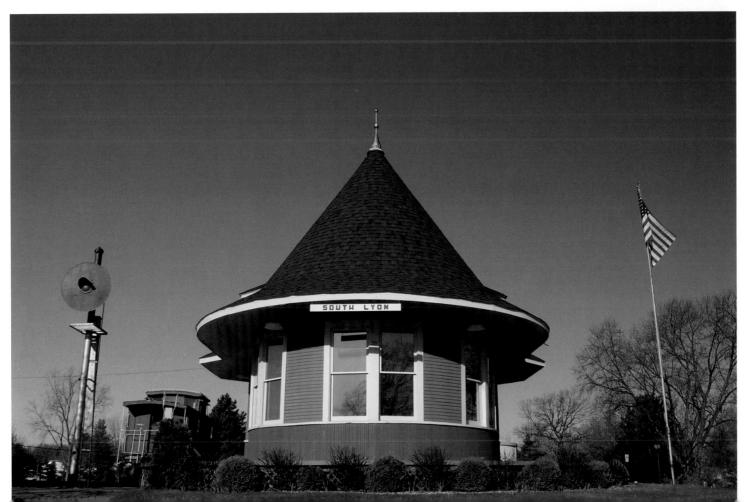

151

The witch's hat station model was repeated in a number of other Michigan towns—among them Saranac (*at right*), Corunna, Fowler, and Clarkston.

that space with the town's old Lutheran church—itself built from Sears and Roebuck plans.

The last regular passenger train came through in 1955, and after that the Chesapeake & Ohio Railway—successor to the Pere Marquette—killed the service. The depot looks very much as it did in 1909, with the exception of the new freight house built in 1981—thoughtfully designed to fit with the station like a hand in a glove. The South Lyon Area Historical Society has taken excellent care of this landmark, though its members will tell you it was in pretty good condition when it fell into their hands. Today, the Witch's Hat Depot Museum, run by the society, occupies the building and is open every Thursday and Sunday. The depot is owned by the City of South Lyon.

Suttons Bay

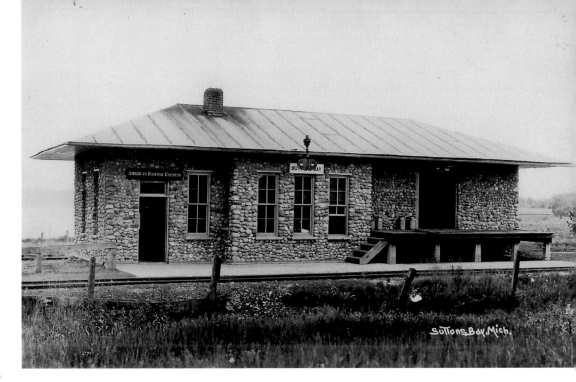

All too often, stations are located on a city's outskirts and thus don't contribute to the appearance of the city center. Suttons Bay, a resort town west of Traverse City on the Leelanau Peninsula, is lucky in this respect. Its instantly likable fieldstone depot acts as the symbolic gateway to the village for anyone driving north on M22, and similarly marks your exit when driving south. It's a key element in the look and identity of the village.

The station is a simple, hip-roofed vernacular building with Arts-and-Crafts overtones, well renovated and used as an office since 1965. The building exterior is mostly unchanged. The tall, narrow, double-hung windows have not been altered, nor have transom windows above wooden doors. A sliding glass door has, however, replaced the old freight door, and at some point a handsome new metal roof, color blue, was added. The latter is probably inaccurate historically—the original was asphalt shingle, like as not black. But the new roof does a

splendid job of setting off station and multicolored fieldstones to maximum advantage.

In 1919 Suttons Bay's only rail lifeline, the tiny Traverse City, Leelanau & Manistique Railroad, declared bankruptcy, saddled with over $40,000 in unpaid taxes—a significant sum at the time. Frightened of falling back into the isolation of the pre-train era, the citizens of the Leelanau Peninsula approached the Michigan legislature to ask if the state would cancel the back taxes if the citizens' group purchased the line. To the surprise of many, the legislature said yes.

Interestingly, the whole point of extending the railroad to Northport, north of Suttons Bay and boasting a look-alike fieldstone station, was to reach the ferry the railroad ran across Lake Michigan to Manistique in Michigan's Upper Peninsula. In this respect, the business plan was very similar to the Ann Arbor Railroad's rationale in running a line to Frank-

"Uncoursed rounded cobble-stones"—or nearly spherical fieldstones—formed the building blocks for Suttons Bay's trim little 1919 station, as well as its near twin at Northport, a few miles north.

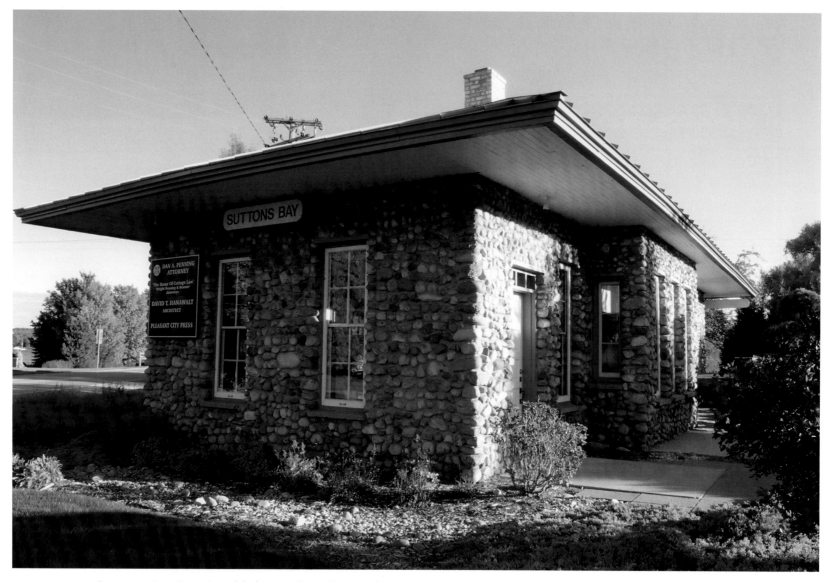

Passenger service to Suttons Bay ended a few years after World War II. The building has since been handsomely renovated into law offices. About the only visual change to the exterior has been replacing the freight door at one end with a sliding glass door.

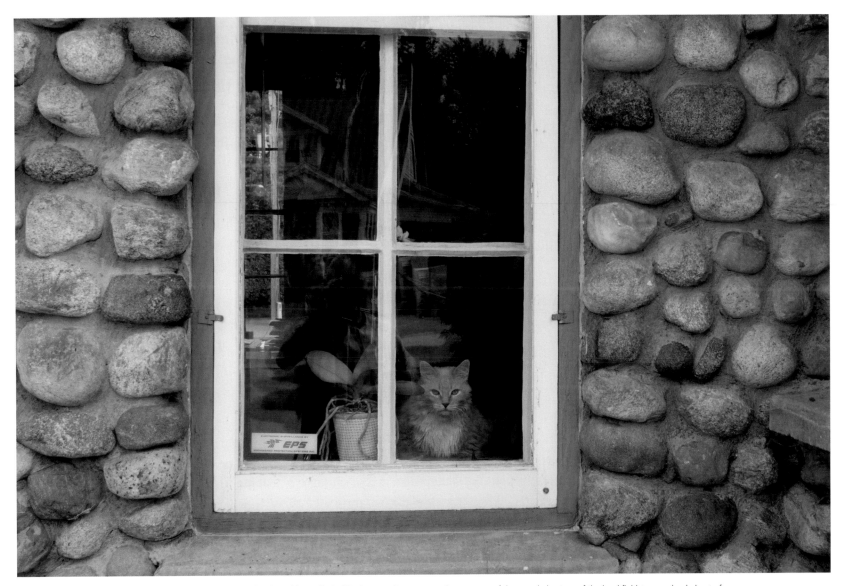

Come what may, "Spike" stands guard over the station day and night. Additionally, in this close-up shot you get a better sense of the rounded nature of the local fieldstones—hauled out of potato farmers' fields—that went into the depot's construction.

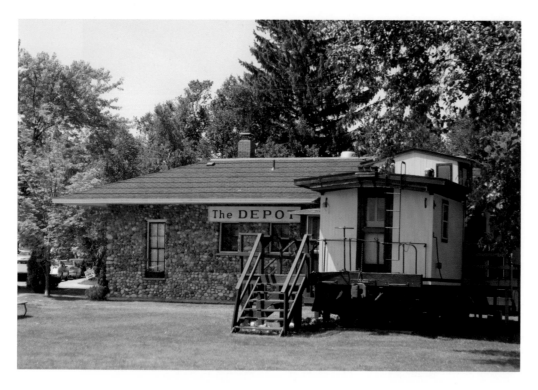

The look-alike Northport station at the tip of the Leelanau Peninsula has in recent years been connected to an old caboose and turned into The Depot restaurant.

Northport ferry, which helped pull down the whole enterprise.

But back to those farmers who now collectively owned a railroad—in 1919, the same individuals built the Suttons Bay and Northport stations with their own hands. Sensible men, they employed the most readily available material the peninsula could offer: rounded, mostly granite fieldstones sculpted by the glaciers that farmers had been cursing and pulling out of their fields for generations. Also known as un-coursed rounded cobblestones, the rocks—ranging in diameter from two to eight inches—built schoolhouses and house foundations all across the peninsula. The couple who filed the paperwork and won state historic designation for the depot, Stuart and Rose Hollander, went to considerable lengths to document whether any other rounded-cobblestone depots (as opposed to ordinary, lumpy fieldstone) exist across the country. They couldn't find any. (Regular fieldstone stations are not unusual. Michigan's prettiest is probably Lawton on the Detroit-Chicago road.)

The Suttons Bay depot was always a place where passengers jostled against freight—and indeed, often took a back seat. All the same, the depot provided welcome cover and warmth in the wintertime. Local praise was unstinting when the station was inaugurated. The *Provemont Courier* wrote on January 8, 1920, "The people of Suttons Bay had to wait a long time for a decent depot but now their fondest dreams are realized."

fort, south of Traverse City. In each case, the rail companies had little interest in the intermediate stations they stopped at. The Michigan-to-Wisconsin ferry at Frankfort, which made money years after the railroad itself was bleeding red ink, was the whole reason to cross the state. By contrast, the Traverse City, Leelanau & Manistique never could make a go of the

Three Oaks

1899—Michigan Central Railroad
1 Oak Street

ARCHITECT: Unknown

LAST PASSENGER SERVICE: 1958

CONDITION: Good

USE: Interior-design studio and home-furnishings store

*J*f there's a handsomer small-town station to be found in Michigan, it's hard to know where to look. Three Oaks was the last stop before the Michigan Central tracks crossed into Indiana, and Michigan Central Railroad execs apparently wanted an attention-getter. And that's precisely what they got—an impeccably tailored, crisp showstopper that cost the company $3,200, a tidy sum for a tiny building at the time. Richly detailed in cut stone and terra-cotta trim, the station's warm-orange brick virtually catches fire in sunset light. (Whoever picked the reddish-brown trim color deserves a round of applause.) At heart, the small building is a Victorian cottage, although one with unusually high production values and sharp little gables like exclamation points. Officially, the architect is unidentified. However, many have pointed to the depot's resemblance to the equally handsome redbrick station at Columbiaville as well as one at Amherstburg, Ontario. Those have been attributed to the Boston firm of Shepley, Rutan, and Coolidge, which did a number of stations for the New York Central over the years. Once the New York Central absorbed the Michigan Central into its network, it's no surprise it might use an East Coast architect it was familiar with.

Shortly after its opening in 1899, the station enjoyed a brief, blazing moment in the sun when President William McKinley stopped in town as part of the celebration surrounding the installation of the Dewey Cannon in a municipal park. The cannon had been captured by Admiral Thomas Dewey in the brief Spanish-American War. To raise money to build a monument to the men of the U.S.S. *Maine,* whose sinking led to hostilities, the cannon was promised to the town whose citizens raised the most per capita. That honor fell to little

Decorative terra-cotta tiles just beneath the "Three Oaks" sign is just one of many touches to this striking 1899 station that elevate it above most other small depots in the state. At the time of its construction, Three Oaks was one of the last stops before the Michigan Central tracks crossed the state line into Indiana. By the looks of it, railroad executives wanted those entering or leaving the state to be duly impressed.

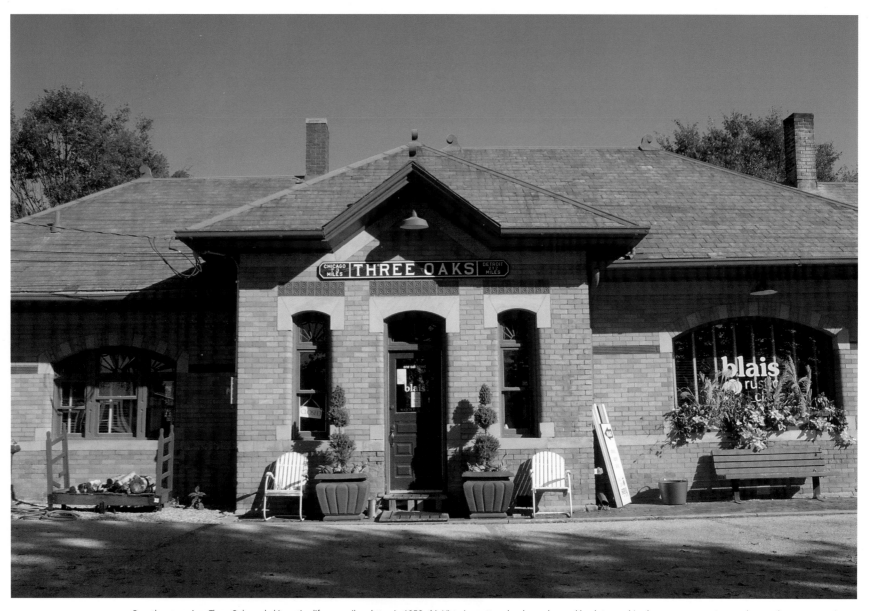

Over the years since Three Oaks ended its active life as a railroad stop in 1958, this Victorian cottage has housed a used bookstore, a bicycle museum, a sportswear shop, and—most recently—an interior design and furnishings studio. Note the leaded glass atop the front door and windows—unexpected grace notes that help give this little building its winning appeal.

in 1883, made a successful transition to turkey-bone stays.

Three Oaks disappears from the New York Central time-table by 1959. The structure was bought two years later by a minister, who lived in and ran a used-books and antique store out of the depot in the summertime. A sale in 1973 subsequently led to fifteen years of neglect and abandonment. In 1988, however, a Chicago businessman bought the place and put $50,000 into repairs and upgrades. Tenants over the ensuing years have included a bicycle museum and a sportswear shop. Today the depot houses Blais, an interior-design firm and home-furnishings store.

Both because of its size and scale, and because of elements like the sunburst window on top of the front door (*below*), the Three Oaks station almost feels more domestic than commercial.

Three Oaks, whose $1,400 in total pledges claimed the cannon in perpetuity. "Three Oaks against the World," crowed a local paper. During the official presentation on October 18, 1899, President McKinley assured the crowd, "We have had many beautiful receptions on our long journey through the great northwest, but I assure you that we have had none more beautiful or picturesque than the one you have given us at Three Oaks."

For years, little Three Oaks's other claim to fame was its dominance in a vital industry—women's corsets made with whalebone stays. (It goes without saying these were shipped to points far distant on the railroad.) Once whales got scarce, the Warren Featherbone Company, established in Three Oaks

Top: Curved finials crown Three Oaks's gable and rooftop, emphasizing this little building's many peaks. Another good choice was the warm orange brick, which catches fire in sunset light.

Bottom: The photograph below is undated, but the clothes suggest the very early twentieth century. (Personal collection of Jacqueline Hoist and Ronald Campbell)

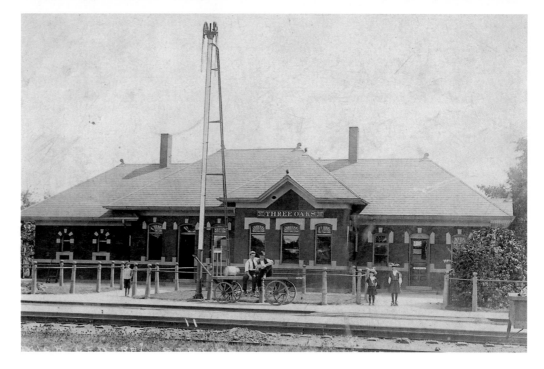

Ypsilanti

1864—Michigan Central Railroad
East Cross Street at North River Street

ARCHITECT: Unknown

LAST PASSENGER SERVICE: 1984

CONDITION: Poor

USE: In private hands

When a building is all but destroyed on two occasions and narrowly misses obliteration on a third, you can't help but think "curse." Calamity hovers over the 1864 structure at the heart of Ypsilanti's Depot Town like a familiar ghost. Conflagration (1910) and collision (near miss in 1929, direct hit in 1939) weren't the only threats. Press accounts back in the day are peppered with worthy citizens who stepped heedlessly in front of speeding express trains ("Killed by a Train: Miss Alice Bissell Meets with Instant Death). Bad luck dogs the modern era as well, as plan after plan for a restaurant in the abandoned building has crashed and burned. Held in private hands as of publication, the depot, in its tidy dilapidation—all windows and so on are secured—stands in mute contrast to Depot Town's extravagant painted ladies across the street—a colorful parade of nineteenth-century commercial row buildings. The station we see today was crafted from the remains of the 1910 fire and looks nothing like the original.

Built by the Michigan Central Railroad at the end of the Civil War, the original depot was a high-Victorian villa, looking very much like the house the Addams family lived in. Besides its steeply pitched roofs, the most significant element of the exuberant design was a several-story tower topped by a severe mansard roof, itself topped by a little wrought-iron fence.

Ypsilanti would likely treasure the original structure were it standing today—an over-the-top, almost campy exclamation point that would round out Depot Town's principal intersection, anchor one of its four corners, and boost the urban character and coherence of what is already one of Washtenaw County's handsomest nineteenth-century city scenes.

The painted ladies of Ypsilanti's Depot Town (*far right*), make a colorful contrast to the genteel dilapidation of the 1864 station and underline its location in the middle of a thriving commercial district. It raises the question, once again, how this admirable little building has managed to sit empty and forlorn all these decades.

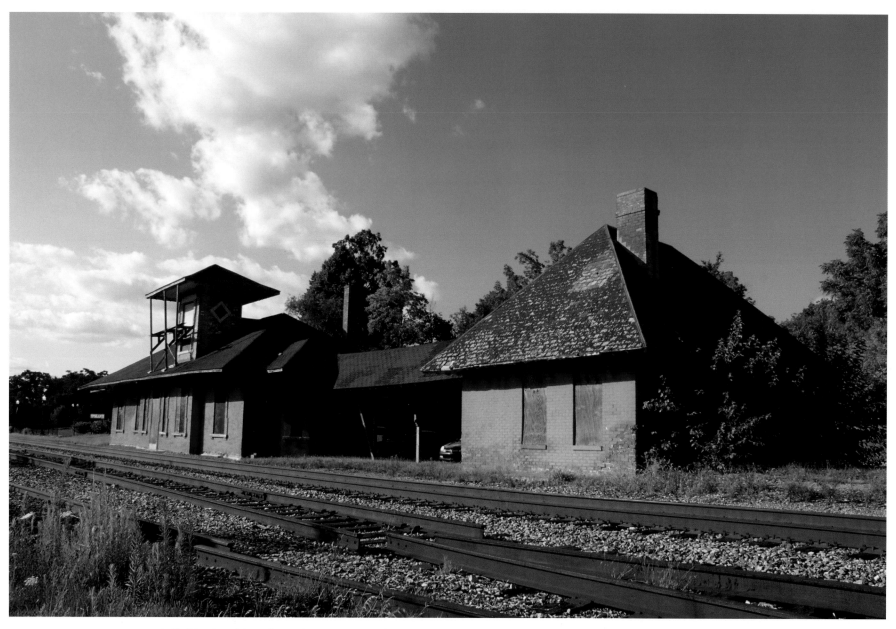

Bad luck has dogged the Ypsilanti Michigan Central station from the get-go, including an unfortunate run-in with a speeding freight train in 1939, which destroyed much of the building's track-side façade. The little tower disappeared in subsequent repairs and didn't re-materialize until 1988.

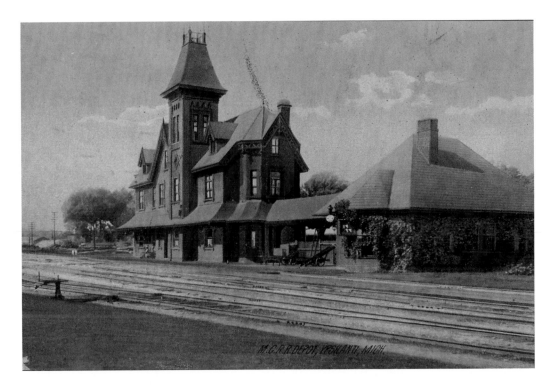

M.C.R.R. DEPOT, YPSILANTI, MICH.

Looking at these two historic postcards, you'd hardly guess you were dealing with the same building in each case. The marvelous Gothic pile at left (*top*) was what the Ypsilanti station looked like from 1864 to 1910, when a catastrophic fire destroyed the top two stories. When the Michigan Central Railroad rebuilt, it opted for brutal economies, reducing the depot to one story with a stubby little tower (*below*). (Personal collection of Jacqueline Hoist and Ronald Campbell)

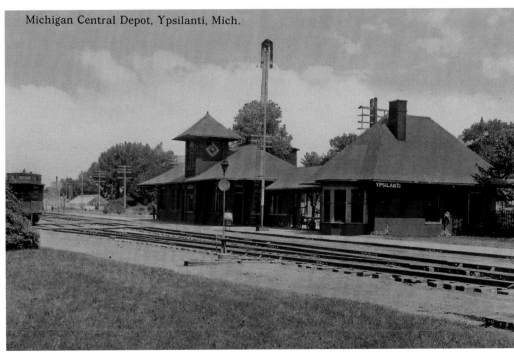

Michigan Central Depot, Ypsilanti, Mich.

The Ypsilanti station was also one of two along the Michigan Central main road—the other being Niles—with extensive gardens and greenhouses. Together the two stations provided all flowers for the railroad—for which there was enormous demand at the turn of the century. In an October 21, 1894, article entitled "An Engine of Flowers," the *Washington Post* reported that in the previous year, Michigan Central porters had presented 28,383 boutonnieres to women passengers and "455 large bouquets to hospitals at Detroit."

Ypsilanti's is the second-oldest depot building in the state and by far the oldest on the Detroit to Chicago track. (A board-and-batten Coldwater station, now a hair salon, was built fourteen years earlier in 1850.) The Ypsi depot hosted President Andrew Johnson in 1866, who stepped down from the train to address to the assembled crowds. With the president (never identified in the *Detroit Free Press* article by name, only as "the president") was a veritable who's who of post–Civil War military and political America. Accompanying him were General Ulysses S. Grant, Secretary of State William Henry Seward, General George Armstrong Custer, and Admiral David G. Farragut, the "Damn the torpedos—full speed ahead!" hero of the Battle of Mobile Bay (1864).

Far more exotic, if fleeting, was the 1871 glimpse the station got of His Imperial Highness, the Grand Duke Alexis of Russia and his entourage, bound for Chicago on the express. They did not stop.

The year 1910 started badly at the depot, with a murder on January 7. Given the fire that almost consumed the station several months later, that January tragedy might have looked in retrospect like an omen. It was a cold night, and three young Detroiters had taken the train to Ypsi where they were, at the time the night watchman discovered them, bus-ily robbing Switzer Brothers Jewelry blind. The thieves fled. The watchman raised the alarm. Two of the three robbers ultimately ended up at the depot at 5 a.m., hiding in the women's waiting room. As the night baggageman and ticket agent tried to take them into custody, one of the two escaped, while the other—apparently never adequately searched—brandished a gun and shot both his captors. The railway men lunged at him, and the three stumbled out onto the train platform like a great fumbling beast. Mortally wounded, night baggageman Henry Minor broke away from the other two, grabbed at an iron railing on the far side of the tracks, and collapsed.

The young gunman, one Harry Harrington, was caught, tried, and sentenced to life in prison just two business days after the crime—justice so swift it almost takes your breath away.

Four months later, tragedy struck again—this time the great fire, which started in the roof. The initial spark was put down to faulty wiring or a hot chimney—not locomotive ash, which sparked the vast majority of depot fires in the age of steam. What you'd think would be a calamity, however, was treated with laconic disinterest by the *Ypsilanti Daily Press*. A short article on the morning fire made the afternoon edition, where—in the editors' defense—it ran at the top of the front page. But the subject promptly disappeared for weeks thereafter, as if losing the town's principal connection to the outside world were no big deal.

By 1910, of course, an 1864 depot was hopelessly out of date to most residents—a relic of their grandparents' quaint but inferior ways, built in an architectural style that was already sliding out of fashion even as it opened its doors. So when the top two stories burned one fine May morning, there were hopes the railroad would build a smart, up-to-the-min-

The future of the Ypsilanti station is clouded, with no clear redevelopment plan on the horizon. Still, it's hard to believe a building as appealing as this will stay vacant forever.

ute new station. But the Michigan Central decided to make do with what was left, producing a one-story depot with a short, square tower—the stumpy remains of the original.

The depot's diminished profile would shrink yet again. At dawn on August 10, 1939, a freight train hauling sand, eggs, and an unidentified "corrosive liquid" derailed yards short of the station. Several cars jumped the track and smashed into the stationmaster's office with a shattering roar, ripping out most of the trackside façade. Remarkably, no one was hurt in the crash, which caused an estimated $3,000 in damages. (In 1929 a similar catastrophe narrowly missed the depot— a freight train instead slamming into the building that now houses the Sidetrack Bar and Grill across the street.)

When it rebuilt this time, the company scrapped the little tower, which had in any case been reduced to rubble. It wouldn't appear again until 1988, erected by new, private owners—although, mystifyingly, built with different-colored bricks than the original. Still, this restored the little depot to its traditional post-1910 outline. And even if it's simply a make-do design, it has to be noted that in aesthetic terms, Ypsi's much-abused station does have simplicity working in its favor. Improvised though it may be, it's not a bad building. Were it to finally reopen as a restaurant or some other semipublic enterprise, it would be a considerable gift to its neighborhood.

Since 1976 at least four attempts have been made to convert the station into a restaurant. The first couple were frustrated by the refusal of the railroad owners—Penn Central, later Amtrak—to sell the building. Bad luck seems to have afflicted all other efforts. The building has sat empty since the early 1960s. (Rail service continued till 1984, but for the last twenty-odd years passengers had to make do with just an outdoor platform.) All these years later, Depot Town waits for a resurrection that keeps receding into the future.

166

Epilogue

It was a doomed train station that first called the modern American historic preservation movement into being. The 1963 destruction of New York's Pennsylvania Station and its replacement by a forgettable office tower and underground depot with bus-station charm jolted the grassroots to life, driving home the panicked realization that if one of the nation's best-loved buildings could go, then nothing was safe. It's easy to romanticize what's lost when a great building disappears, of course, but in this case—once the Beaux-Arts monument based on the Baths of Caracalla was chopped up and hauled off to the New Jersey swamps—the impact on New York's quality of life was palpable. As long as New York had Penn Station, wrote author and critic Vincent Scully in one of architecture's great put-downs, "[One] entered the city like a god. One scuttles in now like a rat."

Grief and rage at that act of architectural vandalism led to the creation of the city's Landmarks Preservation Commission and caught fire again over the next decade when private interests wanted to realize the same short-term gains by ripping down most of New York's Grand Central Terminal. The successful protest, led by Jacqueline Kennedy Onassis, helped mobilize public opinion nationwide and anchor historic preservation in the popular mind as a worthy cause associated with a heroic figure.

Would we have cared as much had Penn Station or Grand Central been office buildings, however famous? Not necessarily. Because of all they have represented over the years, train stations were anchored to deeper emotions than most structures in daily life. In the national imagination before the automobile stole the show, depots were mysterious and sexy, doorways to freedom and escape, passageways to a dizzying future. Great or small, the station framed joyous homecomings and bitter partings, acting as the bridge between here—wherever one's "here" was—and everyplace else on earth.

By the late 1960s, such associations had mostly migrated to the airport, and the thrill of the "jet age." In 1944 U.S. railroads carried more than 910 million passengers. By 1966 that was down to 300 million. The collapse in traffic doomed depots all across the country. Nor was this just an American phenomenon—Great Britain lost more than four thousand stations from the mid-1960s to the mid-1980s. In Michigan, singular stations were pulled down in Detroit, Edmore, Flint, Grand Rapids, Lansing, Owosso, Port Huron, and Sault Ste. Marie, to name just a few. When a station was located on the outskirts of town, like as not in a trackside industrial strip, its disappearance was a loss but not necessarily a tragedy. When it was fitted right into the center of things, however—an indispensable part of the jigsaw creating a downtown—its erasure all too often left a gaping wound that undermined the cohesion of the whole area.

As of 2011, the most imperiled Michigan depot has to be Saginaw's Potter Street Station—a redbrick, spectacular wreck

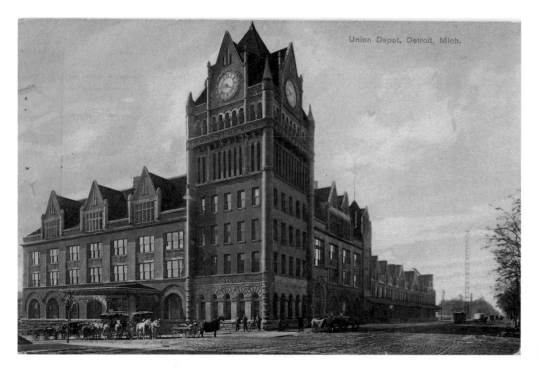

Replaced in 1913 by the Michigan Central Station that still looms over Detroit's near-west side, this Union Depot stood at the corner of Third Street and Fort—where Wayne County Community College's Detroit campus sits now. (Personal collection of Jacqueline Hoist and Ronald Campbell)

of a building that looks like it's been bombed, and is now sealed off with concertina wire. Attempts to rescue the Victorian behemoth have gone nowhere, perhaps no surprise given its location in a dilapidated residential neighborhood well outside Saginaw's commercial heart. Detroit's Michigan Cen-

tral Station surely comes second among depots at risk. Shortly before publication of this book, however, its owner promised to replace the shattered windows and leaking roof in a bid to make redevelopment more likely. Ypsilanti's boarded-up station cries out for renovation and redevelopment, not least because it occupies one of the principal corners in Ypsi's historic Depot Town commercial district.

Happily, while real estate pressures still threaten older buildings, especially in booming cities, the contemptuous rush to tear down and "improve" on the old that characterized so much American building in the 1960s and 1970s has passed. (No style has ever been as glib and dismissive of all that came before it than Modernism.) Still, economics favors mediocrity over excellence, expedience over thoughtful planning. In a culture where the bottom line rules all, it's worth remembering the October 30, 1963, *New York Times* editorial jeremiad, "Farewell to Penn Station," that followed the destruction of the august landmark:

Any city gets what it admires, will pay for, and, ultimately, deserves. Even when we had Penn Station, we couldn't afford to keep it clean. We want and deserve tin-can architecture in a tin-horn culture. And we will probably be judged not by the monuments we build but by those we have destroyed.

Appendix: Historic Designation

Many stations covered in this book are listed in the Michigan State Register of Historic Sites and the National Register of Historic Places. For purposes of identification in the list below, when there's more than one depot in town (as with Ann Arbor), I have included the name of the railroad associated with it.

	Michigan State Register of Historic Sites	National Register of Historic Places
Ann Arbor / Michigan Central depot	X	X
Battle Creek / Grand Trunk Railway		
Birmingham	X	X
Charlevoix	X	X
Chelsea	X	X
Clare		
Columbiaville	X	X
Detroit	X	X
Dexter	X	
Durand	X	X
Flushing	X	
Gaines		
Grass Lake	X	
Holly	X	X

	Michigan State Register of Historic Sites	National Register of Historic Places
Iron Mountain / Chicago, Milwaukee & St. Paul depot		
Jackson	X	X
Kalamazoo	X	X
Lake Odessa	X	
Lansing / Grand Trunk Western depot	X	X
Lawton		
Mayville	X	
Muskegon	X	X
Niles	X	
Petoskey	X	X
Saginaw	X	X
St. Johns		
Shepherd		
South Lyon	X	
Suttons Bay	X	X
Three Oaks		
Ypsilanti		

Bibliography

BOOKS

Andrews, Wayne. *Architecture of Michigan*. Detroit: Wayne State University Press, 1967.

Ann Arbor Illustrated: City of Ann Arbor; Its Resources and Advantages. Ann Arbor: Ann Arbor Businessmen's Association, 1887.

Berg, Walter G. *Buildings and Structures of American Railroads*. New York: John Wiley and Sons, 1911.

Blue, Robert L. *Footsteps into the Past: A History of the Columbiaville, Michigan Area*. Columbiaville, Mich.: Columbiaville Historical Society, n.d.

Blumenson, John J.-G. *Identifying American Architecture: A Pictorial Guide to Styles and Terms, 1600–1945*. New York: Norton, 1977.

Boggs, Brian J., and M. Jean Sloan, eds. *Depot Dreams: A Compilation of Stories, Life and History of Durand Union Station*. Durand, Mich.: N.p., 2005.

Brown, Christopher. *Still Standing: A Century of Urban Train Station Design*. Bloomington: Indiana University Press, 2005.

Campbell, Ronald, and Jacqueline Hoist. *Michigan's Destination Depots: Lighthouses Along the Rivers of Steel*. Fenton, Mich.: Allied Media, 2010.

Cavalier, Julian. *Classic American Railroad Stations*. San Diego: A. S. Barnes, 1980.

Chelsea 125th Anniversary: 1834–1959. Chelsea, Mich.: Chelsea Historical Society, 1959.

Church, Cary, Kathy Clark, and Janet Ogle-Mater. Chelsea, Mich.: *Chelsea: 175th Anniversary, 1834–2009*. Sheridan Books, 2009.

Connelly, Will. *Chelsea's First 150 Years: 1834–1984*. Chelsea, Mich.: Chelsea Michigan Sesquicentennial (1834–1984), 1984.

Daboll, Judge S. B. *The Past and Present of Clinton County, Michigan*. Clinton, Mich.: S. J. Clarke, 1906.

Droege, John A. *Passenger Terminals and Trains*. New York: McGraw-Hill, 1916.

Dunbar, Willis F. *All Aboard! A History of Railroads in Michigan*. Grand Rapids, Mich.: Wm. B. Eerdmans, 1969.

Eckert, Kathryn Bishop. *Buildings of Michigan*. New York: Oxford University Press, 1993.

Fleming, John, Hugh Honour, and Nikolaus Pevsner. *The Penguin Dictionary of Architecture*. London: Penguin, 1991.

Flushing: Sesquicentennial History. Vol. 3. Flushing, Mich.: Flushing Area Historical Society, 1998.

Gates, Henry Louis, Jr., and Evelyn Brooks Higginbotham, eds. *African American Lives*. Oxford: Oxford University Press, 2004.

Grant, H. Roger, and Charles W. Bohi. *The Country Railroad Station in America*. Boulder, Colo.: Pruett, 1978.

Halberstadt, Hans, and April Halberstadt. *The American Train*

Depot and Roundhouse. Osceola, Wis,: Motorbooks International, 1995.

———. *Train Depots and Roundhouses*. St. Paul: MBI, 2002.

Hazelbaker, Randall. *Branch County*. Charleston, S.C.: Arcadia, 2005.

———. *Coldwater*. Charleston, S.C.: Arcadia, 2004.

Hemingway, Ernest. *The Letters of Ernest Hemingway: 1907–1922*. Edited by Sandra Spanier and Robert W. Trogdon. Cambridge: Cambridge University Press, 2011.

Hill, Eric J., and John Gallagher. *AIA Detroit: The American Institute of Architects Guide to Detroit Architecture*. Detroit: Wayne State University Press, 2003.

History of Leelanau Township. Leelanau, Mich.: Leelanau Historical Writers Group, 1982.

Holland, Kevin J. *Classic American Railroad Terminals*. St. Paul: MBI, 2001.

Houghton, Lynn, and Pamela Hall O'Connor. *Kalamazoo Lost and Found*. Kalamazoo, Mich.: Kalamazoo Commission for Historic Preservation, 2001.

Jolly, Craig, with the Birmingham Historical Museum. *Birmingham*. Charleston, S.C.: Arcadia, 2007.

Kavanaugh, Kelli B. *Detroit's Michigan Central Station*. Charleston, S.C.: Arcadia, 2001.

Lester, Larry; Sammy J Miller; and Dick Clark. *Black Baseball in Detroit*. Charleston, S.C.: Arcadia, 2000.

Love, Edmund G. *The Situation in Flushing*. New York: Harper and Row, 1965.

McKinley, William. *Speeches and Addresses of William McKinley, March 1, 1887–May 30 1900*. New York: Doubleday and McClure, 1901.

McMecham, Jervis Bell. *The Book of Birmingham*. Birmingham, Mich.: Birmingham Historical Board, 1976.

Meeks, Carroll L. V. *The Railroad Station: An Architectural History*. New York: Dover, 1995.

Miles, David L., ed. *Bob Miles' Charlevoix II*. Charlevoix, Mich.: Charlevoix Historical Society, 2002.

Mrozek, David J. *Railroad Depots of Michigan: 1910–1920*. Charleston, S.C.: Arcadia, 2008.

———. *150 Years of Michigan's Railroad History*. Lansing: Michigan Department of Transportation, 1987.

Potter, Janet Greenstein. *Great American Railroad Stations*. New York: John Wiley and Sons, 1996.

The Record of Sigma Alpha Epsilon. Vol. 14. Frankfort, Ky.: S.A.E., 1894.

Richards, Jeffrey, and John M. MacKenzie. *The Railway Station: A Social History*. Oxford: Oxford University Press, 1986.

Shackman, Grace. *Ann Arbor in the 19th Century: A Photographic History*. Chicago: Arcadia, 2001.

Smith, Burge Carmon. *The 1945 Tigers: Nine Old Men and One Young Left Arm Win It All*. Jefferson, N.C.: McFarland, 2010.

Stilgoe, John R. *Metropolitan Corridor: Railroads and the American Scene*. New Haven, Conn.: Yale University Press, 1983.

Uhelski, John M., and Robert M. Uhelski. *An Inventory of the Railroad Depots in the State of Michigan*. Crete, Neb.: Railroad Station Historical Society, 1979.

Wolff, Magritta. *Whistle Stop*. New York: Scribner, 1941.

Newspapers and Magazines

Ann Arbor Courier
Ann Arbor Observer

Architectural Record

Argus-Press

Battle Creek Enquirer and News

Birmingham Eccentric

Charlevoix Courier

Charlevoix Sentinel

Chicago Tribune

Clinton Republican

Detroit Free Press

Detroit News

Dexter Leader

Durand Express

Fenton Press

Flushing Observer

Holly Advertiser

Hour Magazine

Jackson Citizen Patriot

Jackson Daily Citizen

Lansing State Republican

Mackinac Island Town Crier

Michigan History

Michigan Reports (Michigan Supreme Court)

New York Evangelist

New York Times

Niles Weekly Mirror

Oakland Advertiser

Owosso Argus-Press

Petoskey Daily Resorter

Petoskey Evening News

Petoskey Record

Provemont Courier

Railroad Gazette

Railway Age

Report of the Interstate Commerce Commission

Saginaw Courier

Saginaw News

St. Johns News

Washington Post

Watchword (United Brethren in Christ)

Ypsilanti Daily Press

Websites

http://www.detroit1701.org

http://www.michiganrailroads.com

http://www.pbs.org/unforgivableblackness

http://www.railroadmichigan.com

http://www.umich.edu/whitehouse

http://user.mc.net

Index

(Personal collection of Jacqueline Hoist and Ronald Campbell)

186